D1422613

PRIVATE EYE

A CARTOON HISTORY

PRIVATE EYE

A CARTOON HISTORY

EDITED BY NICK NEWMAN

Published by Private Eye Productions Limited 2013

10 9 8 7 6 5 4 3 2

Photographs of cartoonists on pages ix courtesy of the Victoria & Albert Museum, London
Photographs of cartoonists on pages xi (top) and xiv (top and middle left) © Janie Airey
Tony Reeve photograph on page x courtesy of Andrew Godleman
David Austin photograph on page xii courtesy of Reg Gadney
David Austin train photograph on page xii courtesy of First Great Western
Michael Heath cartoon on page xiii courtesy of the Cartoon Museum Collection, London

First published in Great Britain by Private Eye Productions Limited 2013

6 Carlisle Street
London W1D 3BN

www.private-eye.co.uk

A CIP catalogue record for this book is available from the British Library

ISBN 978-1-901784-61-9

FSC
www.fsc.org

MIX
Paper from
responsible sources
FSC® C023561

Designed by Peter Ward
Printed and bound in Great Britain by Butler Tanner & Dennis Ltd, Frome, Somerset

CONTENTS

INTRODUCTION

All human life is here. And quite a lot of dogs too. And other animals. And dinosaurs. And a few aliens. And in fact just about everything else. That is the joy of the cartoon, in that it can be about anything. Or nothing. From a sharp comment on politics, to an insight into the nature of relationships, to a very silly pun, the only thing that matters is that it is funny. Whether describing the nature of reality or just escaping from that reality, the cartoon is a captured moment of laughter, a unique window on a comedy landscape, a preserved comic fragment of delighted recognition across the unforgiving march of time . . . and a very good way to get into *Pseuds Corner*.

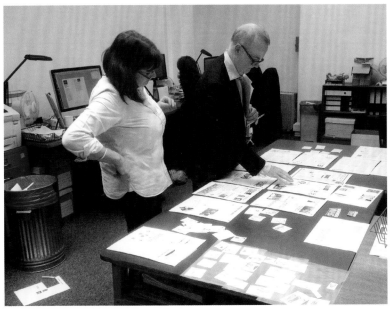

Judgement Day –
art director Bridget Tisdall and
editor Ian Hislop decide a
cartoon's fate on Press Monday

There is nothing more likely to kill a joke than discussing it, so I will skip the academic thesis. Suffice to say that the cartoon is a curious art form. Originally the word meant a preliminary drawing for a painting or fresco, hence the gags about Raphael's cartoons 'not being very funny'. Now it means a stand-alone drawing that is specifically designed to provoke laughter and the cartoonist has to display both a talent for draughtsmanship and a talent to amuse.

This tends to make us writers jealous since we usually have one talent, at most. Nick Newman and I produced a parody of *Punch* magazine once for our student magazine which contained a small cartoon in the middle of a large chunk of prose. It showed two men talking to each other, one saying, 'Do you think anyone is reading this article?' and the other one saying, 'No, they are all looking at this cartoon'. Cartoonists believe this is entirely true and are happy to tell me, particularly after a few drinks, that the only reason anyone buys

Private Eye is for the cartoons. The readers apparently put up with all that dreary prose as a sort of penance for laughing at the drawings. This book is the cartoonists' idea of perfection with a minimum of prose and a maximum of jokes.

Still, it is the editor who gets to choose the cartoons and cartoonists always think there is some conspiracy at work in the selection of the small number of jokes that make it into each issue. There isn't. It is merely what makes the editor laugh at the time. You can't guess what other people will find funny, you just have to hope that they will enjoy what you do. This is what I learnt from my predecessor as editor of *Private Eye*, Richard Ingrams, whose love of cartoons and promotion of them made the magazine such a showcase for comic talent. He always made it clear that choosing the cartoons was not only one of the most important jobs of the editor, but also one of the most enjoyable.

I think this was because his great friend from school, Willie Rushton, was a cartoonist. The two of them had collaborated on a student magazine at Oxford before the launch of the *Eye* and then worked on it together. When I took over as editor the pattern repeated itself, as I was working with my great friend from school, the cartoonist Nick Newman, with whom I had collaborated on our student magazine at Oxford.

This book, then, is a tribute to cartoonists. And also a small counter-cultural tribute to the enduring nature of print. These are drawings in ink on paper, printed on dead-wood in a magazine and then published here again in an old-fashioned book. I don't think that print is dead and I don't think that the cartoon is dead either.

It is a proud *Private Eye* tradition to take cartoons, er, seriously. They are vital to the success of the magazine and I should make clear to any cartoonists reading this that I mean that as a sincere compliment, rather than as a promise of a pay rise.

Ian Hislop
July 2013

FOREWORD

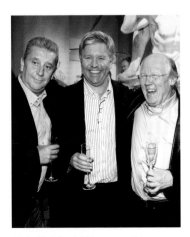

Celeb's Mark Warren with Nick Newman and Ken Pyne, doing what cartoonists do best: drinking

The great and usually grumpy Michael Heath

The ins and outs of the cartoon production process

Cartoonists are a contradictory breed: shy, yet desperate for exposure; craving approval and yet embarrassed when praised; grateful and resentful by equal measure. Cartooning is much like being a stand-up comedian – but without hearing any laughter. Rejection is a daily occurrence, success is treated with suspicion. No wonder that cartoonists, however successful, end up feeling paranoid. And no wonder the themes of so many cartoons are misfortune, disaster and pain.

Cartoonists themselves come from all walks of life – from artists to actors, teachers to taxi drivers. Hugh Burnett, who became synonymous with monks, produced the 1960s seminal interview show *Face to Face*. Mike Barfield, the man behind the strip *Apparently*, wrote the jokes for *Who Wants to be a Millionaire?* Geoff Thompson worked at Westland Helicopters. Simon Key was, ironically, a private eye. The cartoonist 'Ingo', who drew bird gags in the 1960s, was in real life the editor of a satirical magazine.

So why does anyone put pen to paper and face imminent failure? Producing joke ideas can give you a strange and exciting feeling of white heat in the pit of your stomach. Opening a magazine to find a gag published provides an enormous rush. Receiving a request to buy an original drawing transports you to the promised land. It doesn't happen

It's Grim Up North's Jez and Quin, masquerading as Knife (*right*) and Packer (*left*)

No longer with us: cartoonist Tony Reeve who died at the height of his powers

often. For the most part, the response to a published cartoon is deafening silence. A complaint about a joke, while distressing, is gratifying simply because it proves someone actually saw the offending drawing. But despite the negatives, anyone who gets published in *Private Eye* should feel immensely proud of themselves. Over 500 unsolicited cartoons pour into the magazine every fortnight – which are boiled down to just 35 or so published gags. They come in all shapes and sizes – and range from the hilarious to the frankly deranged. Some are offensive – or in the most appalling taste: these are invariably published.

I began sending cartoons into the *Eye* while I was at university – all were quite rightly rejected. The *Eye*, along with *Punch*, was the pinnacle of cartooning achievement. Both titles provided the ultimate shop window – but whereas *Punch* published cartoons shining out amidst a frame of boring text – the *Eye* presented a different challenge: the cartoons had to compete with great written jokes and photo-gags. All the artists I admired worked for both. Sending ideas in regularly was to provide a lottery-like thrill – would this week provide a life-changing bonanza? No. My gags would come back with a charmingly printed rejection slip, advising me 'No thanks. Try again/try *Punch*'.

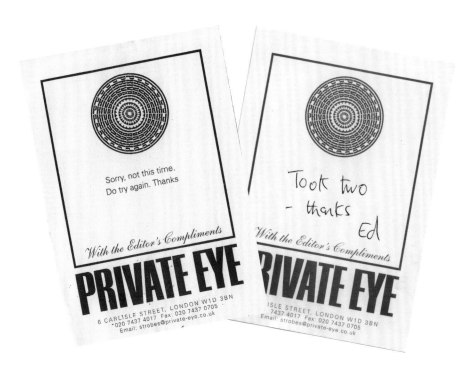

Gloom or glee: rejection and acceptance slips

Still going strong: cartoon legends Ed McLachlan . . .

. . . and Martin Honeysett

And then, finally, I had a gag published and I instantly made plans to resign as a well-paid business journalist and move to a garret where I could drink myself to death like a true cartoonist – but instead of self-destruction, the excitement of getting published again made me focus on getting more jokes in print. Regular gags led to a strip cartoon – and then more strips, and more gags.

On reflection, I certainly wouldn't print my 'jokes' of the period (though one or two have made it into this collection, because they were apparently popular at the time). I'm sure all cartoonists feel the same. Gerald Scarfe burnt all his early drawings, and I'd like to do likewise (that is, burn MY old cartoons – not Scarfe's). Yet one of the pleasures of editing this tome has been to see the progression of the *Eye*'s cartoonists from scratchy at first, to confident and accomplished draughtspersons. The very best, like McLachlan and Honeysett, have barely changed. The rest of us have adapted, copied and evolved.

The space for cartoons in the magazine has generally become smaller – so the drawings have become simpler (the uncompromising McLachlan excepted). With the demise of *Punch*, the *Eye* expanded, the competition to get published became fiercer, and the editor's desire to accommodate the increased cartoon volume meant that the jokes became smaller. Likewise, a tendency towards topicality: the lifespan of a topical gag being much like that of a mayfly has meant that in recent years stand-alone gags have suffered. This situation is now changing.

What hasn't changed is the cartooning process. It's a lonely business, involving much space-staring and displacement activity. Topical cartoonists can rummage through the press for inspiration – but the crutch of newspapers won't make up for the essential requirement to think laterally or literally. There are stock situations to fall back on – psychiatrists' couches, men on window ledges and desert islands – but such scenarios have to be approached with invention and originality. The great thing about cartooning, for some of us, is that you don't have to be able to draw particularly well. Some cartoonists are true artists, but many are self-taught, and one of the most highly-paid scribblers draws stick-men. But what you do need is charm – and that unifies the

The late David Austin and the train named after him

Eye's cartoonists. However the bleakness of the sentiment, however sick the joke, if it's delivered with charm you can get away with it – and with only a handful of cancelled subscriptions.

Most regulars will send in half a dozen ideas every issue, roughly drawn in pencil or biro, from which the editor will pick one – or none. The cartoonist will then curse, vow never to work for the magazine again, before promptly submitting more jokes. If accepted, the cartoonist will just gratefully draw up the selected gag and hope that one day it makes it into the magazine. The hit rate for even the most successful cartoonists is about one in ten and, once approved, the finished artwork is sent in via email, fax or (if you're feeling lucky) by post. The cartoon may then eventually appear – or not. Acceptance is sadly no guarantee of publication: news changes and other publications may beat you to the joke. The payment of a 'kill fee' in no way makes up for the disappointment of not making the final cut. It's a depressingly brutal process, all fuelling the cartoonist's sense of paranoia and injustice.

Rejection is the glue which binds rival cartoonists together – and the experience which defines us as a breed. If you can deal with rejection, you will succeed as a cartoonist. It took Steadman three years to get into *Punch*. I began submitting to the *Eye* in 1976 – and was finally accepted in 1982. Any gathering of gagsters will quickly degenerate into a whinge-fest of shared pain. It isn't enough that the editor accepted three gags – he rejected another four, so obviously has no sense of humour and the jokes are all chosen by myopic moles. At one cartoonists' get-together we established that who we are really trying to impress was neither editors, nor readers – but fellow cartoonists. Make Brother Brush laugh and you've hit the bullseye. A target audience of miniscule proportions.

The best depiction of the cartoonist's life was drawn by Michael Heath, an *Eye* regular for over 50 years and the closest thing cartooning has to Picasso: a genius with the pen who breaks all the rules of draughtsmanship. It's a brilliant illustration of all the essential ingredients of cartooning: misery, frustration, hope, joy and anger – with a big dollop of self-pity. Above all, it captures what cartooning is truly about: being incredibly funny.

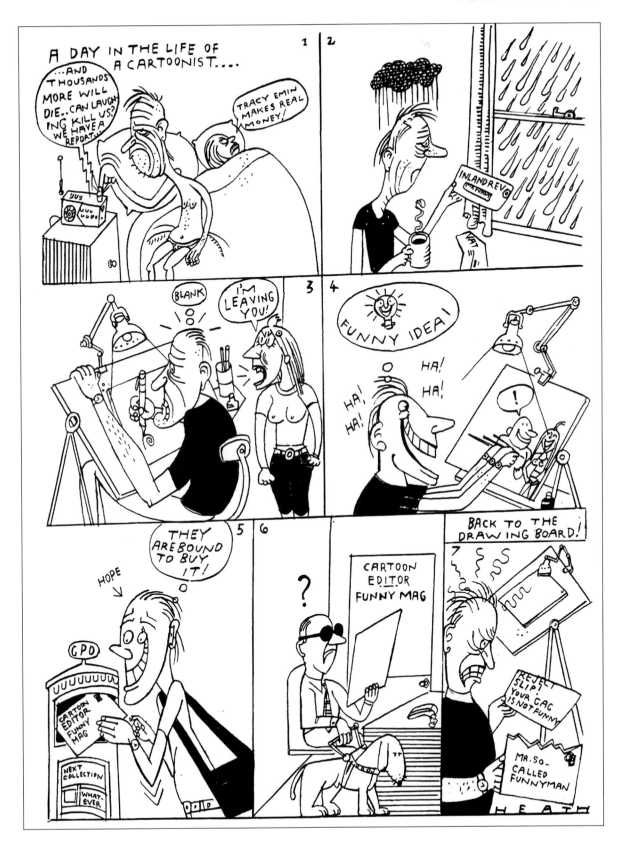

The multi-talented Giles Pilbrow

The *Eye*'s 2010 Big Draw winning team of Simon Pearsall, Steve Way, Henry Davies and Andrew Birch

RGJ, aka Richard Jolley

Three generations of Lambs. KJ (Kathryn) is in the centre

As editor of this collection, I've had to switch roles from author to critic – from lamp-post to dog. It has been a humbling process – and I've had to make some agonising decisions. Boiling down over 30,000 cartoons from more than 1300 issues has been no laughing matter. The hardest call of all has involved the strip cartoons. An essential feature of the magazine for 50 years, they often don't make any sense now due to topicality – and so I've limited myself to representative samples. My heartfelt sympathies go to those who, for reasons of topicality or space, didn't make the cut. The result does, I hope, contain some of the funniest cartoons ever drawn. It is also, as a sober social history, a visual chronicle of the past half century – holding a fairground mirror up to life and having a right good laugh.

I am hugely indebted to the *Eye*'s editors past and present, along with Sheila Molnar, Bridget Tisdall, Tony Rushton, the designer Peter Ward, The Cartoon Museum, Kent University's Cartoon Archive and *The Dictionary of British Cartoonists and Caricaturists* by Mark Bryant and Simon Heneage. Above all, my thanks go to the *Eye*'s brilliant cartoonists – the wittiest, most inventive artists in existence, who have made the process such a pain and a pleasure.

Nick Newman

July 2013

PRIVATE EYE

6 CARLISLE STREET, LONDON W1D 3BN
Telephone: 020 7437 4017 Fax: 020 7437 0705 Email: strobes@private-eye.co.uk

Nick,
 Sorry not quite
Can you send in some other
forewords- maybe half a dozen
or so ? If not I'll get ken
Pyne or Martin Honeysett to do
one .
 cheers.

Pressdram Limited. Registration: London 708923.
Registered Office: Lynton House, 7-12 Tavistock Square, London WC1H 9LT.
Directors: Ian Hislop, Sheila Molnar, Geoff Elwell.

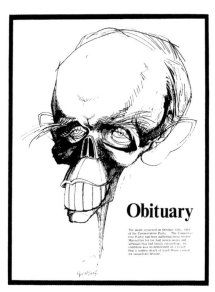

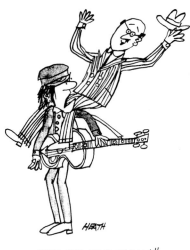

Obituary

The death occurred on October 18th, 1963, of the Conservative Party. The Conservative Party had been suffering from severe Macmillan for the last seven years and although this had finally cleared up, its condition was so debilitated as a result that a sudden attack of Lord Home caused its immediate demise.

"GET OFF MY BACK, DAD!"

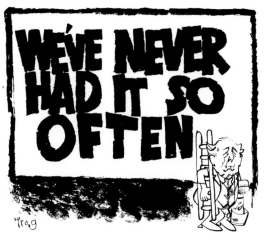

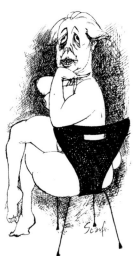

THE 1960s

The launch of *Private Eye* in 1961 opened a new chapter for cartoonists. From the outset, cartoons were an essential feature of the magazine, and although Willie Rushton drew almost all of the *Eye*'s early jokes and illustrations, he was soon joined by Steadman and Trog – refugees from *Punch* and the *Spectator* respectively. By 1963, more cartoonists were breaking away from the staid and conservative confines of *Punch* to express their darker and weirder side. Bill Tidy, Larry, McLachlan, Scarfe, Steadman and Hector Breeze all enjoyed the freedom of the *Eye*'s more daring editorial policy, while Michael Heath and Barry Fantoni captured the inanities of the psychedelic hippy era. Satire boomed and, as hair grew longer and the cold war became cooler, the permissive society dawned, the space race lifted off, the Sixties swung, scandal brought down the government and the optimism at the end of 13 years of Tory rule quickly gave way to disillusionment and cynicism. It was to prove fertile ground for the *Eye*'s cartoonists.

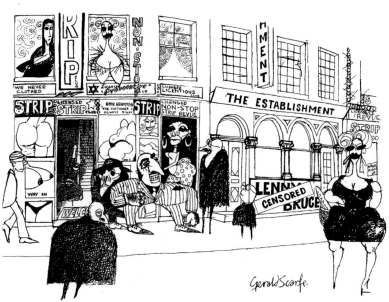

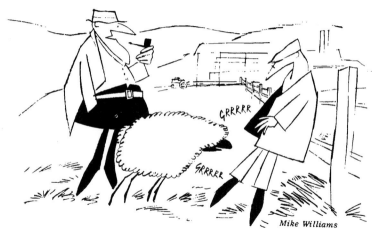

"It's a sheepdog"

"Right, that does it! No more Royal trains!"

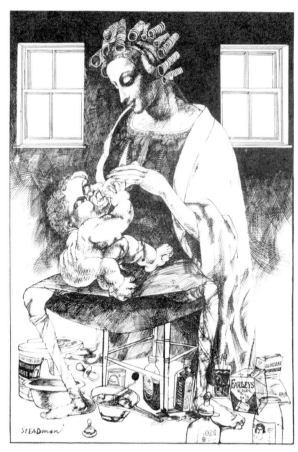

THIS SEPTIC ISLE Mother & Child

*"By God, Hornpipe, I wouldn't like to
be a nudist on a night like this"*

an old cow-hand...

"Lloyd George knew my mother"

"Gentlemen, gentlemen! Disorder, please, disorder"

Roger Law

"Nigel, I think we're going to have an abortion"

BORE of the WEEK The TWIST

Yes, the dance that doesn't need a partner — only an audience. The dance that you can do standing still — so long as you've still got room to move about in. The dance that's so simple anyone can do it — except you and the 15 million others who've spent the last three months trying to learn. The dance, in short, that everyone's doing — not because it's easy, or graceful or fun — but just because everyone's doing it.

PRIVATE EyE presents an exclusive close-up view of London's latest Temple of the Twist — the hippest hotspot for Mayfair's Youngest Set — the fabulous Torture Chamber, run by well-known TV personality and woman Miss Hilaire Corset.

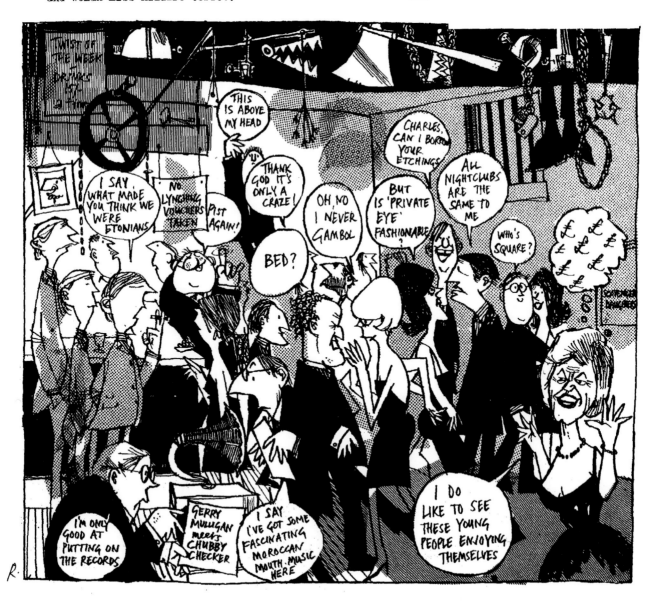

AESOP REVISITED

The quasi-strip *Aesop Revisited*, drawn by Rushton and written by Christopher Booker, Richard Ingrams and Rushton himself, appeared in early copies of the magazine and served as a means of attacking public figures such as Stirling Moss, Tony Hancock – and the Greatest Dying Englishman – Sir Winston Churchill. This provoked the magazine's first libel writ, served by Churchill's son Randolph, who was writing his father's biography. The strip pointed out some of Churchill's less creditable achievements – such as Gallipoli. In the first of the series, *The Satirist* (*shown here*), the satirists attacked themselves; Jonathan Crake is an amalgam of Peter Cook and Jonathan Miller – who were at the time finding fame with *Beyond the Fringe*.

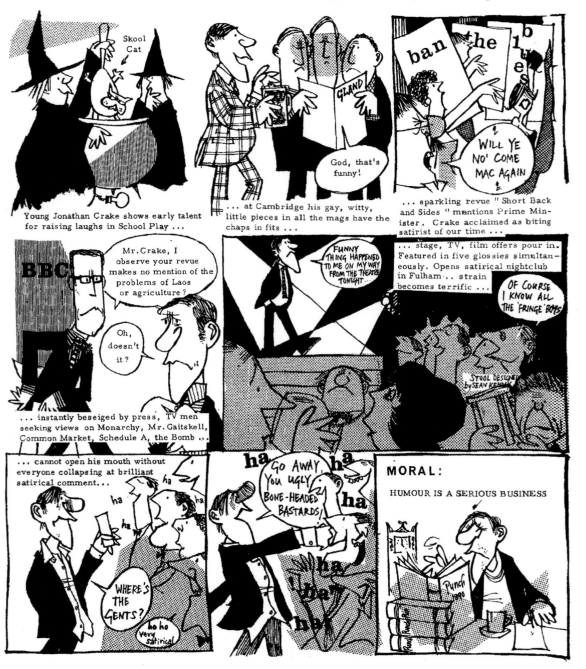

"WELL YOU WILL JUST HAVE TO STOP GROWING WON'T YOU."

HEATH on FallouT SHelters

"YES, IT MUST BE VERY FROUSTRATING FOR YOU."

"IT MUST BE NICE TO HAVE A HOBBY."

"THERE'S SOMETHING AT THE DOOR DEAR."

RUSHTON

A contemporary of Richard Ingrams, Paul Foot and Christopher Booker at Shrewsbury, Willie Rushton cut his teeth drawing illustrations for the school magazine the *Salopian*. Rejected by Oxford, he still contributed to the student magazine *Mesopotamia*. After Oxford 'we all agreed that no one went into the Stock Exchange: we gave ourselves a year to get the magazine [*Private Eye*] off the ground'. Rushton's drawings veered towards whimsy and surreal flights of fancy rather than classic jokes. After helping to discover Scarfe and Steadman he said, 'That's it, they can do all the fucking drawing. They've had the best of me.' Nonetheless, and despite a successful TV, film and radio career, Rushton continued to contribute illustrations and gags to the magazine until his death in 1996. 'It's very difficult to get a cartoon right,' Rushton once said. 'It's very difficult to think of what the hell to draw.' Although it never showed.

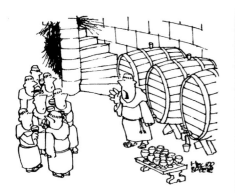

"Last Holy Orders, please"

I suppose there's going to be a lot of fuss about this Henry Miller book . . .

. . . personally, I find it very boring . . .

. . . and I should know . . .

. . . after all, I've read it 27 times !

CHATTO, drawn by Rushton and written by the *Eye* team, provided a topical take on the news by the sort of man you'd meet on a train from Tunbridge Wells who worked in the ministry. Henry Miller's *Tropic of Cancer* had been banned in the US for obscenity – and Scotland Yard had contemplated banning it in the 1960s (they didn't).

"I am your Labour candidate, Sid Polls"

JUST ONE FOR MY BABY AND ONE MORE FOR THE TOAD

STEADMAN
Ralph Steadman was 26 when *Private Eye* launched. He'd worked as a trainee manager for Woolworths and an apprentice aircraft engineer before studying art part-time at East Ham technical college and becoming a cartoonist. Infuriated with *Punch*, he turned to the *Eye*. Often confused with Gerald Scarfe, he turned away from political cartoons towards illustration – and became strongly associated with the American writer Hunter S. Thompson – with whom he produced *Fear and Loathing in Las Vegas*.

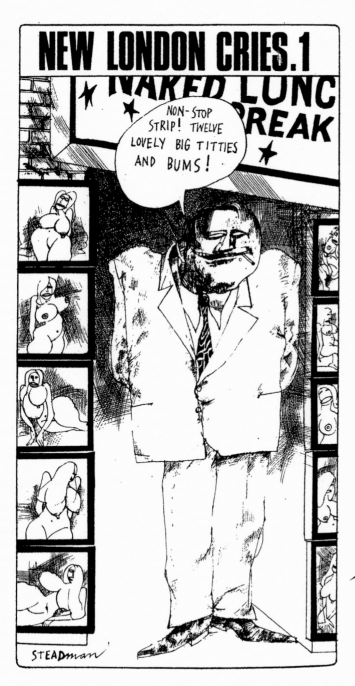

"SHOOT!"

McLACHLAN

"Waiter! There's soup in my fly!"

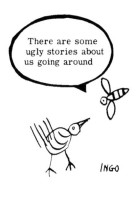

There are some ugly stories about us going around

INGO

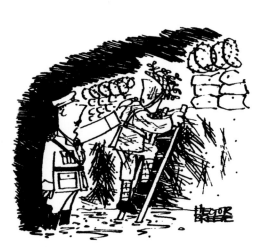

"Good luck, Hopkins, and – who knows? –
there might even be a posthumous
VC in it for you"

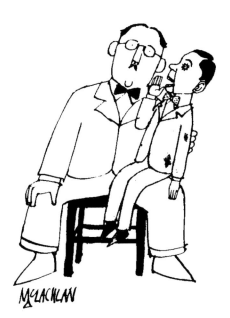

McLACHLAN

"B. O."

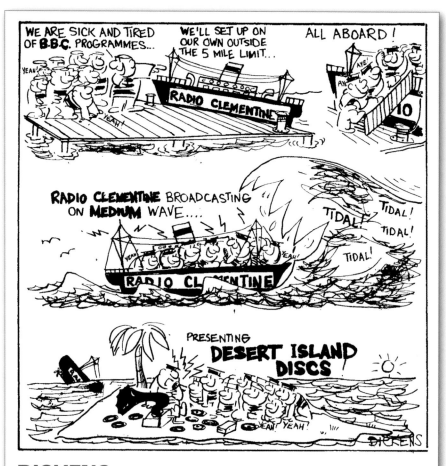

"WE HAD SEX TODAY"

DICKENS

Frank Dickens, the creator of *Bristow*, contributed a series of ironic set-pieces, including swipes at the brain drain and party political broadcasts. This celebrates the birth of Pirate Radio.

NASTY NIP IN THE AIR, LOBETHRUST

STUFF THIS FOR A LARK

INGO

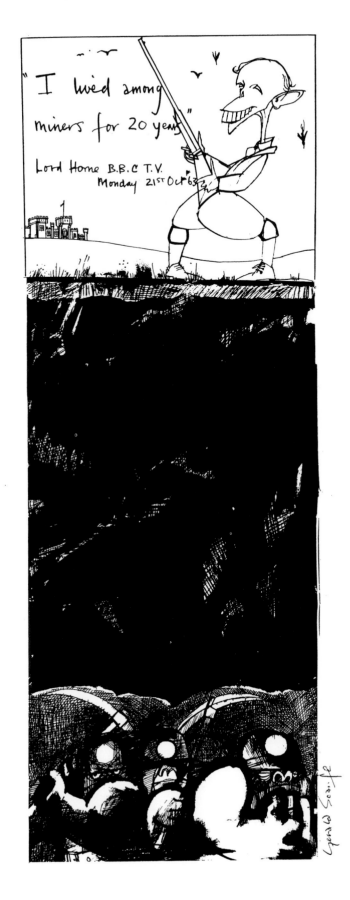

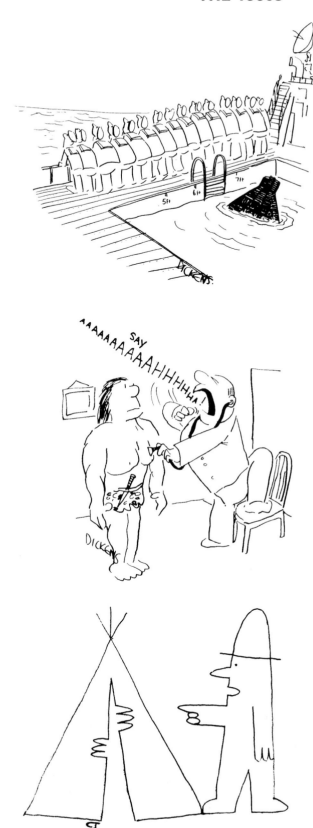

"I arrest you for loitering within tent"

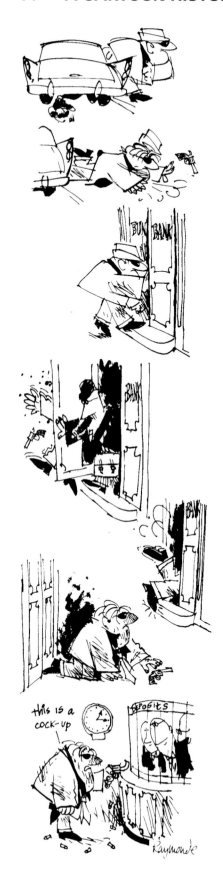

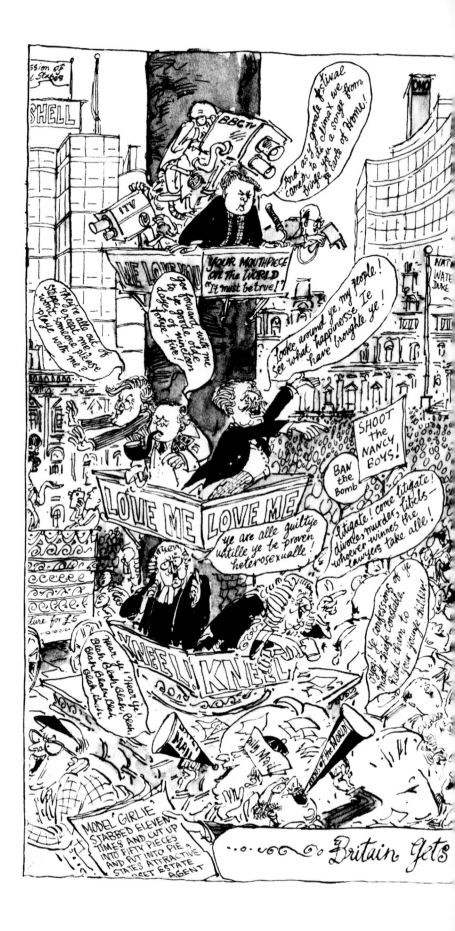

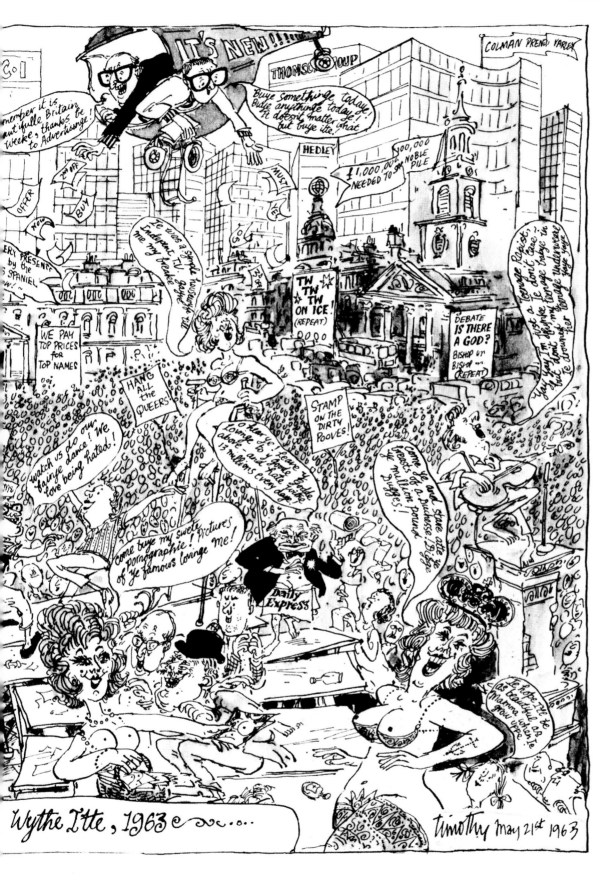

"Wafer or cornet?"

GERALD SCARFE

Gerald Scarfe studied at Central St Martin's before becoming a freelance cartoonist. His early drawings for *Punch* – including a desert island cartoon – were unrecognisable compared with the scabrous venom of his *Private Eye* work. Encouraged to draw caricatures by Rushton, and collaborating with the *Eye* team, he soon acquired the reputation for being extreme, shocking and grotesque. Scarfe remembers 'It was the drawing of Macmillan posing as Christine Keeler on that famous chair that changed everything for me. Suddenly I was written about, asked to go on TV etc. It was quite extraordinary. I owe a lot to the *Eye*.' Indeed, it led directly to his drawing for the *Daily Mail*, *Time*, the *Sunday Times* – and of course his association with rock band Pink Floyd. He later tried to burn all his early drawings – though luckily some survived. His cover for the *Eye*'s 1963 annual caused it to be banned by W.H. Smith, amongst others. At an *Eye* party he met his future wife, *Eye* shareholder Jane Asher.

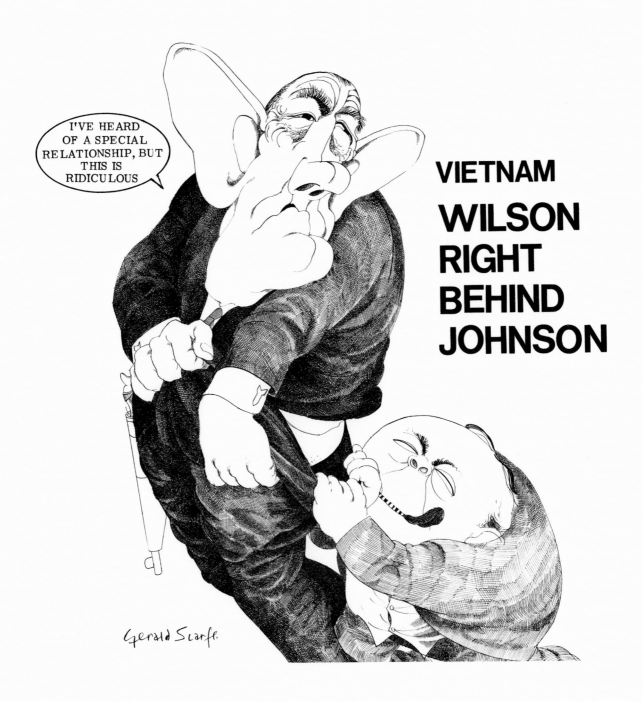

I'M FEELING A LITTLE STIFF TODAY

"OK. Relax Jack. This is just a run-through"

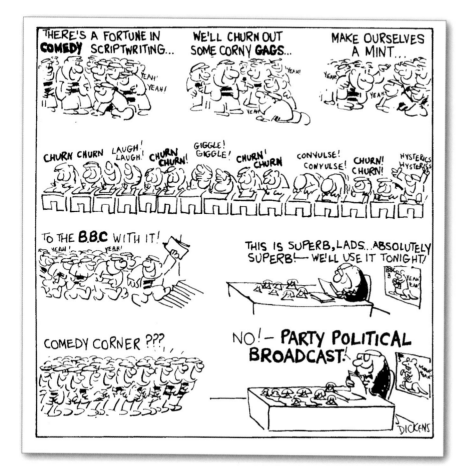

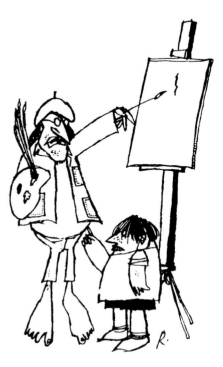

"Are you Pop or Dada?"

CHATTO

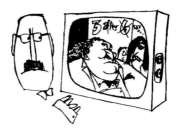

I MUST CONFESS I'M NONE TOO HAPPY..

ABOUT ALL THIS CONVERSATION...

- FUDDY DUDDY I MAY BE BUT THERE DOES SEEM TO BE A SERIOUS DANGER...

...THAT IT COULD RUIN THE WHOLE ART OF TELEVISION .

"That's the last time the Vicar gets in here, he's just exorcised the Ghost Train!"

"Now . . . What would Nanny have done?"

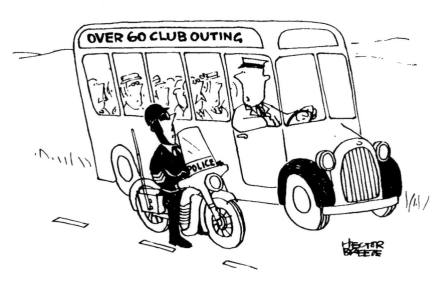

"Of course I was doing over sixty!"

HOGARTH '65

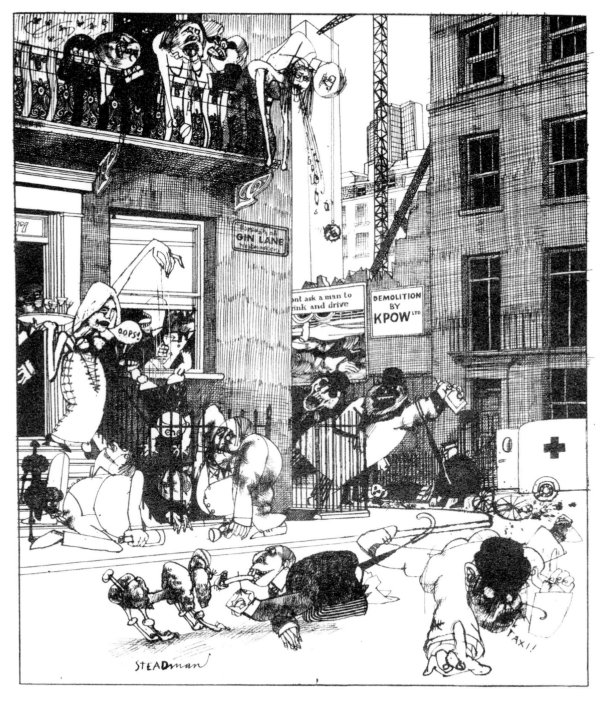

GIN LANE S.W.3.

SPECIALLY ENGRAVED BY RALPH STEADMAN

PRINTED AND PUBLISHED BY LORD GNOME

TROG

Polymath Wally Fawkes – Trog – turned to the *Eye* when his thalidomide cartoon (*right*), published at a time when abortion was still largely illegal, was rejected by the *Spectator*. His work appeared in the *Eye* for the next two crucial and formative years. A brilliant jazz clarinettist, playing alongside Humphrey Lyttelton, Trog worked for most Fleet Street papers and magazines, until poor eyesight cruelly cut short his cartooning career in 2005.

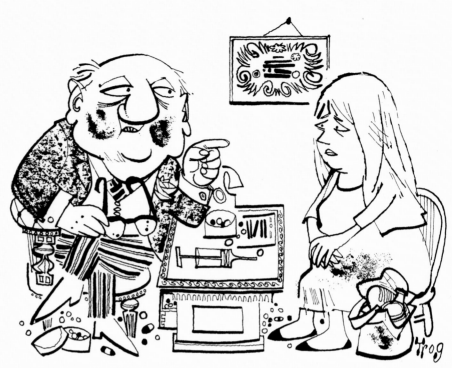

"I'm sorry, but the ethical position is quite clear. Thalidomide was a legal prescription, but what you suggest is an illegal operation"

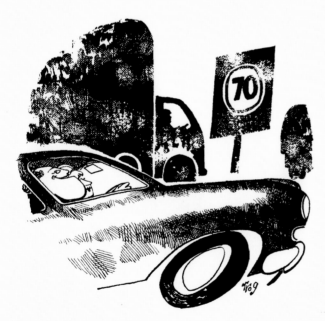

"Splendid! A nice bit of fog! Now they won't see us doing more than 70"

"Waiter! There's a mammary gland in my soup!"

HEATH

Probably the most prolific and the grumpiest cartoonist ever, Michael Heath was the son of a children's comics illustrator. Born in 1935 he attended Brighton Art College and has contributed to *Private Eye* since 1962. His detailed eye and observation of fashion marks him out as a true original – as well as a spontaneous drawing style which often defies perspective and convention. His *Great Bores of Today* drawings were a feature of the magazine from the 1960s, and his strip cartoons include *The Regulars*, *The Gays*, *Numero Uno* and *Heath's Private View*. His world view is summed up by his catchphrase 'Nightmare!', and his extraordinary output for so many publications may be attributed to his saying 'Many piddles make a puddle'.

"I see poor old Hoddinot's fading away"

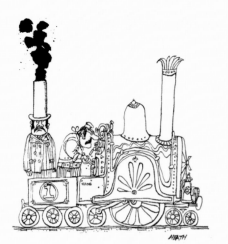

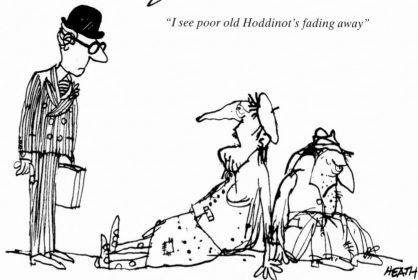

"You've been a great disappointment to your father"

"Stuff it! I've got egg on my tie"

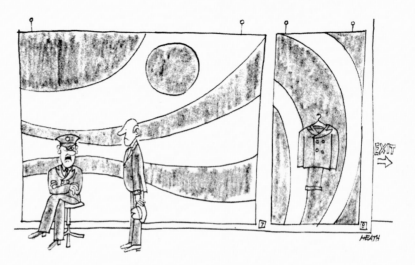

"No, I don't know where the loo is. I'm part of the goddamn painting"

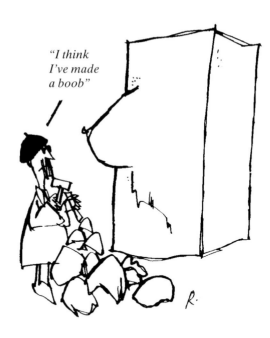

"I think I've made a boob"

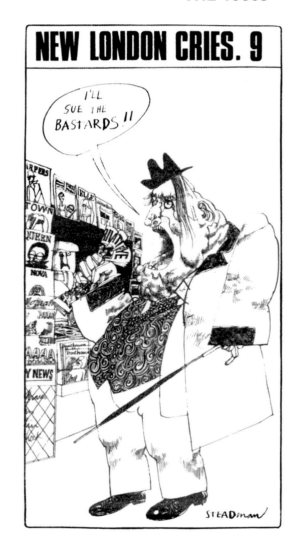

NEW LONDON CRIES. 9

I'LL SUE THE BASTARDS!!

STEADman

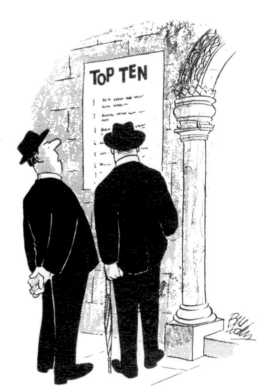

"I see 'Thou shall not commit adultery' has dropped to eighth ..."

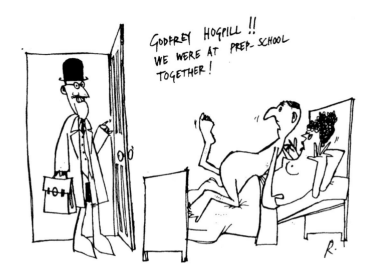

GODFREY HOGPILL!! WE WERE AT PREP-SCHOOL TOGETHER!

BILL TIDY

After military service, Tidy worked in an advertising agency before becoming a freelance cartoonist, writer and broadcaster. His 1960s gags for the *Eye* were a mainstay of the magazine, but his crowning glory was his cartoon strip – *The Cloggies*. For all its quaint, northern humour, *The Cloggies* was an early precursor of Tony Husband's *Yobs* – and was essentially about drinking and violence, as the clog-dancing team toured such northern pubs as The Bull & Veterinary Surgeon, The Rat & Goldfish, The Horse & Shovel, The Truss & Slagheap, The Fox & Pervert, The Grunting Duck and Gridley's Soap Works. In 1966, *The Cloggies* eclipsed the England World Cup winners by bringing home the United Kingdom Drunk and Disorderly Shield.

"I'm all for cleaning up television, Miss Whitby, but let's keep life filthy!"

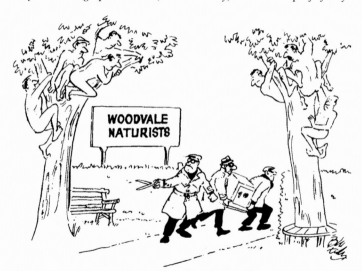

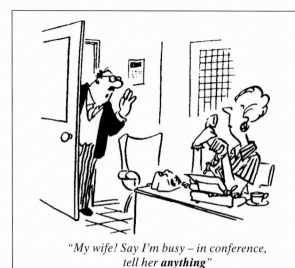

*"My wife! Say I'm busy – in conference, tell her **anything**"*

"He's on the couch with Miss Burnham"

THE RAKE'S PROGRESS: PUNCH

A one-off strip that lampooned the *Eye*'s rival – *Punch* magazine. *Punch* was widely seen as the voice of The Establishment. This parody of William Hogarth's celebrated 1733 paintings was significant for being drawn by *Punch* stalwart, the legendary Ronald Searle. So effective was the attack that *Punch* closed (38 years later).

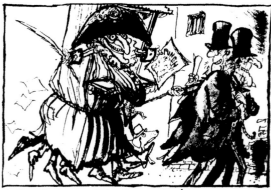

1. Born in penury, 1841. Meagre circulation and impertinent views. Inclined to Republicanism. Queen Victoria Not Amused. Financial stringency leads to takeover by printers, Bradbury & Evans.

2. Respectability achieved. Captions lengthened. Servants and Foreigners good for a laugh. Queen Victoria amused. Thackeray, too drunk to find editorial seat, carves initials on Table.

3. Tenniel Knighted. Partridge Knighted. Queen Victoria Knighted. A.P. Herbert blessed and Knighted. Dog Toby Knighted. Everything great fun. Circulation drops.

4. Muggeridge appointed Editor. Queen Victoria disgusted. Advertisers disgusted. Editorial office disgusted. Regular Readers disgusted. Paper improves. Advertising drops. Muggeridge dropped.

5. Dazed by 'sixties'. Price increased. Economy cuts in Humour. Hollowood gets 'with it' – starts Women's Page. Homosexuality mentioned twice. PRIVATE EYE lampooned.

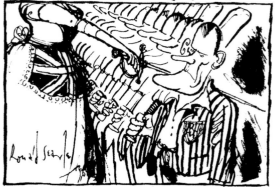

6. Hollowood Knighted, Bernard Hollowood Knighted, A.B. Hollowood Knighted, B. Hollowood Knighted, A. Hollowood Knighted, Boothroyd Knighted, Thelwell Knighted, Bradbury & Agnew Knighted, Publicity Manager Knighted, Doorman Knighted. Kate Greenaway Award. 1965.

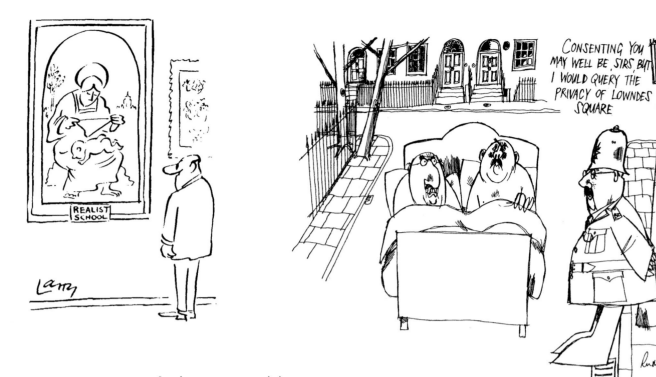

"The library wants their 'Unnatural Sex Practices' book back"

"Well, aren't you going to ask me what sort of a day I had at the kerb?"

FANTONI

Barry Fantoni, like Trog, was a multi-talented Camberwell Art School alumni. A jazz musician, novelist, pop-artist and broadcaster, Fantoni began drawing for the *Eye* in 1963 and was almost immediately co-opted onto the editorial staff where he remained until his retirement in 2011. Co-writer of *Sylvie Krin* and *E.J. Thribb* among countless other features, his ability to find a character's voice made him an essential member of the writing team. His chameleon-like talent was equally

on display with his drawing and painting – able to produce parody works as well as his own distinctive Pop-Art style of portraits. This was in sharp contrast to his cartoons. TV personality of the year in 1966, he was the *Times*'s diary cartoonist from 1983-91.

"I've got this fantastic idea for an idea, man"

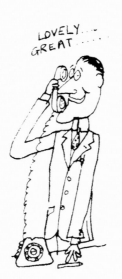

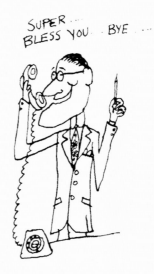

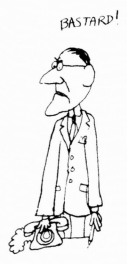

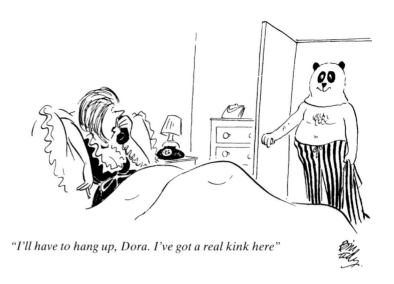

"I'll have to hang up, Dora. I've got a real kink here"

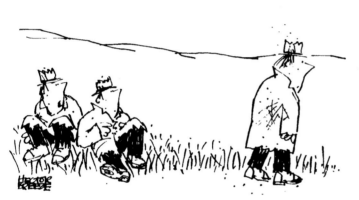

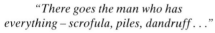

"There goes the man who has everything – scrofula, piles, dandruff . . ."

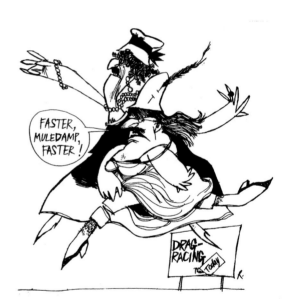

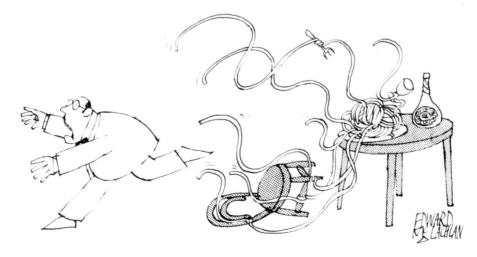

BARRY McKENZIE

Written by Australian comedian Barry Humphries and drawn by Nicholas Garland (later political cartoonist of the *Daily Telegraph*), Barry McKenzie (originally called 'Barrie McKensie') was an Australian *Candide*. It proved a hugely popular take on the arrival of Aussies in the UK – notoriously settling in London's Earl's Court. It was the magazine's first cult hit, most notable for its vocabulary which introduced such phrases as 'chunder' (*see below*), 'liquid laugh' and 'technicolour yawn' (vomiting), and 'pointing Percy at the porcelain' (urinating) into the vocabulary. The strip was eventually spiked by Richard Ingrams for obscenity – or Humphries' increasing inability to deliver the script.

Words by
Barry Humphries

BARRY McKENZIE

Drawings by
Nicholas Garland

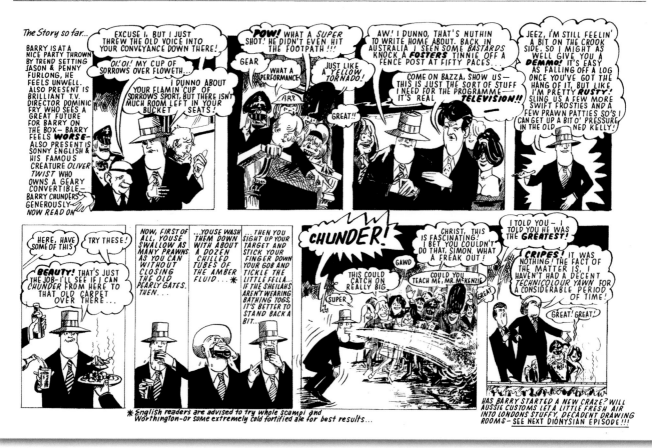

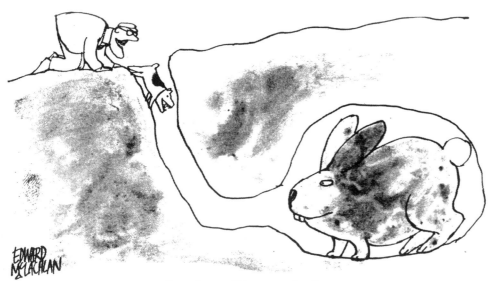

"Go on boy, rabbits, go get 'em"

"If there's anything I hate,
it's organised fun"

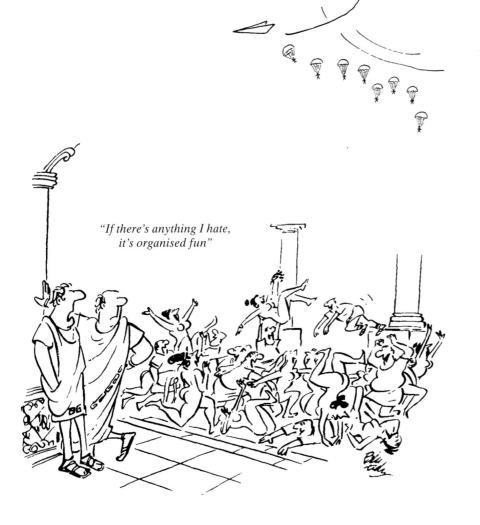

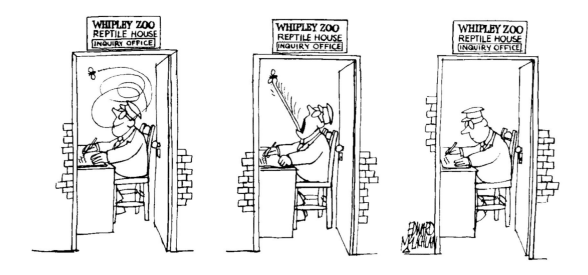

"Do I hear any advance on £10,000 for this beautiful vase, and a place in the lifeboat?"

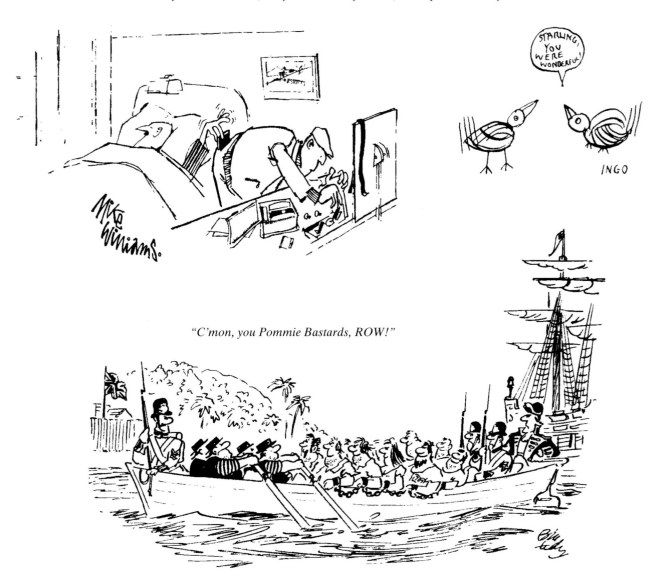

"C'mon, you Pommie Bastards, ROW!"

LARRY

– or Terence Parkes – studied at the College of Arts and Crafts in Birmingham before teaching art in Lincolnshire and turning freelance. He was nicknamed 'Larry' by his pupils, after Larry Parks, star of the Al Jolson story. The purity and simplicity of Larry's often captionless cartoons belied his artistic talent – and outside the *Eye* his admiration for Daumier led him to experiment with sculptured clay cartoons. His work has been lauded by Peanuts creator Charles Schulz and Harpo Marx.

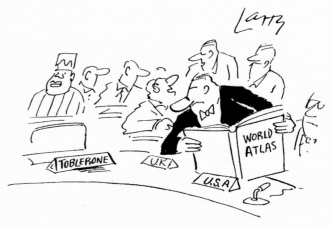

THE CLOGGIES by BILL TIDY
An everyday saga in the life of Clog Dancing Folk

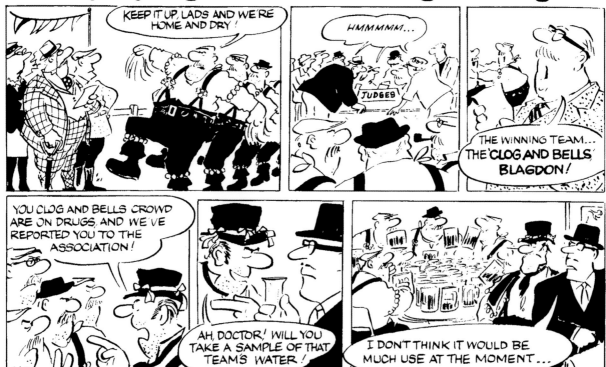

THE CLOGGIES

Created by Bill Tidy, *The Cloggies* ran in the *Eye* from 1967 until 1981. Satirising northern British male culture, it appeared to be a celebration of Lancashire Clog Dancing – but actually laughed at male violence and drinking. The character 'the Blagdon Amateur rapist' probably wouldn't be tolerated today. The first *Cloggies* actually appeared as a gag (*right*). After *Private Eye*, their dancing career ended in the *Listener* magazine.

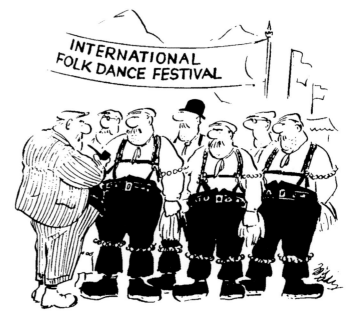

"If the Lithuanians look like getting on top, Neville, put the boot in"

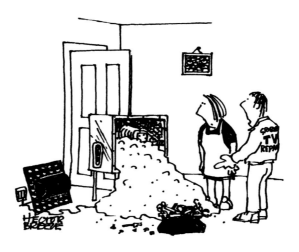

"There's your trouble, lady – it's full of instant mashed potato"

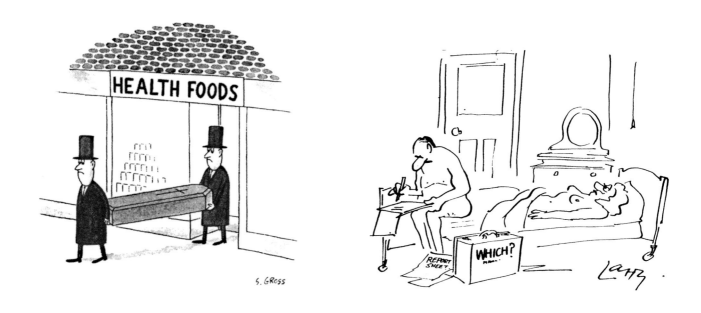

"IN VIEW OF THE SPECIAL CIRCUMSTANCES SURROUNDING THIS CASE I HAVE DECIDED TO BE LENIENT WITH YOU"

Gerald Scarfe's Box of Throwups

Gerald Scarfe is fascinated by the brittle, gay, tinsel world of fashion and trends.
His heroes are ephemeral - but heroic, invulnerable and grotesque. FRANCIS WYNDHAM

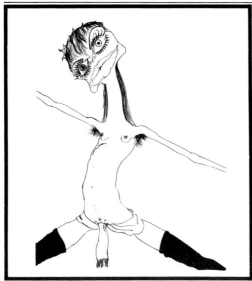

Jean Shrimpton

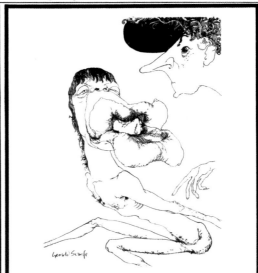

Mick Jagger & Cecil Beaton

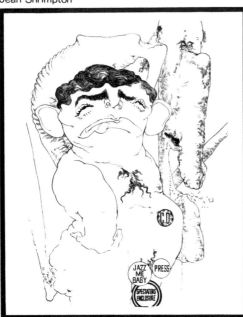

Nigel Lawson & Patrick Campbell

Lord Snowdon

Gerald Scarfe's Box of Throwups parodied photographer David Bailey's *Box of Pin-Ups*, published in 1965 and featuring iconic celebrities of the 1960s. Here Scarfe caricatures (*clockwise*) supermodel Jean Shrimpton, Rolling Stone Mick Jagger and Cecil Beaton (who had himself photographed Jagger), Lord Snowdon – photographer husband of Princess Margaret and *Spectator* editor Nigel Lawson (later Chancellor of the Exchequer) with writer Patrick Campbell. Says Scarfe, 'I remember people were appalled not by the fact that Shrimpton was in a Christ-like position, but by the fact that she had hair under her arms. As for Jagger and Beaton, I remember that 114 schoolgirls wrote to me saying, "Dear Mr Scarfe, for what you've done to our Mick we are going to get you and cut your balls off. Yours sincerely, Janet Davis, Monica Thompson . . . etc." Sweet things.'

"Aye, strange things can happen at sea"

"I've decided to go forth and multiply – !"

GROCER HEATH AND HIS PALS

Drawn by New Zealander John Kent, *Grocer Heath* was the first of many Kent satirical strips about politicians and their adversaries. 'Grocer' Heath (so nick-named after negotiating for the UK at a food prices conference) was then Tory leader – and eventually became Prime Minister in 1970. His pals here are former PM Sir Alec Douglas Hume and Anthony Barber – later the Chancellor of the Exchequer. The film-maker in question is Bryan Forbes – director of 1970's *The Railway Children*.

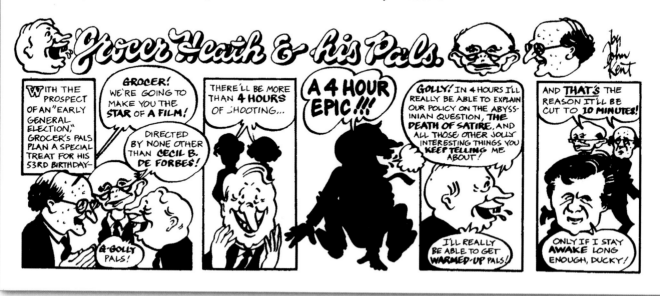

"It's from Jane. She's living in sin with someone called Tarzan!"

"Bloody lupins!
Late again"

HECTOR BREEZE

Born in 1928, Hector Breeze worked in a government drawing office while studying art in evening classes. He sold his first drawing to *Melody Maker* in 1957, and has worked for *Private Eye* since 1963, specialising in gags about royalty and the poor – often combining the two. The *Eye* produced a collection of his best work in 1973.

"Permission to go berserk, sir!"

"That's the man!"

"I'll just have one more try before I make my vow of poverty"

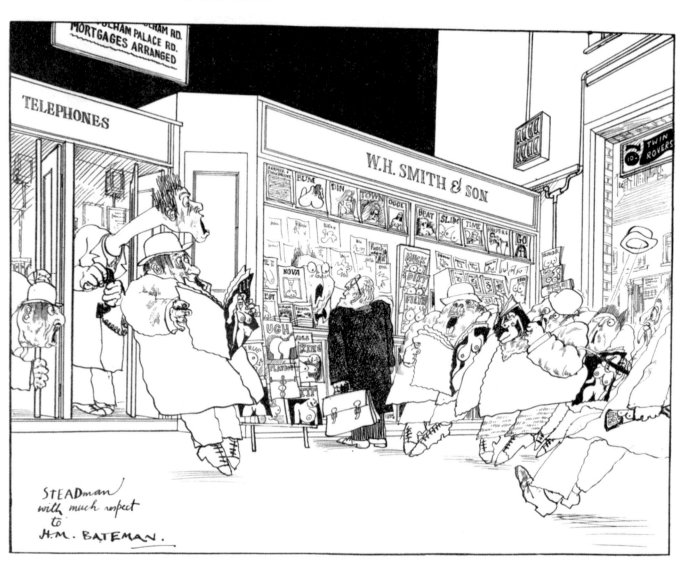

The man who asked for *Private Eye* at W.H. Smith

THE 1970s

The 1970s were marked by hippies, flares, strikes, mullets and Showaddywaddy. On the bright side, thanks to power cuts during the three day week, for much of the time you couldn't see the hippies, flares and mullets – or hear Showaddywaddy. The decade saw a succession of struggling governments clinging to – and losing – power. Wilson's Labour gave way to Heath's Tories who were beaten by Wilson's Labour until Wilson abandoned ship to leave Callaghan on the bridge, while the trade unions flexed their muscles and a sea-change in Conservative party politics saw a woman elected leader: Margaret Thatcher. To relieve the gloom, the *Eye*'s regular cartoonists toiled relentlessly – and the stars of the 60s were joined by the likes of Honeysett, Ken Pyne, ffolkes, Woodcock, Ray Lowry and Austin. The number of jokes and strips published in the magazine more than doubled. The gags were weird and sometimes worrying – much like the 1970s.

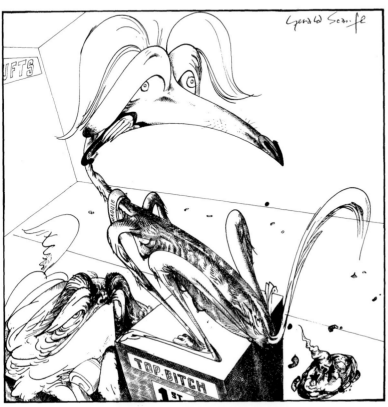

TOP BITCH

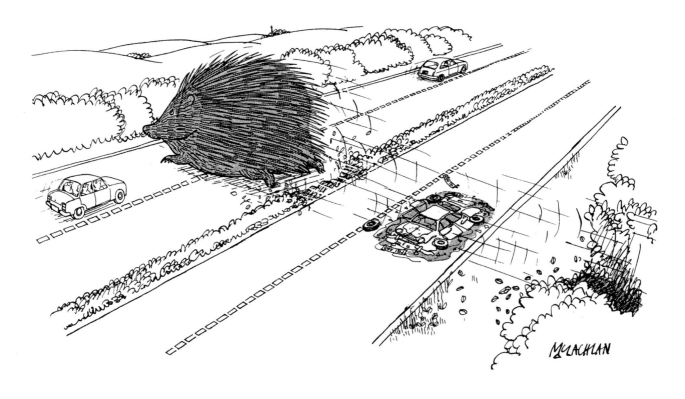

MCLACHLAN

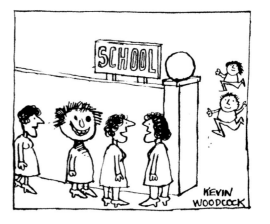

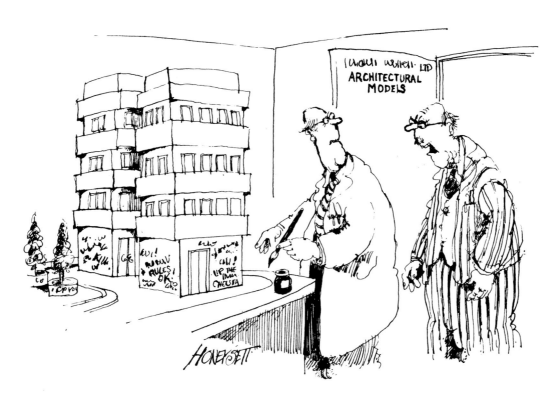

"We can do without your down-to-earth realism, Henshaw"

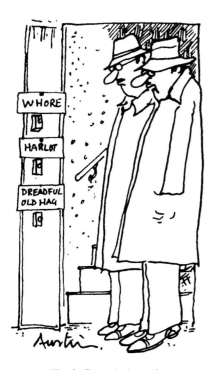

*"Trade Descriptions Act
is beginning to bite"*

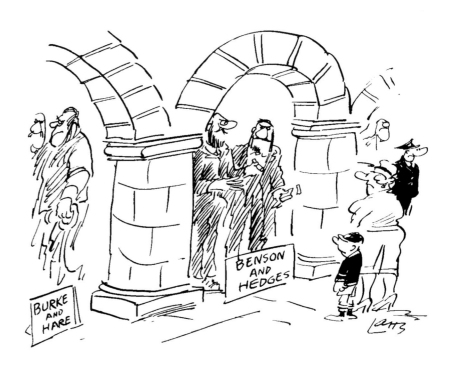

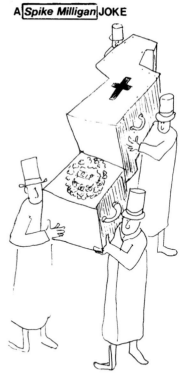

A Spike Milligan JOKE

"They say he was a contortionist"

"There's not much on the television tonight"

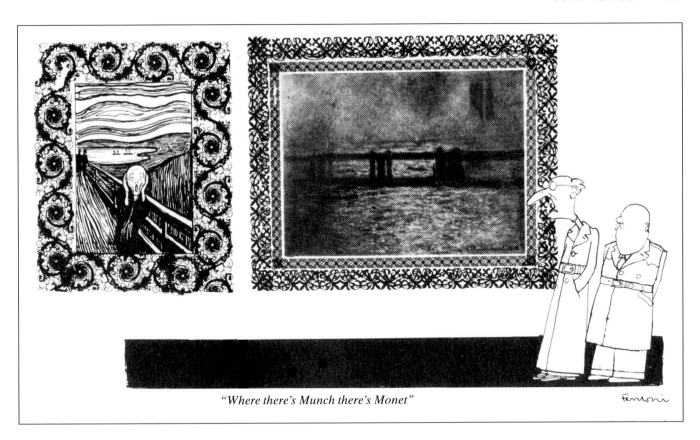

"*Where there's Munch there's Monet*"

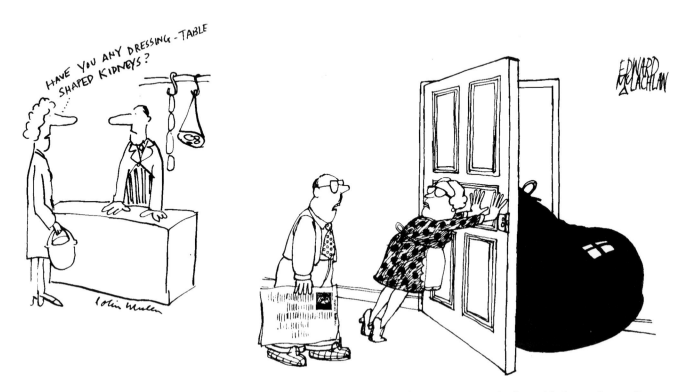

"*For heaven's sake, Alice, you've got to be firm with these salesmen*"

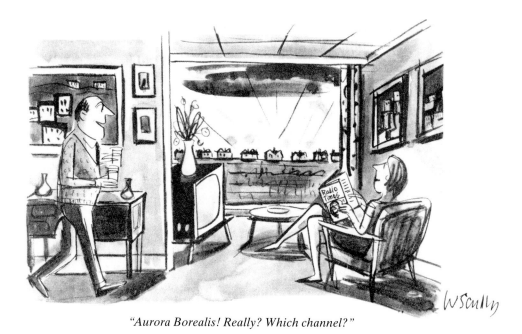

"Aurora Borealis! Really? Which channel?"

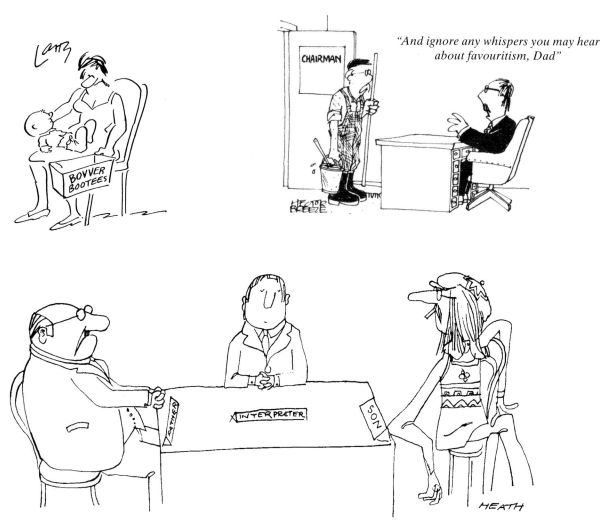

"And ignore any whispers you may hear about favouritism, Dad"

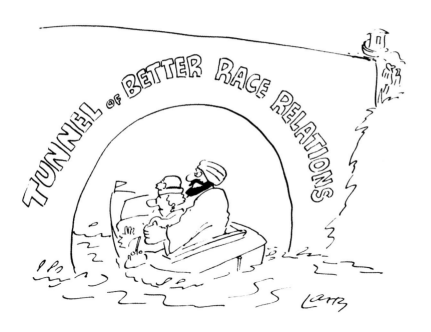

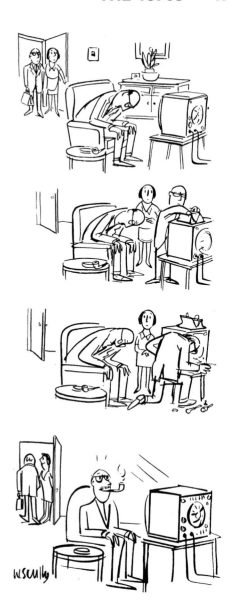

"I like your qualifications, Gribson – you have all the makings of a first-class underling"

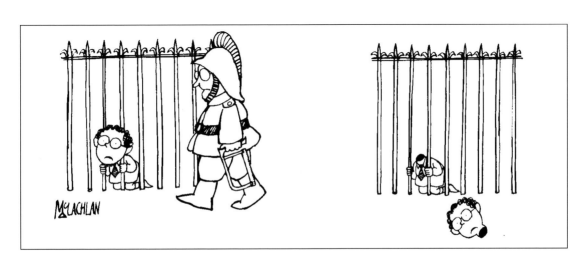

GLASHAN

Born in 1927, John Glashan was the son of portrait painter Archibald A. McGlashan. After studying at the Glasgow School of Art, Glashan moved to London to paint portraits – but it was as a cartoonist that he found fame – through the pages of the *Eye* and the *Observer*. His put-upon bearded characters inhabited a baroque world of large-bosomed women. He once wrote 'Being funny is not funny'. He died in 1999.

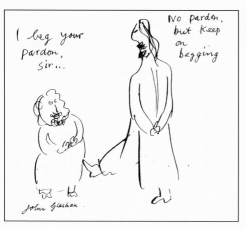

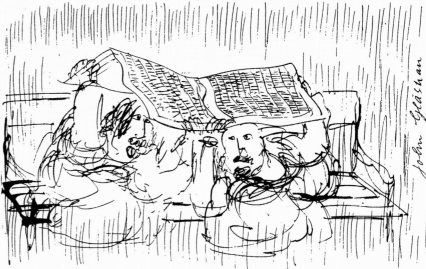

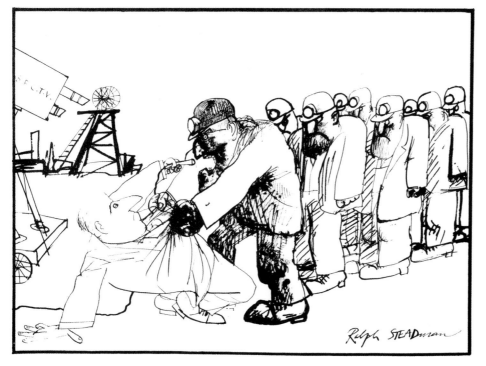

"What d'you mean – 'Has there been any intimidation?'"

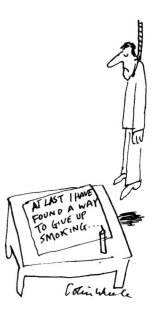

GROCER HEATH AND THE MINI BUDGET

Featuring Heath (now Prime Minister) and his Chancellor of the Exchequer Anthony Barber, the strip points out the benefits of Heath's notoriously single status.

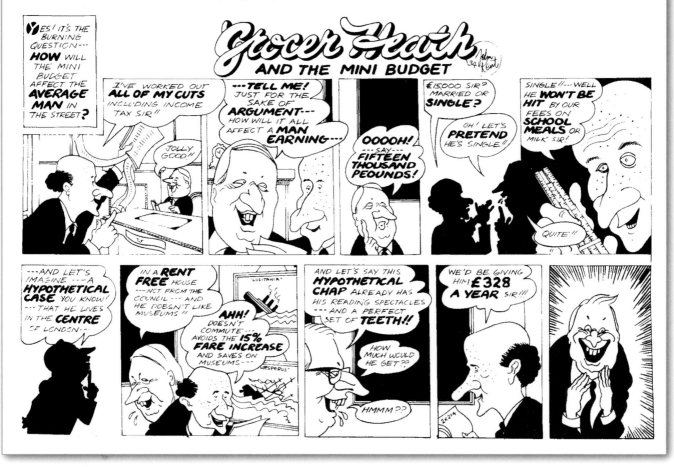

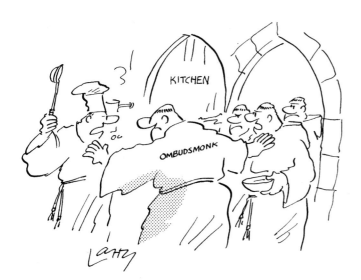

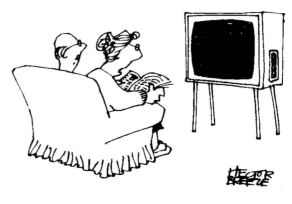

"It's a repeat of a temporary fault first shown on BBC2"

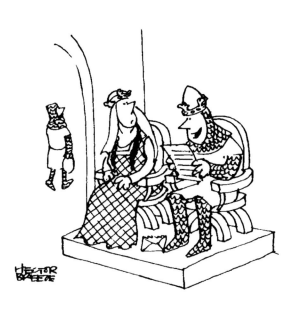

"Great news! My Domesday Book's coming out in paperback"

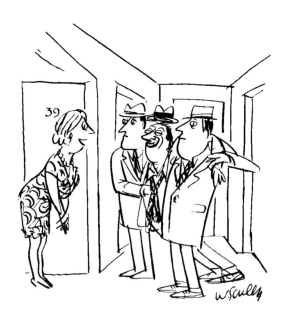

"Why, darling! You remembered it was our wedding anniversary"

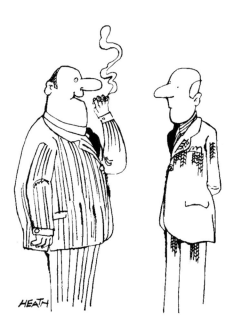

"No, I'm alright. I've just found out I'm dying of something else"

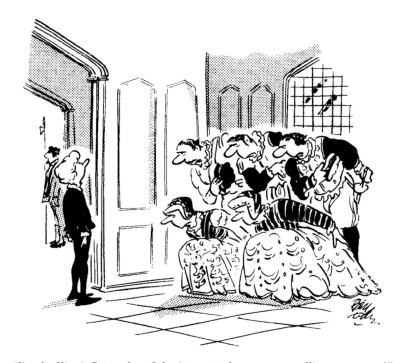

"I'm the King's Bastard, so I don't want to hear anyone calling me names!"

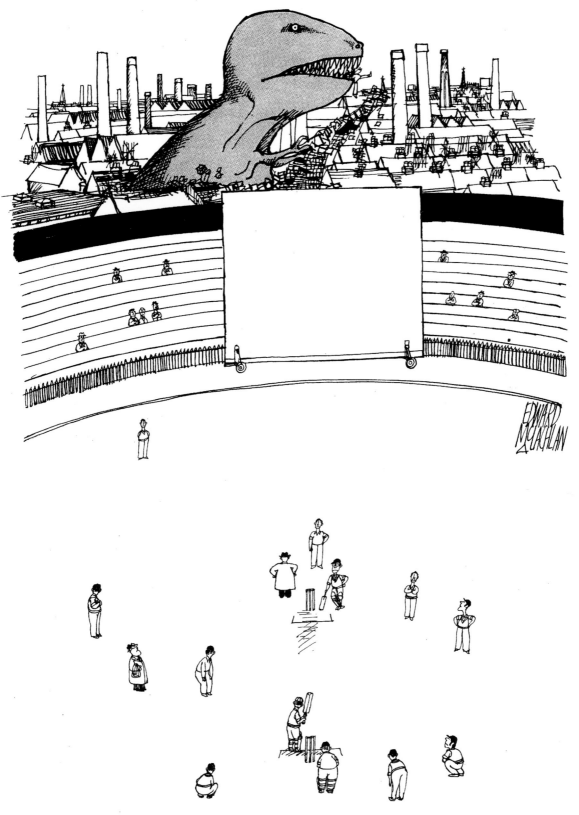

"... and once again we have interruption of play caused by
movement behind the bowler's arm..."

"Look here, Hugget, the Committee would like to know why you're not wearing a club moustache"

A Spike Milligan JOKE

"I've been looking for that everywhere"

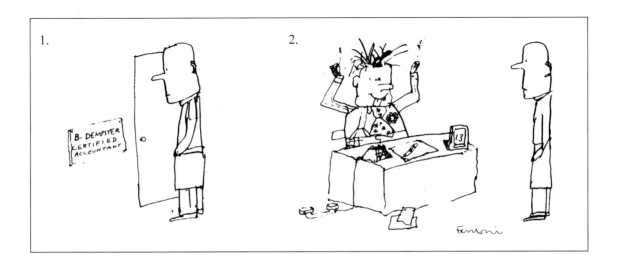

1.

2.

B. DEMPSTER
CERTIFIED
ACCOUNTANT

McLACHLAN

Ed McLachlan studied at Leicester College of Art and has been a *Private Eye* regular since 1967 when he was submitting gags while lecturing in graphics at Leicester Polytechnic. Born in 1940, his black, twisted sense of humour has made him a master of the stand-alone gag – winning him many awards. He cites his influences as Giles, André François and Leo Baxendale – as well as early Scarfe and Steadman – but his style is entirely his own. McLachlan submits batches of huge, meticulously detailed biro roughs which he turns into finished artwork drawn on giant card. A single-column gag may be the size of an A3 sheet of paper. His enormous, surreal drawings – often of enormous animals – became a characteristic feature of the magazine in the 1970s and beyond. His favourite cartoon published in the *Eye* is his Giant Hedgehog (*see page 42*). 'I must have redrawn this cartoon at least 20 times,' says McLachlan.

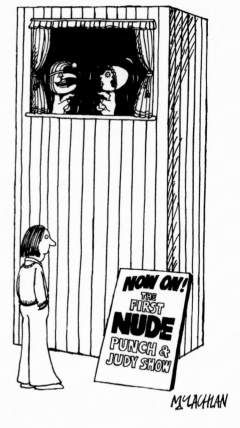

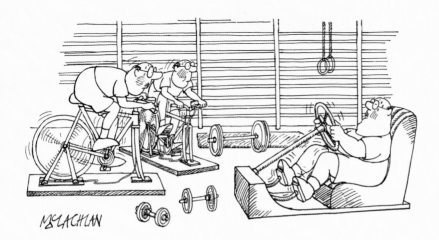

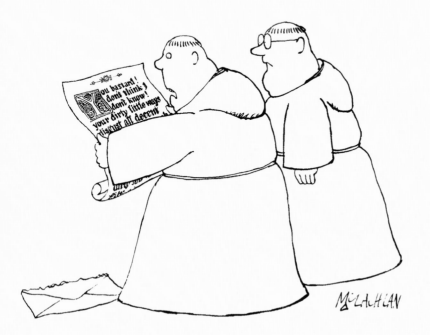

"Another poison pen letter"

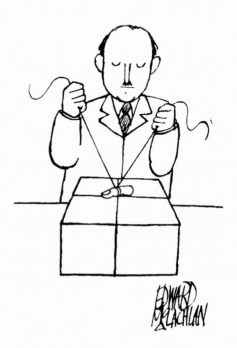

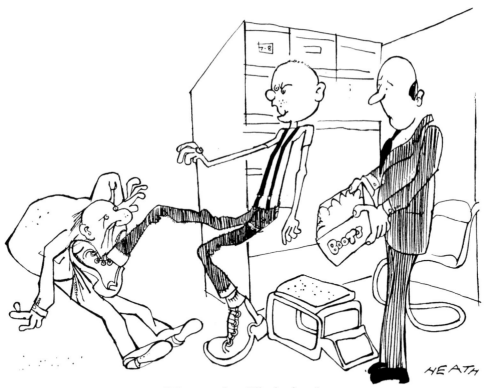

"These are fine, I'll take these"

"You are the father of my child"

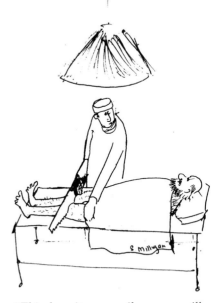

"This doesn't necessarily mean you'll paint like Toulouse Lautrec"

A Spike Milligan JOKE

"You twit! That's Everest over there!"

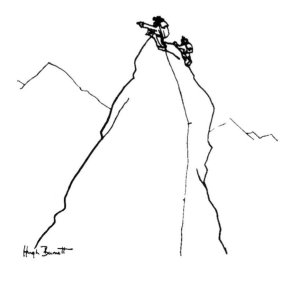

"I'm either drinking too much or the dawn comes up like thunder"

"Your humans are undone"

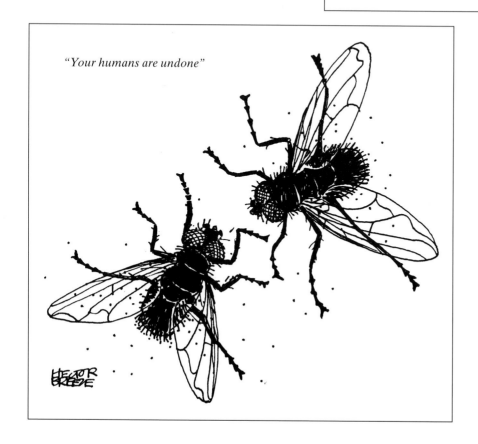

STRANGLED BY HIS
SEAT BELT AND
ASPHYXIATED BY THE
SAFETY AIR BAG

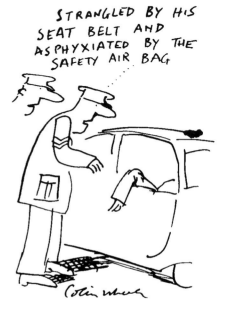

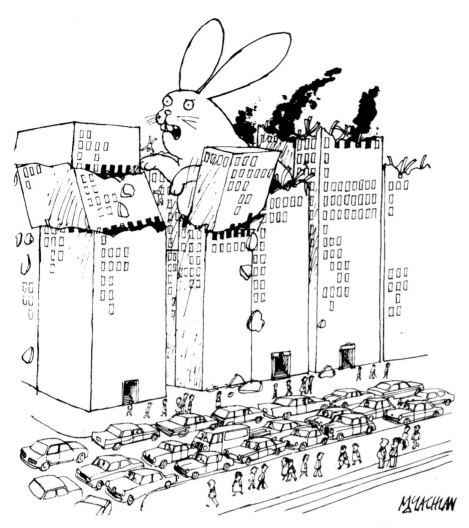

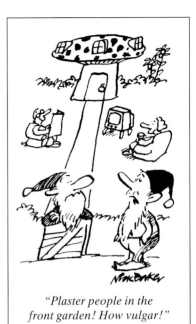

"Plaster people in the front garden! How vulgar!"

"I suppose if it was a gorilla, people would take it seriously"

"Just look at that pylon ruining the view!"

HOM. SAP.

The very first episode of David Austin's classical creation, which was to last for 35 years. Editor Richard Ingrams liked characters with beards. Set in Ancient Rome, it proved an endlessly inventive source of satire about the modern world – from philosophy and politics to medicine and manners. Austin worked right up to his death from cancer in 2005 – phoning in a joke from hospital.

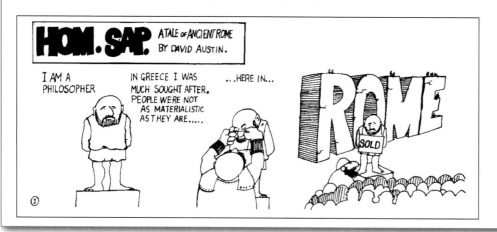

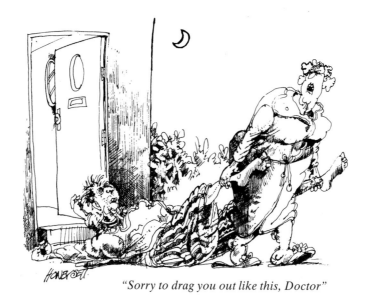

"Sorry to drag you out like this, Doctor"

Reach for the sky.

S. Milligan

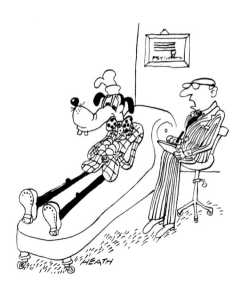

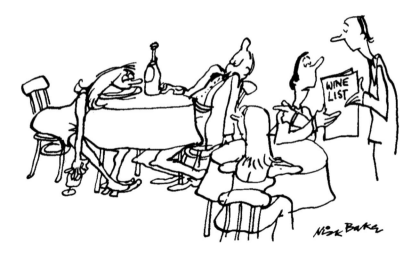

"We'll have two bottles of whatever it was they had"

"Listen, I can't do any more for you.
You're goofy"

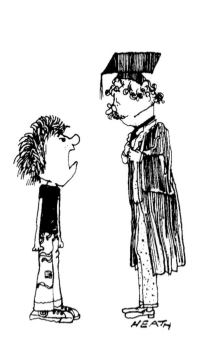

"Screw off, Mr Chips!"

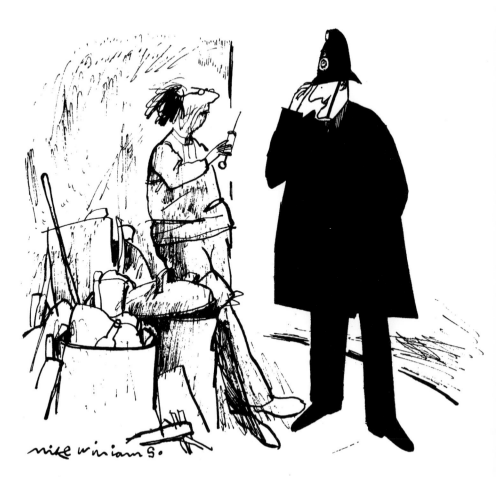

"Not while I'm on duty, sir"

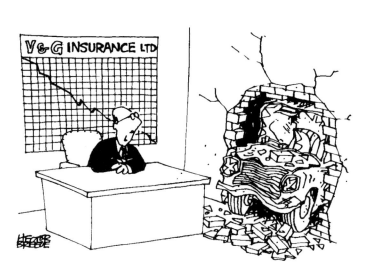

"You're not insured with us, I hope?"

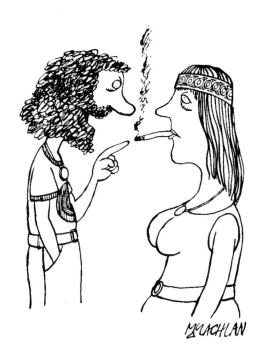

"Hey, what's a nice joint doing in
a girl like this?"

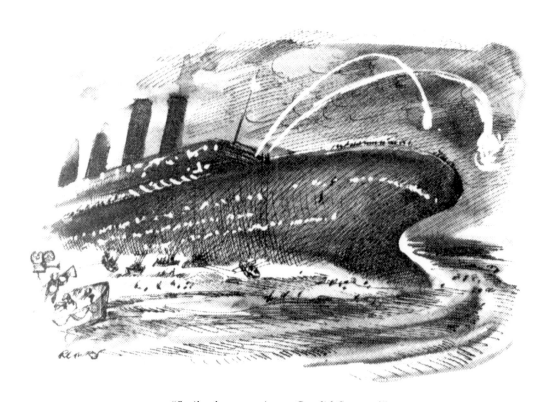

"Smile please, you're on Candid Camera!"

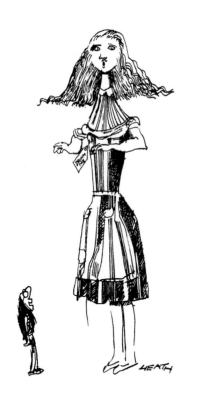

"*Doll, you really get high on that stuff*"

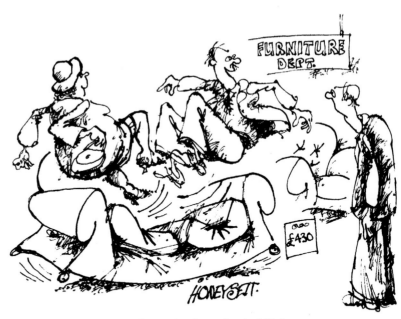

"*Just trying it out for the kids*"

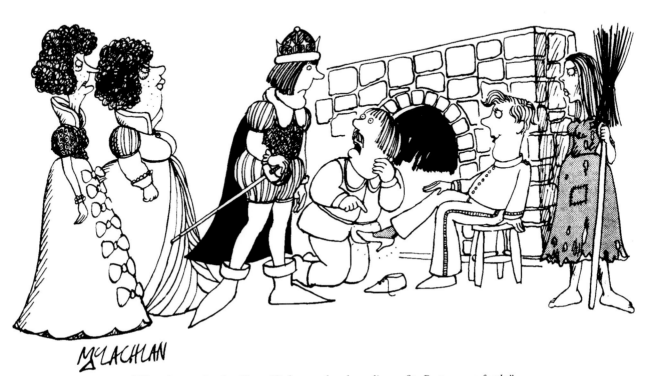

"*There's no mistake, Your Highness, the glass slipper fits Buttons perfectly*"

KEVIN WOODCOCK

One of the most brilliantly original cartoonists to grace the pages of the *Eye*, little is known of the intensely reclusive Leicester cartoonist. A disappearing back view is fleetingly glimpsed in a 1980s BBC2 *Arena* documentary about the *Eye*'s cartoonists. He never visited the *Eye*'s offices or met the then editor, Richard Ingrams. Yet his work featured heavily in the *Eye* of the 70s – during which time he drew some of the funniest jokes of all time. Spare and spikey, his surreal drawing style was honed at Leicester College of Art. Like Larry, his cartoons were of the purest form – captionless – with one exception: the first *Eye* cartoon he had published (*see top right*).

Tragically, he took his own life in 2007, at the age of 65. He left his carefully prepared effects, including sketchbooks, to the Cartoon Museum. They now reside at Kent University's Cartoon Archive.

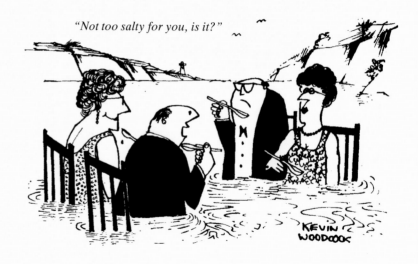

"Not too salty for you, is it?"

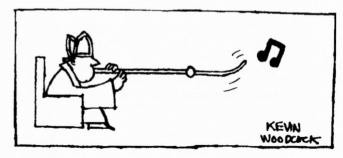

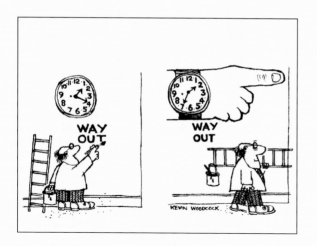

"... and a little man from the village delivers our vegetables"

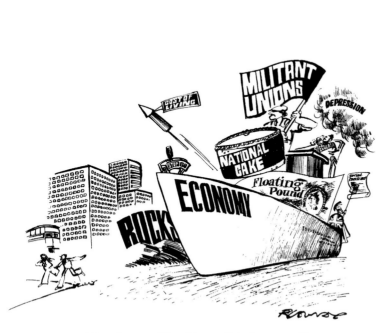

"Run for your life – it's a political cartoon!"

"Well, what did we expect Tarzan to look like after all these years?"

"... and, of course, a company car"

GREAT BORES OF TODAY

The *Eye* had always been fond of attacking bores – and in 1974 they became a feature of the magazine which was to last three decades.

Drawn by Michael Heath and written initially by Heath, Ingrams and Fantoni, joined subsequently by Hislop and Newman – and finally by Harry Enfield.

"*Haven't you got anything dangerous?*"

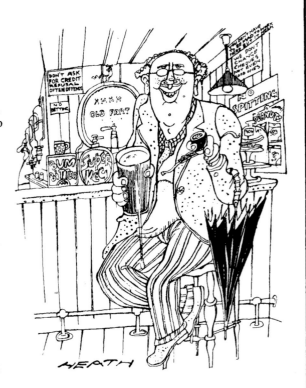

GREAT BORES OF TODAY *3.*

"I read about this little place in the *Guardian*. It's the only pub in the Mendips where you can still get a pint of real 4-X Old Fart bitter straight from the wood. What is more the barrel is mounted on special brass latchets which is the only way to make sure that the yeast remains alive. If you've got time it's worth going to have a look at Fart's Brewery in Frome. It's still run by the Fart family as it has been since the days of Charles I. 4-X is pretty strong, not like the fizzy muck you get in most pubs. It's got a curious taste – a bit difficult to describe – but if you've ever drunk Bladder's Extra Mild or Tomlinson's Old Jubilee Stout – you'll have a vague idea of what's in store. It's real beer all right and it doesn't taste at all bad if you put a dash of lime in it. . . ."

"*I can't help you – they're an endangered species*"

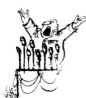

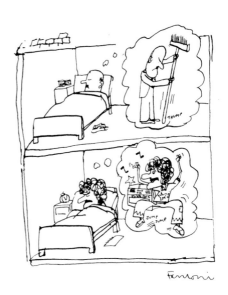

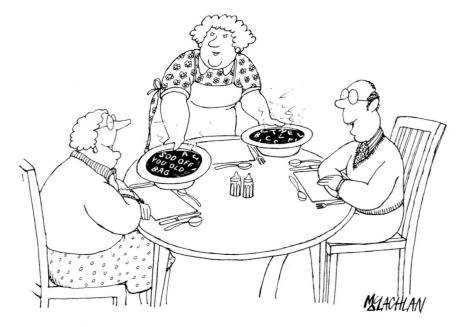

"Oh, look, mother, it's Mabel's special – Alphabet noodle soup"

"Damned gardener's run out of flowers"

"You'll like this, sir.
It'll make you both very drunk"

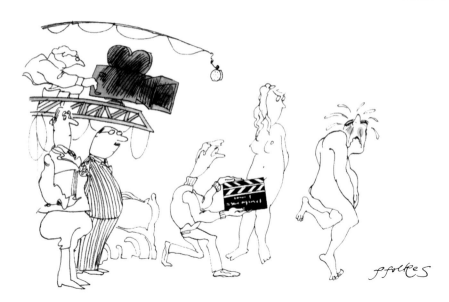

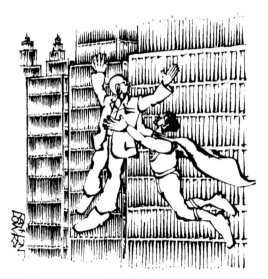

"If you wouldn't mind letting me go, I was trying to commit suicide"

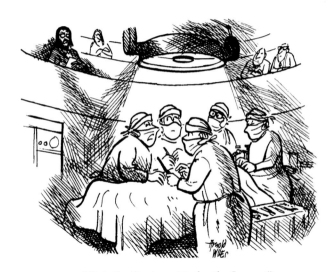

"He's the theatre critic for the Lancet"

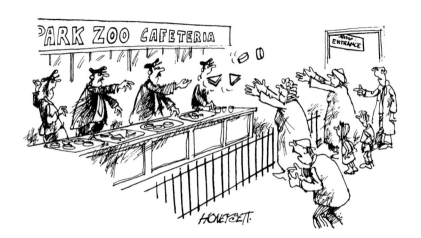

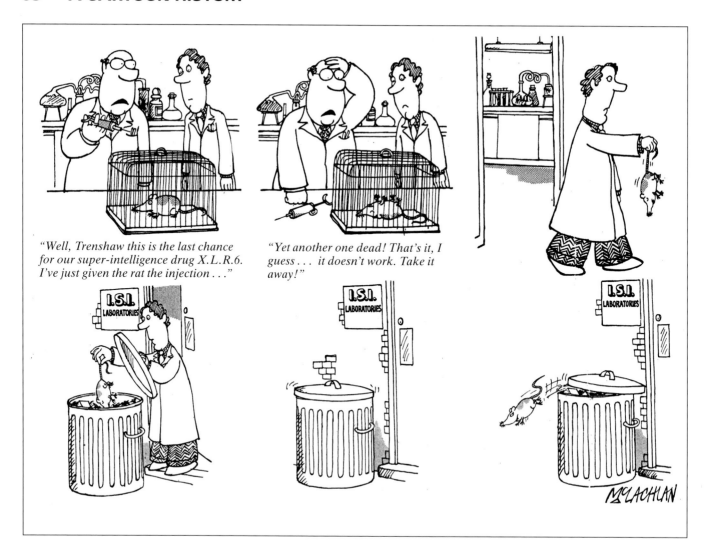

"Well, Trenshaw this is the last chance for our super-intelligence drug X.L.R.6. I've just given the rat the injection . . ."

"Yet another one dead! That's it, I guess . . . it doesn't work. Take it away!"

"He was a very short-sighted unicorn"

"It's a fully automatic camera, it even goes to Boots on its own"

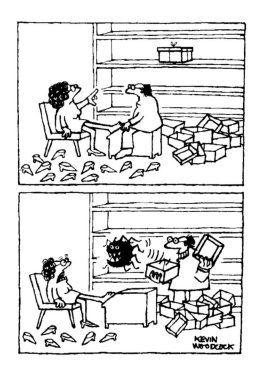

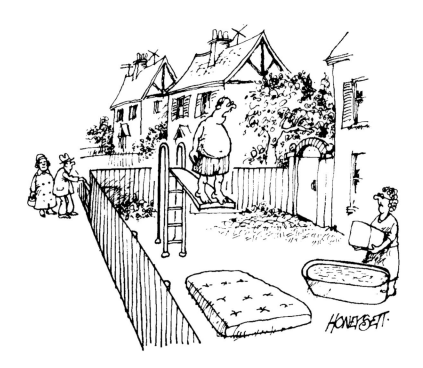

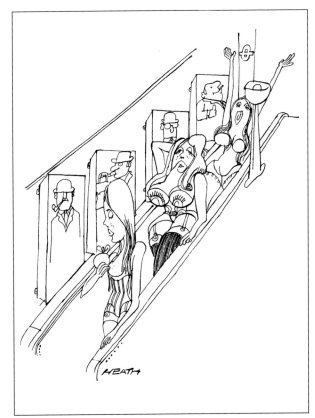

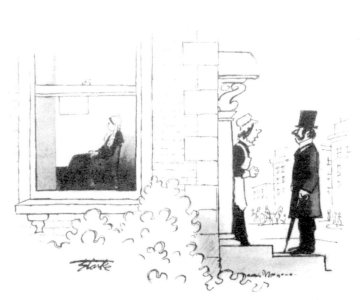

"Ready? They're coming"

"You have just missed him, sir, but if you'd like to speak to his mother . . . !"

FFOLKES

Michael ffolkes – real name Brian Davis – was a cartoonist as baroque and flamboyant as his drawings. He lived a champagne lifestyle of velvet jackets and open-top Bentleys quite at odds with his usually impoverished and morose cartooning colleagues. Born in 1925, he studied at St Martin's and Chelsea School of Art. He illustrated the *Daily Telegraph*'s *'Way of the World'* column from 1955 until his death in 1988. Waspish and occasionally insensitive, an abiding memory of ffolkes is that of a fellow cartoonist shoving a cake in his face at a gallery opening, so becoming a living cartoon.

"They always seem to bring the most awful weather with them"

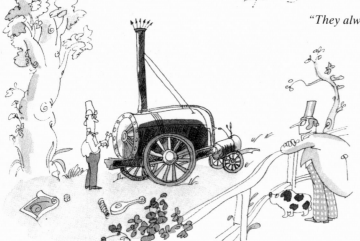

*"Don't be foolish, Stephenson, you'll never get **that** to fly"*

ffolkes Fables

ABSINTHE MAKES THE HEART GROW FONDER

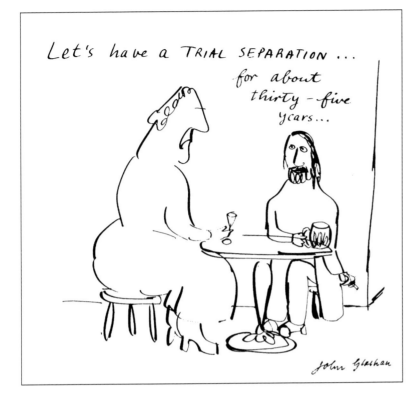

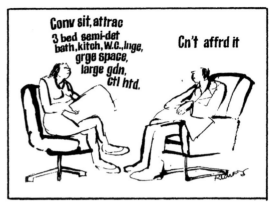

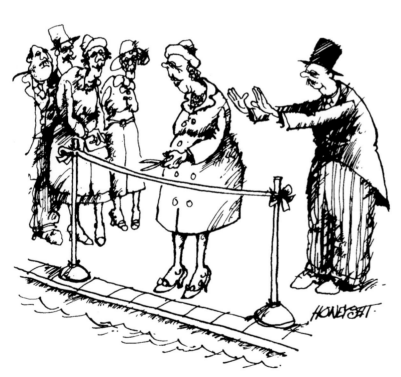

"I now declare these swimming baths open"

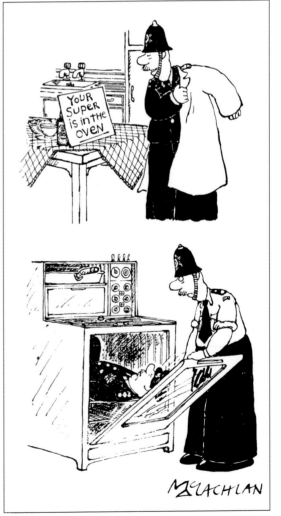

"And I say you're going around with the wrong set!"

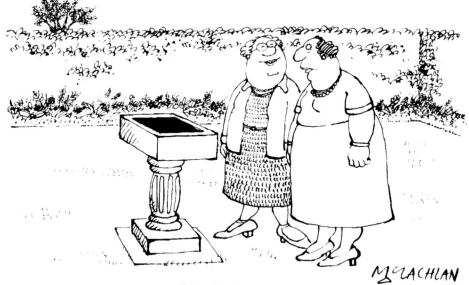

"It's a digital sun-dial, dear"

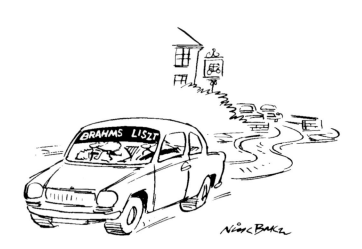

"Who taught your kettle to swear like that?"

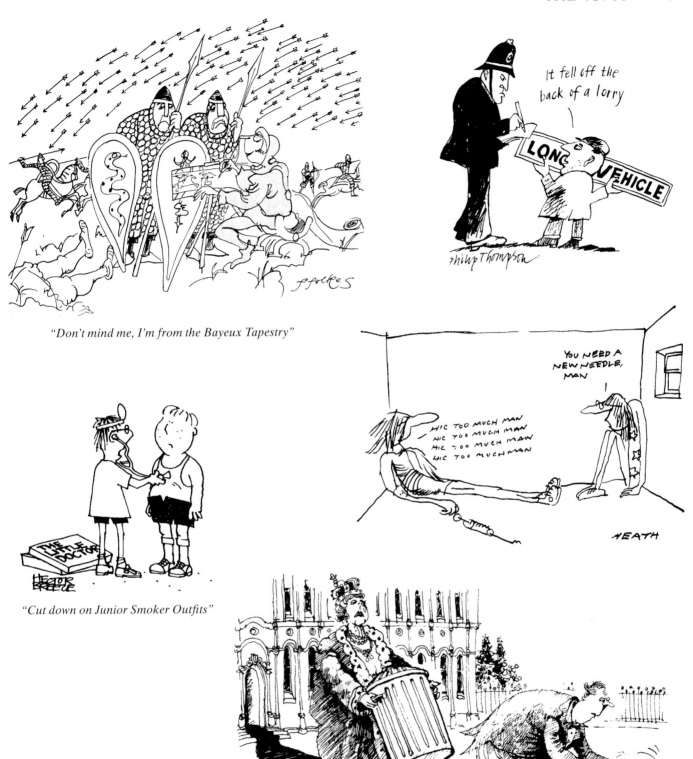

"Don't mind me, I'm from the Bayeux Tapestry"

"Cut down on Junior Smoker Outfits"

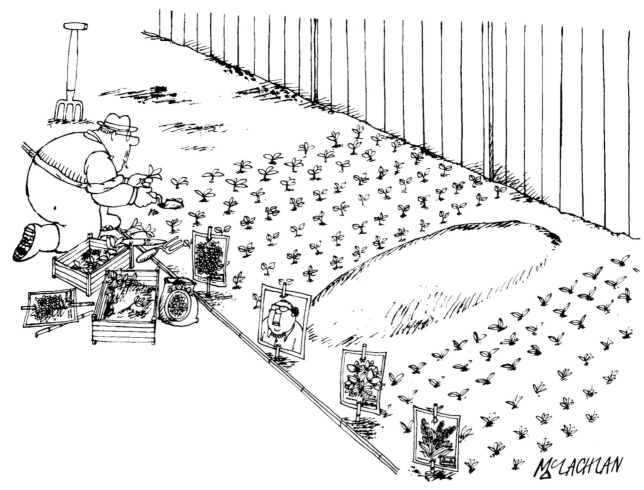

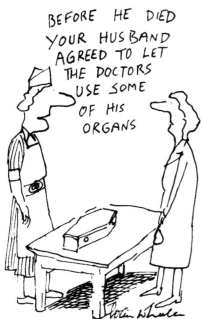

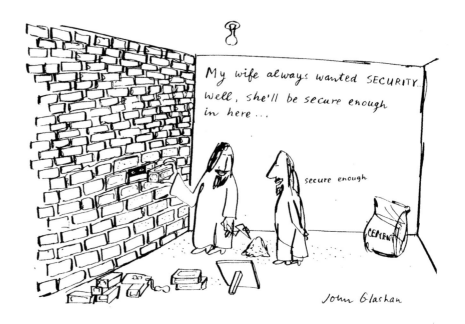

"I want a batch of rigged questions to stop any more questions about rigged questions!"

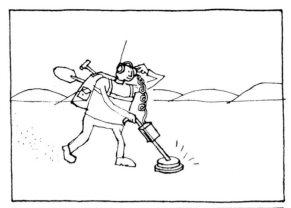

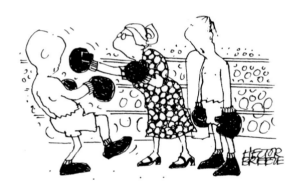

"Don't fuss, Mother! I said I can manage!"

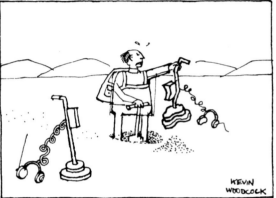

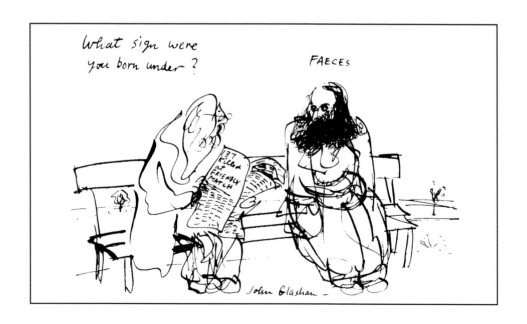

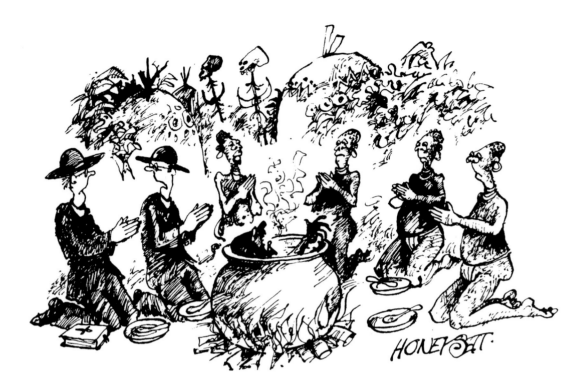

"It's a start, brother, it's a start"

"Air buses, I should think"

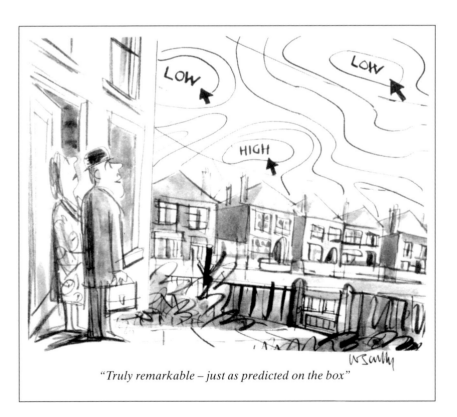

"Truly remarkable – just as predicted on the box"

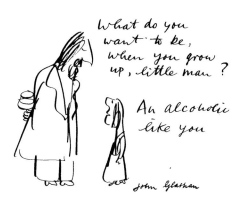

What do you want to be, when you grow up, little man?

An alcoholic like you

John Glashan

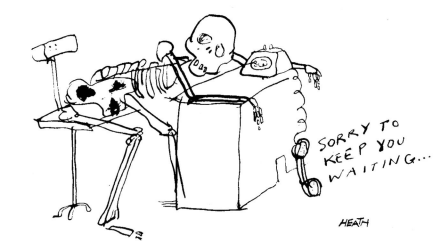

SORRY TO KEEP YOU WAITING...

HEATH

THE BROTHERS

With Grocer Heath booted out of power and Labour's Harold Wilson now Prime Minister, Trade Unions sought to flex their muscles. John Kent's response was a strip that pilloried this relationship. Here, Wilson is joined by TUC leader Len Murray and Eric Varley, Secretary of State for Industry.

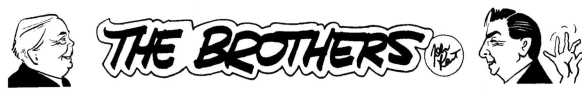

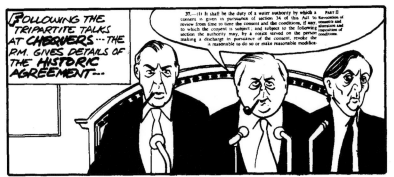

FOLLOWING THE TRIPARTITE TALKS AT CHEQUERS... THE P.M. GIVES DETAILS OF THE HISTORIC AGREEMENT...

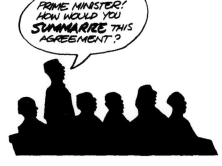

PRIME MINISTER! HOW WOULD YOU SUMMARIZE THIS AGREEMENT?

BRITAIN'S IN THE SHIT!

*"I think that might very well
be a cry for help"*

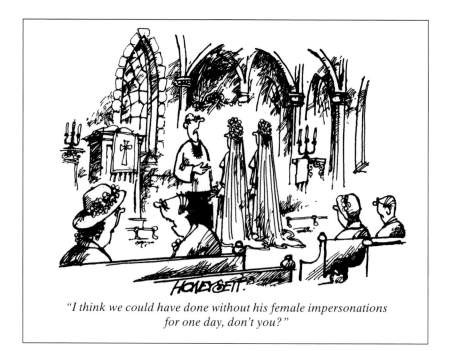

*"I think we could have done without his female impersonations
for one day, don't you?"*

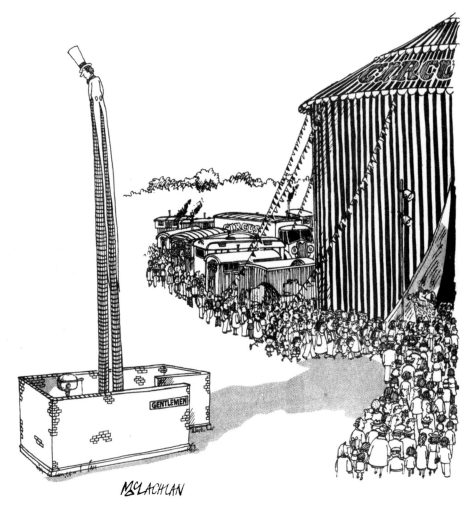

HONEYSETT

Born in 1943, Martin Honeysett attended Croydon School of Art before moving to New Zealand where he had numerous jobs, including working as a lumberjack. Returning to England in the late 60s, he worked as a bus driver while cartooning in his spare time. His macabre, grotesque characters – seedy and decrepit – burst into the *Eye* in the 1970s, and he soon became one of the magazine's most prolific stalwarts. *Private Eye* published a collection of his cartoons in 1974. He was a visiting professor at the Kyoto Seika University, Faculty of Art, Japan, from 2005 to 2007.

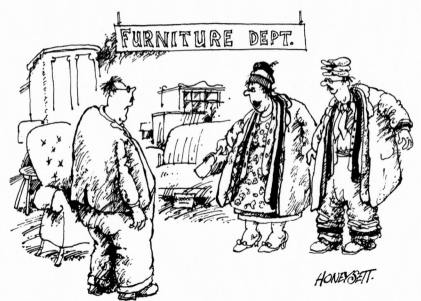

"We'd like to see some wardrobes, please"

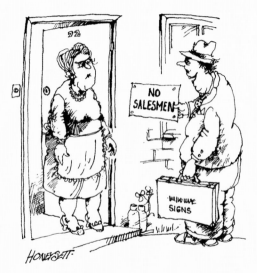

"Good morning, you pasty-faced old crone, can I interest you in one of these?"

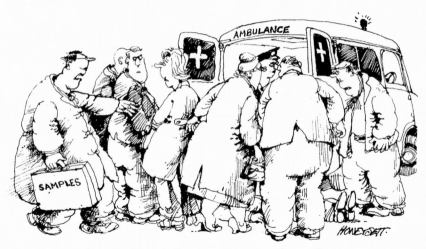

"Let me through, I'm an underpants salesman"

"I still say there's a public footpath through here"

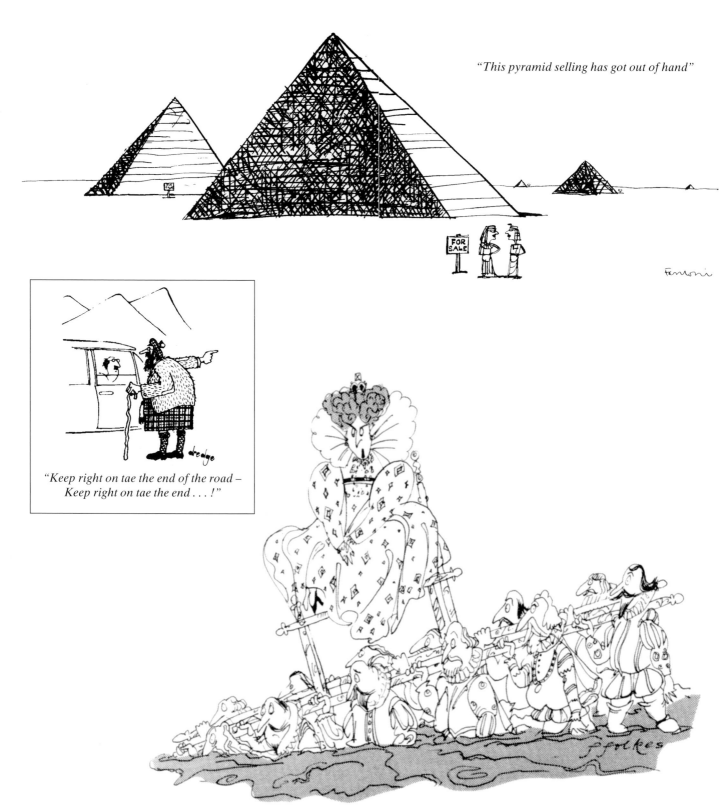

"*This pyramid selling has got out of hand*"

"*Keep right on tae the end of the road –
Keep right on tae the end . . . !*"

"*Does this damned thing have a reverse?*"

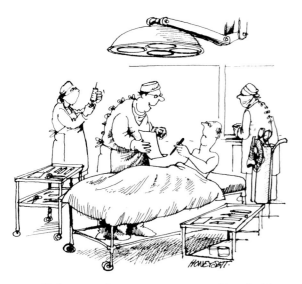

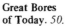

"It just says that you agree to me taking the bits home for my dog"

Great Bores of Today. *50.*

". . . and I now ask your Lordships to turn for a moment if you will to the cartoon on page 4 of *Private Eye* Issue 389 that's exhibit JMG 586 in your Lordships' bundle and there can be no doubt in our submission that this cartoon constitutes a clear and undoubted referenc to myself in the light of which I crave leave to refer your Lordships for a moment to *Rex v Aspinall Steam Laundry* where it was stated by Mr Justice Cocklecarrot Times Law Report 1936 that to hold up the Learned Counsel of a party to litigation to obloquy thereby subjecting him to public contumely and opprobrium constitutes and this is our submission in this case my lord a clear case of *scandalum magnatum* for which the defendant should be imprisoned. . ."

"We're done for, Sarge, the Viet-cong are solid up front and the drug-squad are attacking in the rear"

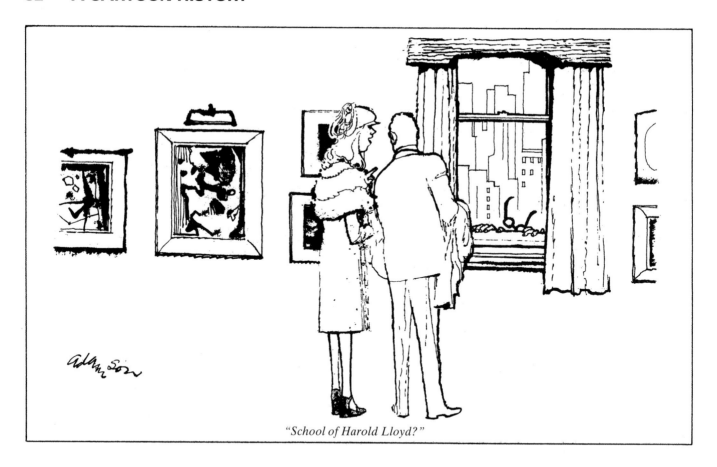

"School of Harold Lloyd?"

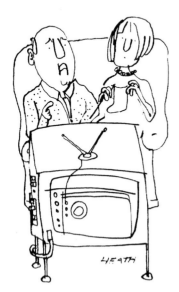

"Is Cliff Richard a guest on the Cilla Black Show, or is this the Cliff Richard Show with Cilla Black as a guest?"

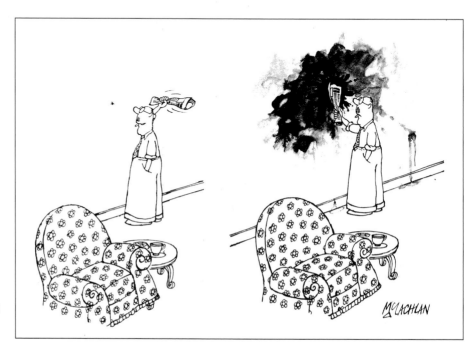

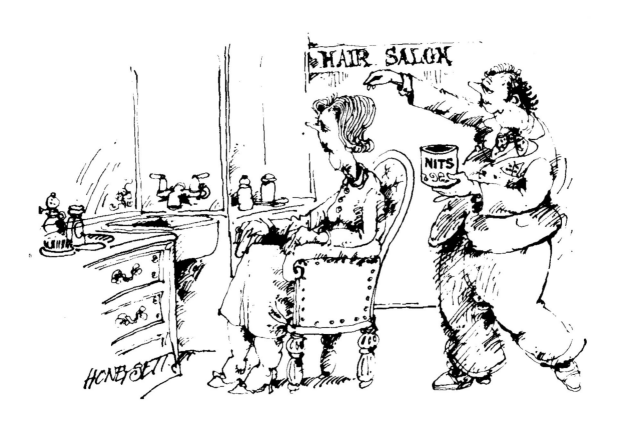

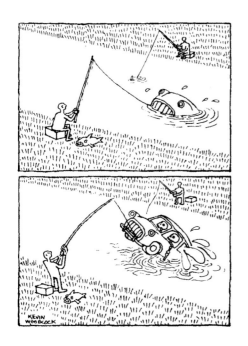

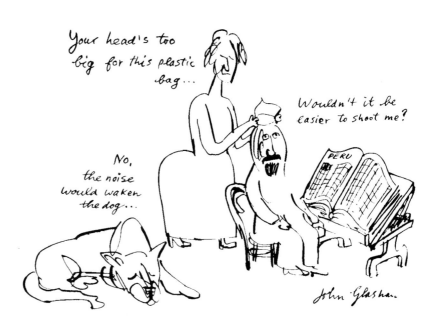

FOCUS ON FACT

A parody of similar strips that featured in the tabloids, *Focus on Fact* was drawn by Barry Fantoni and written by Stuart Harris – a pseudonym for writers including Ingrams, MP Tom Driberg and hack Patrick Marnham. It was often simply factual, rather than trying to be funny – but it was not without humour. Other celebrities focussed on were Esther Rantzen and The Astors. It proved a showcase for Fantoni's portraiture skills.

FOCUS ON FACT— *The Frost Story*

By BARTY FENTON & STUART HARRIS

(8)

FROST TAKES AN ACTIVE INTEREST IN THE FAMOUS **CAMBRIDGE** ACTING CLUB **THE FOOTLIGHTS**. ONE DAY HE IS SENT TO **GREAT YARMOUTH** TO ARRANGE THE PUBLICITY FOR A CONSERVATIVE CLUB CABARET FEATURING **PETER COOK, JOHN BIRD,** AND **ELEANOR BRON**.

TO THE SURPRISE OF ALL THE POSTERS SAY:

GREAT YARMOUTH C.C.
★★ PRESENT ★★
DAVID FROST
★ ★ & THE **FOOTLIGHTS**

1 **2** **3** **4**

5 **6** **7**

AUSTIN

David Austin was a self-taught cartoonist whose strip *Hom. Sap.* holds the record as the longest running *Eye* cartoon strip. He was also a prolific pocket cartoonist for the *Eye*, the *Spectator* and for the *Guardian*. Born in 1935, he read Chemistry at Leicester University before becoming a teacher – notably at the controversial William Tyndale junior school in Islington – from which he resigned in disillusionment. He was already drawing *Hom. Sap.* for the *Eye*. He is the only cartoonist to have had a train named after him (*see page xii*).

"*You wait about six weeks*"

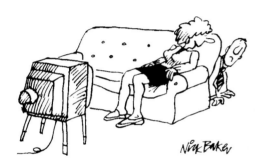

"*You can come out now, dear. The news is over*"

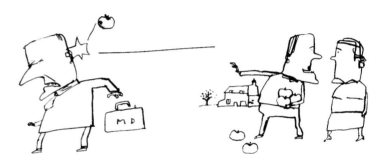

"*An apple a day keeps the doctor away*"

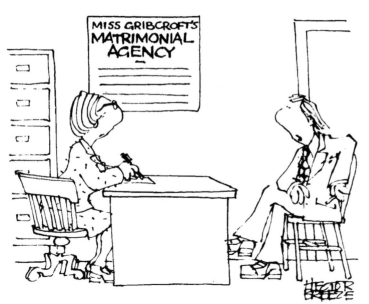

"Never mind the details – I just want someone to be unfaithful to"

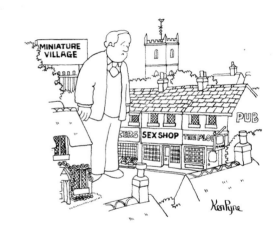

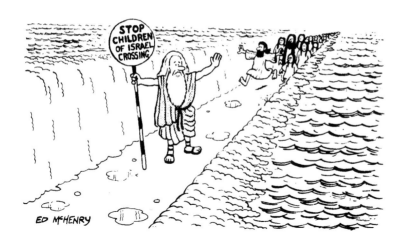

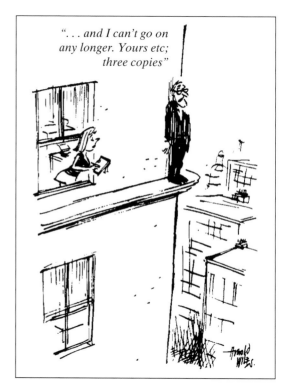

"... and I can't go on any longer. Yours etc; three copies"

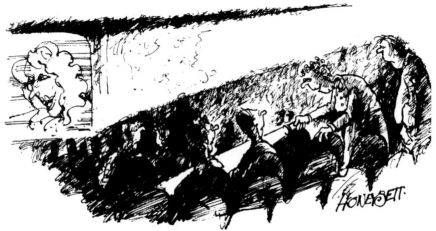

"Sorry to trouble you, but this gentleman thinks he left some chewing gum under that seat"

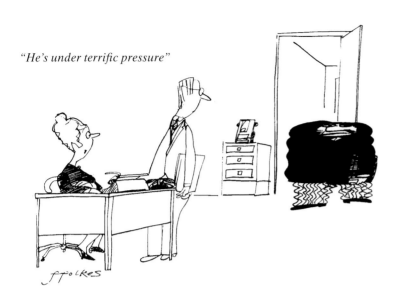

"He's under terrific pressure"

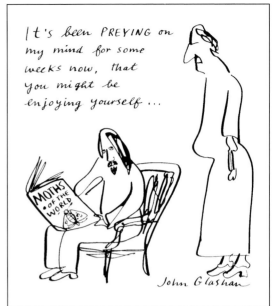

It's been PREYING on my mind for some weeks now, that you might be enjoying yourself...

John Glashan

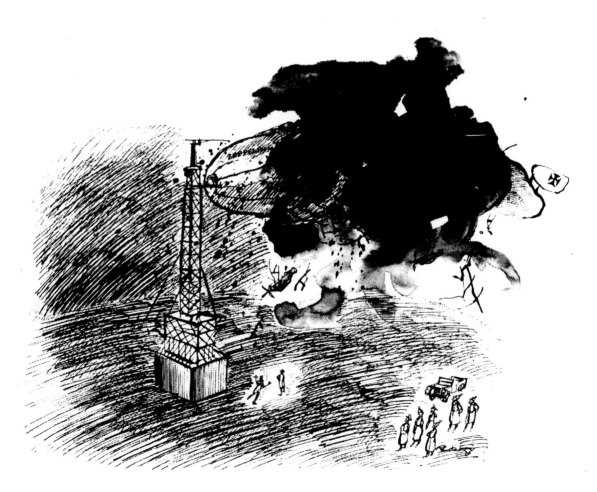

"Does anybody know whether they're supposed to do that?"

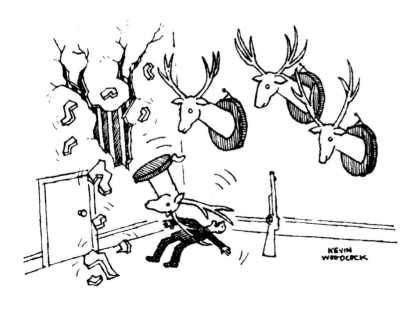

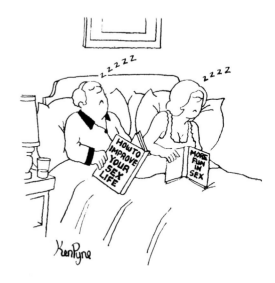

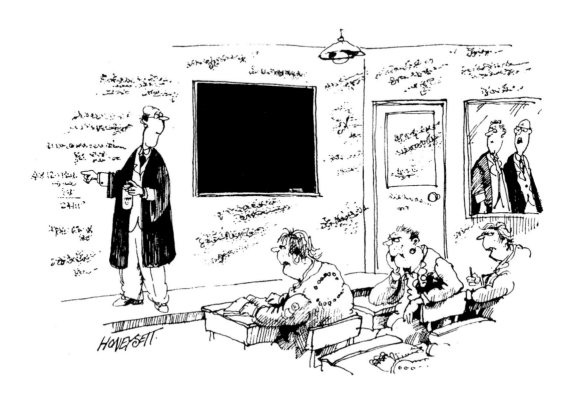

"Henderson seems to be one of the few who can cope with 5D"

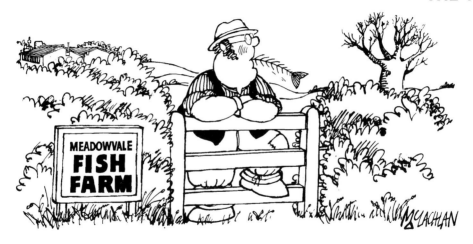

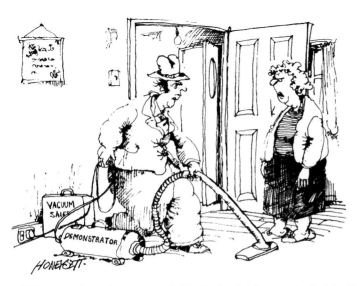

"I hope you're going to put all this dirt back when you're finished"

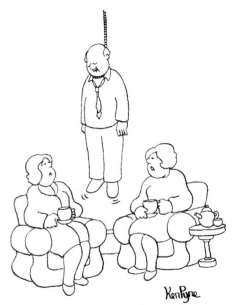

"Just ignore him – he's only trying to draw attention to himself"

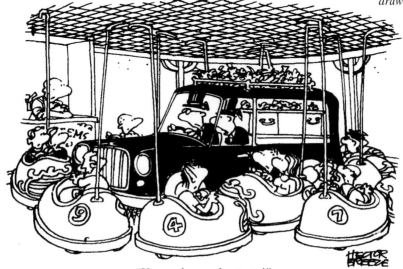

"You and your shortcuts!"

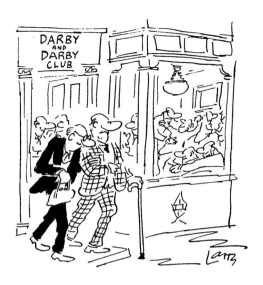

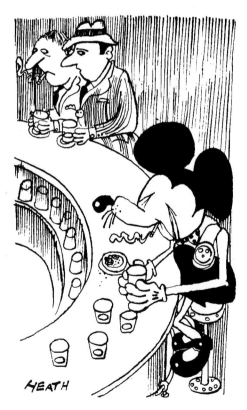

*"He used to be one of the all-time
Hollywood greats"*

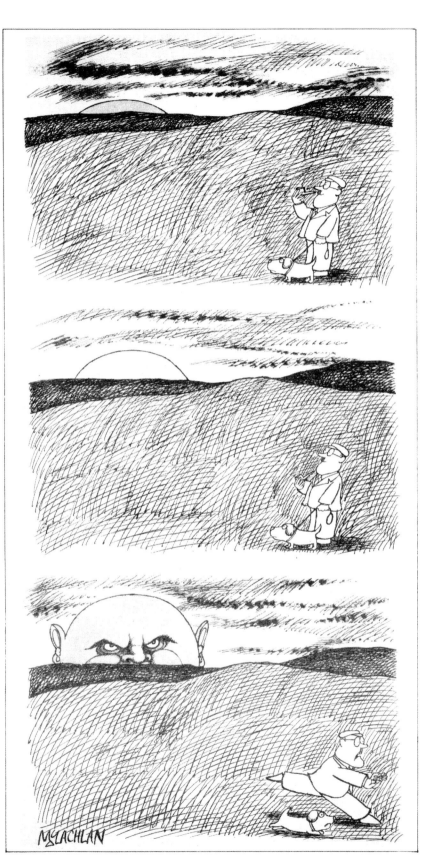

LORD ARTHUR AND HIS SQUARE TABLE

The surreal and whimsical family created by Kathryn (KJ) Lamb was first published while she was still studying at Oxford University, where she contributed to the student paper *Cherwell*. The table subsequently became round.

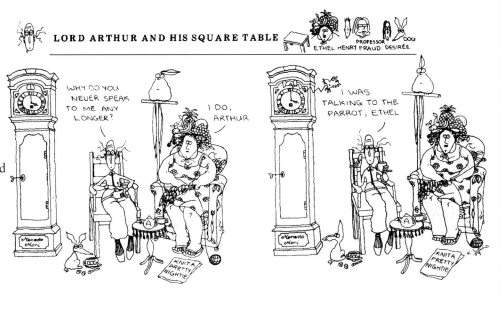

"Tell me, doc, how bad is it?"

RAY LOWRY

Ray Lowry was a true rock-and-roll cartoonist. Born in 1944, he started off in advertising in Manchester before becoming a regular contributor to the *New Musical Express*. *Private Eye* provided an outlet for his madder ideas – often about disaster, impending apocalypse . . . or Nazis. A journalist and illustrator for the music press, he created the cover artwork for the Clash's *London Calling* album of 1979. When he died in 2008, the band Oasis dedicated a song to his memory during a concert in Birmingham.

"Good God, you're right! It is the end of the world"

"Don't you think this is perhaps a trifle premature? After all, the Financial Times Index is only down six points"

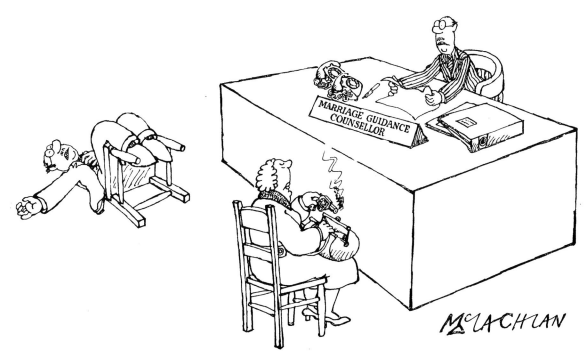

"*Well, we haven't made a very good start, have we, Mrs Turnstone?!*"

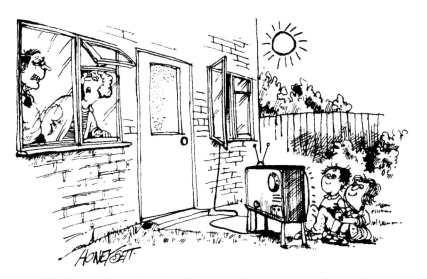

"*Well, you did say they should go outside and get some fresh air*"

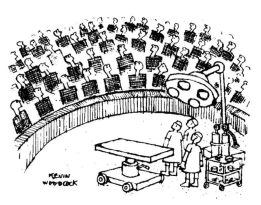

"Now, Mrs Abthorpe, if you think you see the man who assaulted you, we just want you to touch him on the shoulder"

"No, I didn't recognise any of those men"

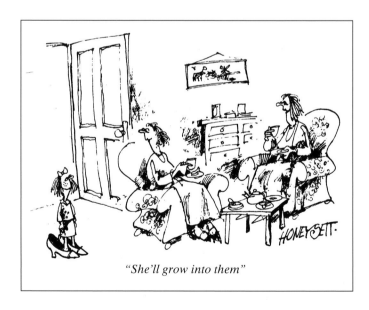

"She'll grow into them"

**Great Bores
of Today.** *54.*

". . . always the same story two inches of snow and the whole country grinds to a blinding halt I was due into the office at 9 o'clock as it was I got to the station only to be informed that all down trains were running late nobody knew the first thing about it I finally caught the 11.51 which promptly ground to a halt due to frozen points then they put us on a bus which skidded into a caravan just outside Northolt anyway to cut a long story short when I got to Ealing Broadway they said all the underground trains were delayed due to so-called adverse weather conditions eventually I took a taxi which pranged a lorry on Chelsea Bridge killing two Arabs and I finally got to the office only to be told it was a Bank Holiday now let me tell you about the trouble I had getting home. . ."

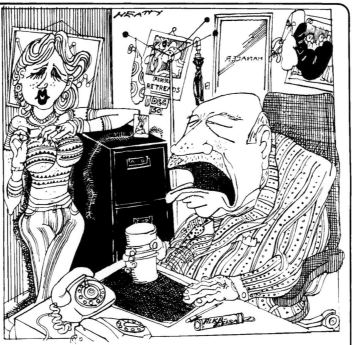

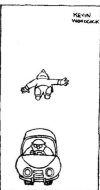

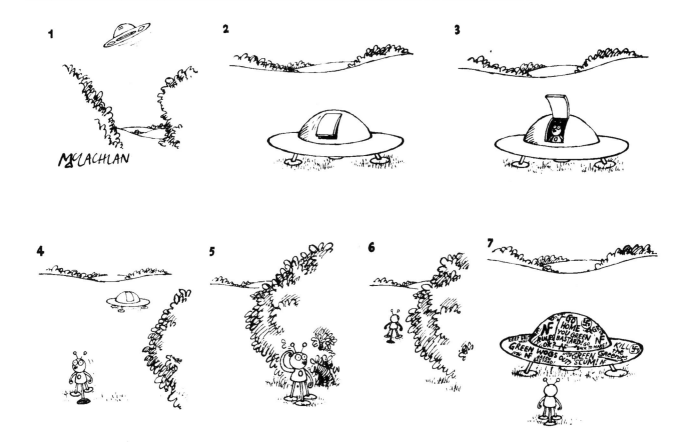

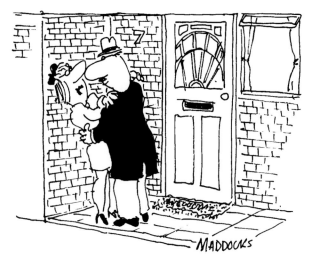

"Gosh – your wife's cooking smells good!"

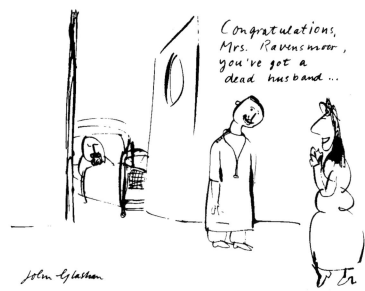

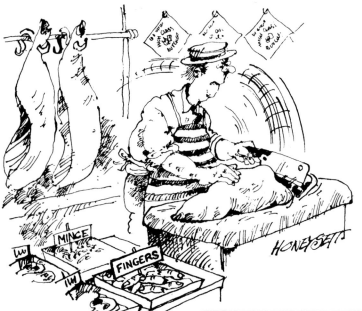

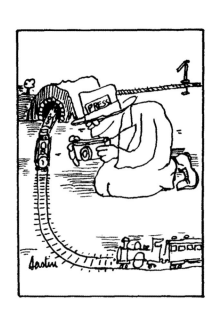

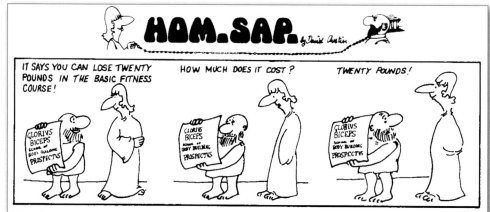

*"And how are the machine gun
lessons coming on?"*

"Of course you're depressed. I'm very expensive"

"This is Mr Andrews, our new salesroom manager. He used to be a supermarket manager with Tesco"

KEN PYNE

Born in 1951, Pyne has been an *Eye* mainstay since he was first published in the mid-1970s. Specialising in sour depictions of suburban relationships, Pyne evolved into a sharp topical cartoonist and caricaturist. His award-winning strip *London Life*, which he drew for the *Evening Standard*, was axed almost immediately he made his acceptance speech. Self taught, Pyne was, at 16, the youngest cartoonist to be published by *Punch*, before working as a layout artist on that other mirth-filled periodical, *Scrap & Waste Reclamation & Disposal Weekly*. Pyne says of his profession, 'They say it's an extension of childhood. It's like being a footballer, but with a lot less money.'

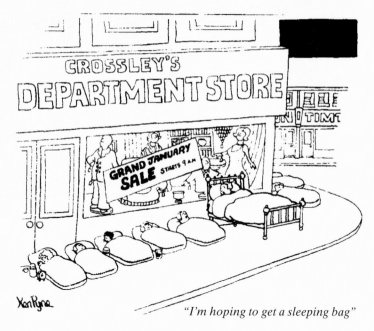

"I'm hoping to get a sleeping bag"

"Read that bit again where I disinherit the whole family"

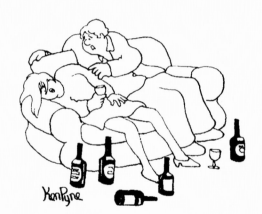

"But you can't pass out! One thing hasn't led to another yet!"

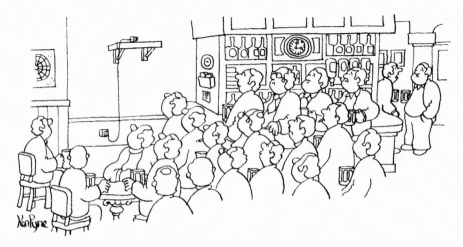

"No, the new landlord hasn't made any changes – apart from taking the television away"

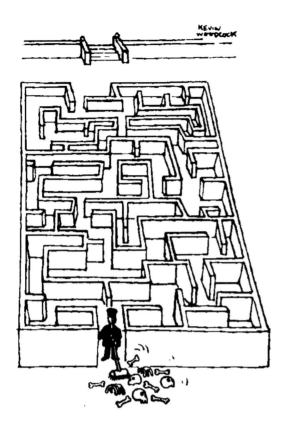

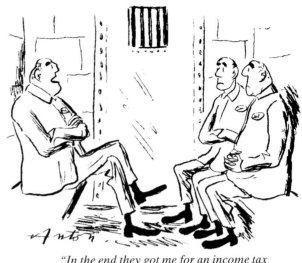

"In the end they got me for an income tax offence – I strangled the inspector"

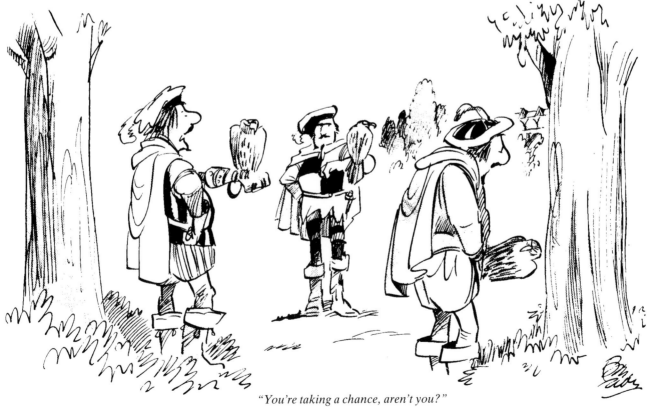

"You're taking a chance, aren't you?"

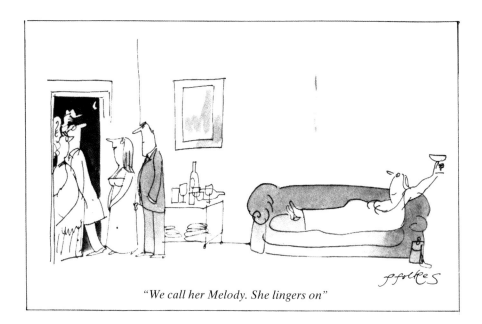

"We call her Melody. She lingers on"

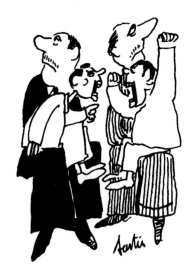

"Don't worry, there'll be another one along in a minute"

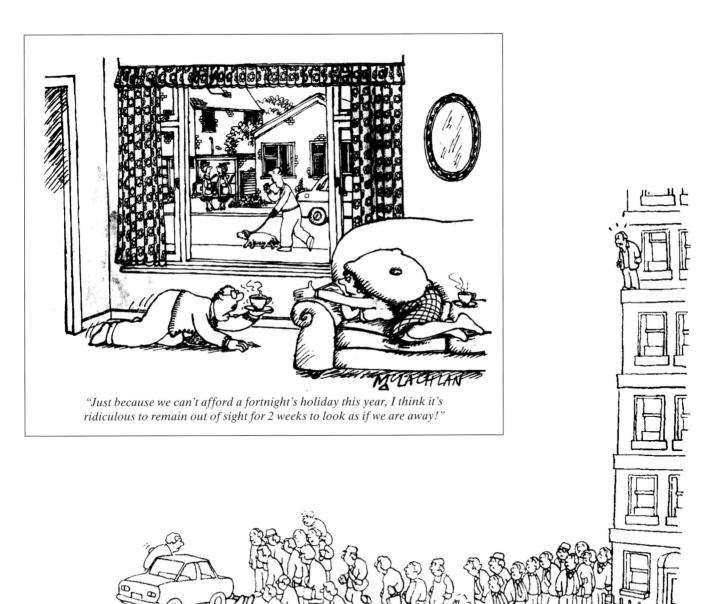

"Just because we can't afford a fortnight's holiday this year, I think it's ridiculous to remain out of sight for 2 weeks to look as if we are away!"

"When I was a boy we had to make our own entertainment"

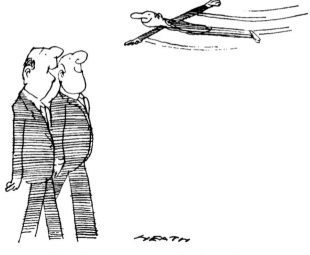

"I see Benson's overcome his fear of flying"

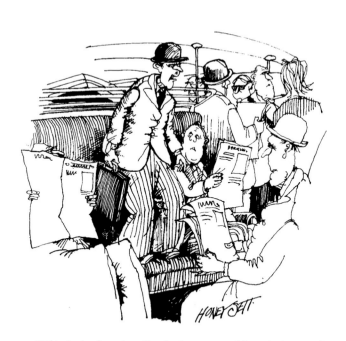

"This is the first time I've had a seat on this train in years"

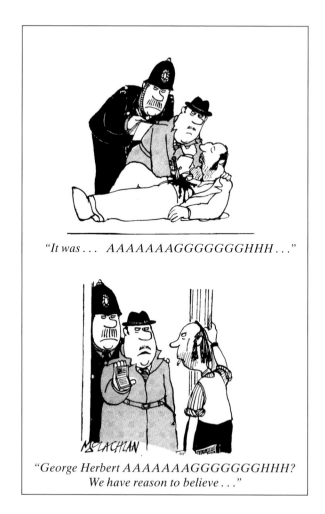

"It was . . . AAAAAAAGGGGGGGGHHH . . ."

*"George Herbert AAAAAAAGGGGGGGGHHH?
We have reason to believe . . ."*

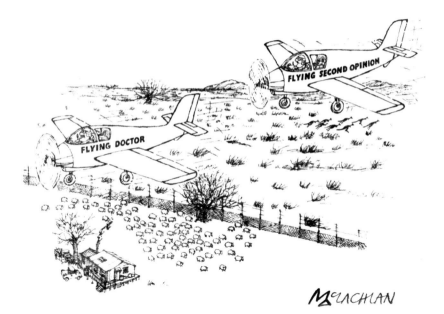

McLACHLAN

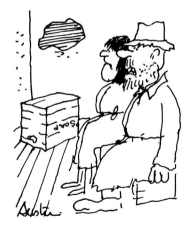

"Let's stay in and watch the box tonight"

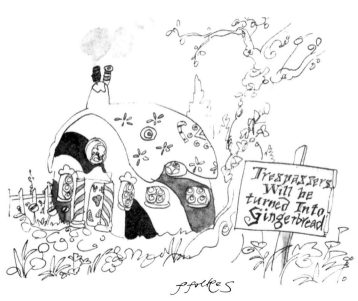

"If we were upper class we could commit some youthful indiscretions"

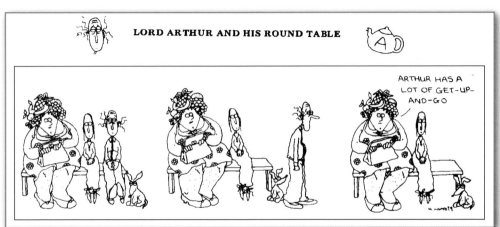

PHEW, WHAT A SCORCHER!

Barry Fantoni's series on clichéd tabloid headlines about the weather presaged what has become an *Eye* tradition: the running joke. Beginning in the 70s, it ran appropriately into the 80s and 90s – phew, what a series!

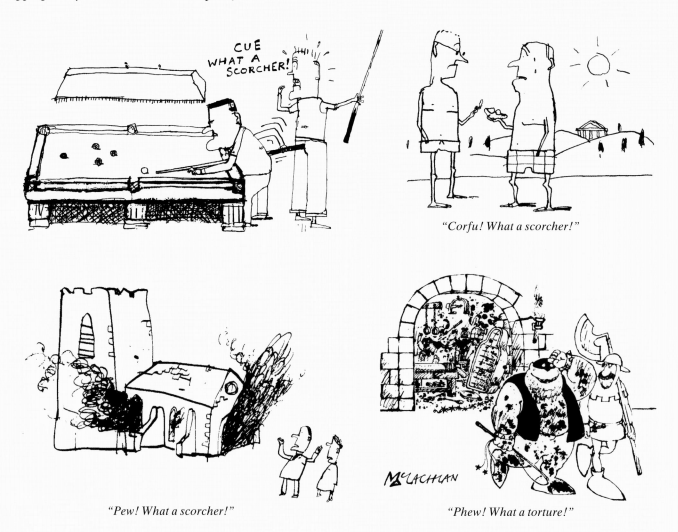

"Corfu! What a scorcher!"

"Pew! What a scorcher!"

"Phew! What a torture!"

THEY
DIED
TO SAVE
HER FACE

THE
FALKLANDS
1982

NEW WAR MEMORIAL

AIDS
CLINIC

AIDS

KenPyne.

THE 1980s

The 1980s saw the arrival of war, famine, plague and death – and not just in the *Eye*'s cartoons. The Falklands War saved Margaret Thatcher's government, the Ethiopian drought brought conscience to celebrity, and the spread of Aids turned from concern to panic. Meanwhile, John Lennon was shot, the City boomed, greed was good and estate agents became the most reviled subsection of society after politicians. The *Eye*'s cartoonists enjoyed their own boom and new scribbling stars included Tony Husband, Cluff, de la Nougerede, Newman and Neil Bennett. Strip cartoons were as plentiful as yuppies – perhaps in a search for a replacement for the cult of Barry McKenzie. And as Thatcher went on and on and on, Richard Ingrams announced he'd had enough – and handed over the *Eye*'s editorship to Ian Hislop in 1986. Meanwhile, the computer age had truly begun – signalling the end of Fleet Street. Big hair came and went, along with shoulderpads, New Romantics and Rubik's Cubes. The only constant was the quality of the cartoons.

NOW TELL ME-
HOW LONG
HAVE YOU BEEN
A TULIP ?

R.86

IM A
NOBODY,
DON'T.
SHOOT

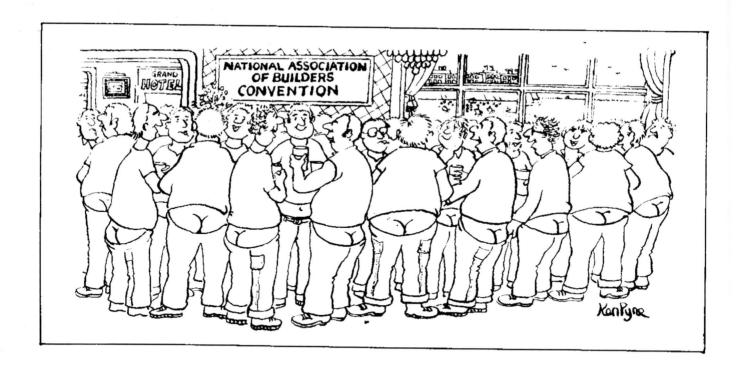

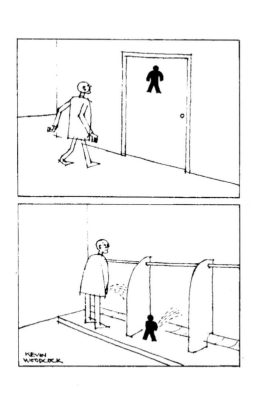

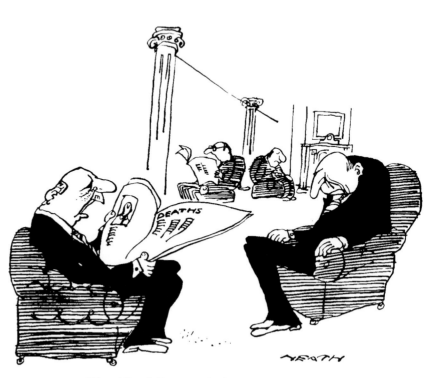

"Good Lord, Fenton, I had no idea you had died!"

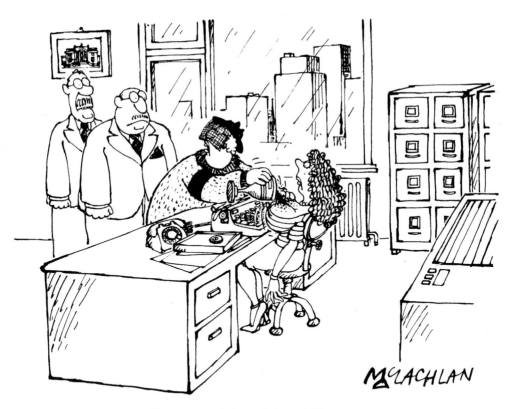

"It was your chairman's last wish"

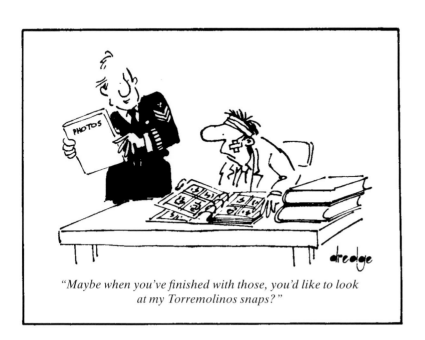

"Maybe when you've finished with those, you'd like to look at my Torremolinos snaps?"

"Bloody Joneses!"

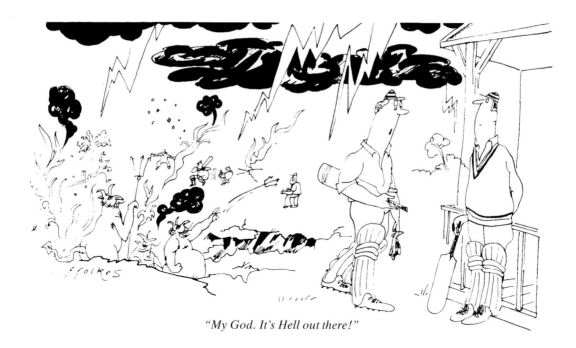

"My God. It's Hell out there!"

"Apparently, it's going to re-open
in three days"

"I'm sorry, I must ask you to leave – you've got a tie on"

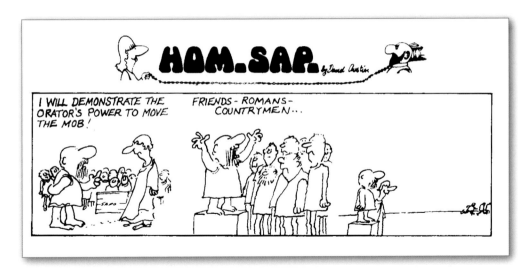

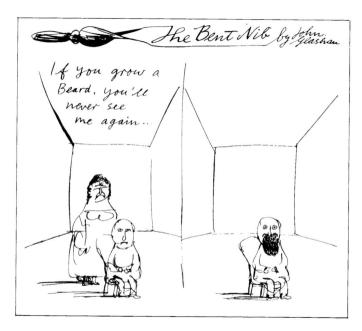

"He's dead. Is there an undertaker in the house?"

"Probably pre-menstrual tension"

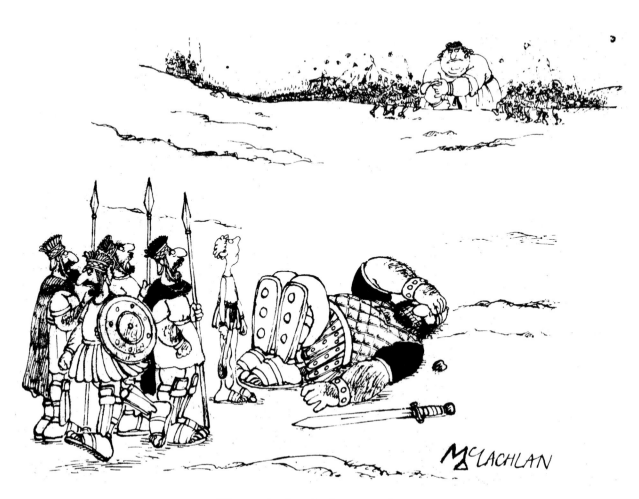

"Now you've done it – here comes his mother!"

"It was twelve originally, but we went decimal"

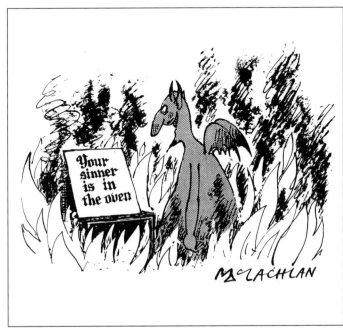

MARCUS by Michael Heath

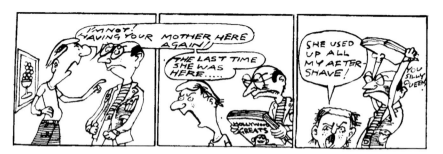

THE GAYS

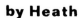

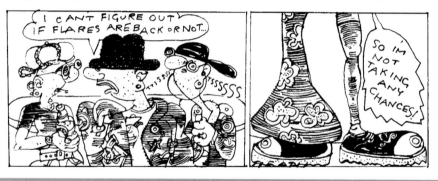

The Regulars

HEATH

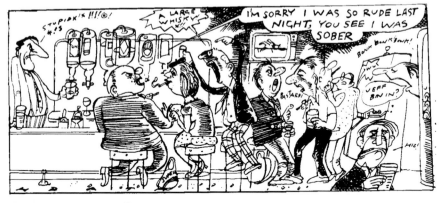

NUMERO UNO

MICHAEL HEATH

HEATH STRIPS

Michael Heath's strips chronicling fads and trends were a prominent feature of the 1980s *Eye*. Heath's gadfly mind and acute observation produced a flood of semi-autobiographical gags.

Marcus followed the sad world of a divorcé.

The Gays might have been construed as homophobic lampoonery – except its razor sharp depiction of the Soho Gay scene was loved by gays as much as straights.

The Regulars featured the clientele of the *Eye*'s favoured watering hole 'The Coach and Horses', including the notoriously rude landlord Norman Balon, art critic Bruce Bernard (brother of infamous drunk writer Jeff), and ZZ Top lookalike Christopher Howse, now the *Daily Telegraph*'s chief writer on faith. One notable absentee is the Coach's thirstiest patron, Jeff Bernard.

Numero Uno – caricaturing the utterly mad universe of fashion.

"Well, from what you tell me,
I'd say you are dead!"

"I'm sorry, sir, but if they've put money in the meter, there's nothing I can do"

TONY HUSBAND

Born in Blackpool in 1950, Tony Husband started in advertising and jewellery repairing before turning full-time cartoonist in 1984 – sending out hundreds of gags a week to publications around the country. Inspired by Pont, Bill Tidy, Mike Williams, Sempé and Larry, he began contributing to the *Eye* in 1985 – and immediately made an impact with his speedy style and prolific output. His seemingly unlimited supply of gags led to the launch of the comic *Oink* and inevitably spread into television – producing the award-winning children's TV show *Round the Bend*. Husband's comic inventiveness is matched only by his inventive spelling.

"Hello Bill. How's the wife?"

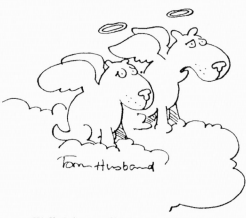

"Well, I don't call it heaven when we're not allowed to sniff each other's bottoms"

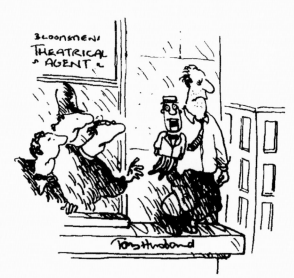

"Gye, gye, cruel world"

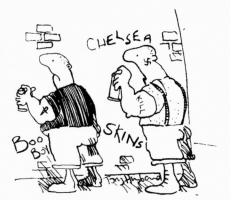

"How do you spell N.F.?"

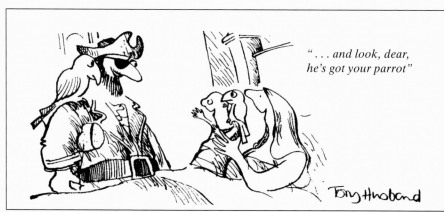

". . . and look, dear, he's got your parrot"

BOD

NEWMAN

BOD The first cartoon strip to be produced by Hislop and Newman. A rather bland, topical everyman.

"I told you never to ring me at the office!"

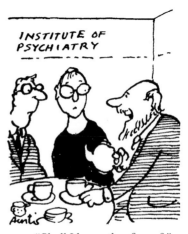

"Shall I be mother figure?"

5TH FORM AT ST MAGGIE'S

The election of Margaret Thatcher in 1979 prompted a change in John Kent's strips. The yah-boo nature of the schoolyard has proved a popular vehicle for satire – and survives today in the *Coalition Academy*. Here, Mistress Maggie gets tough about the 1980 Moscow Olympics.

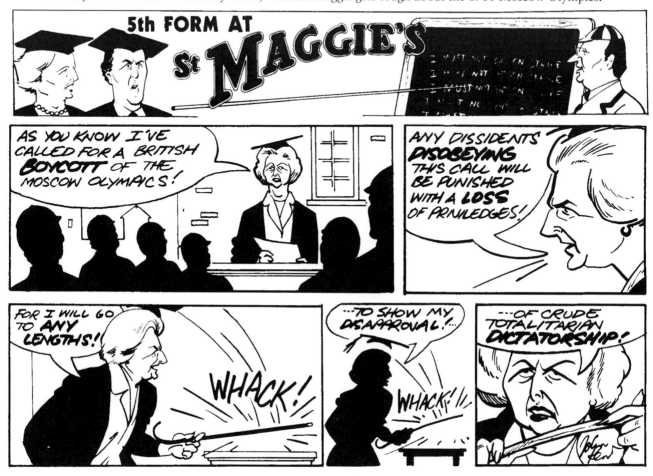

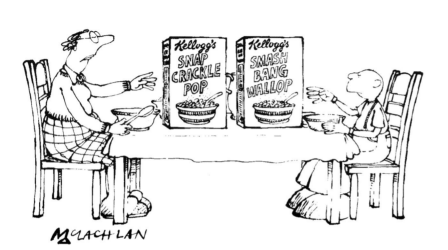

"We were playing football in no-man's land when fighting broke out among the spectators"

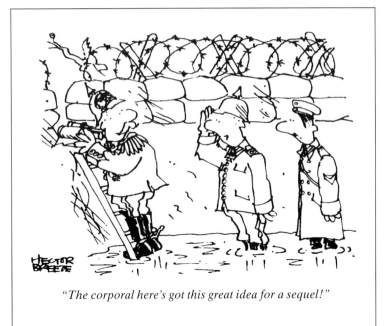

"*The corporal here's got this great idea for a sequel!*"

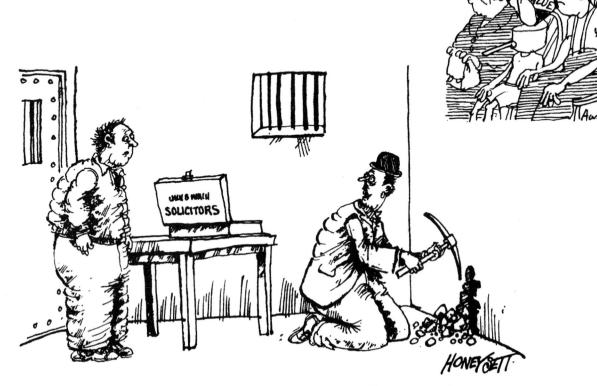

"*Don't worry, Mr Benson, we'll have you out of here in no time*"

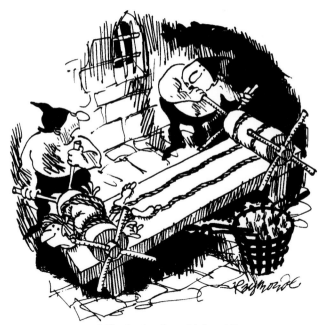

"Clockwise, knucklehead!"

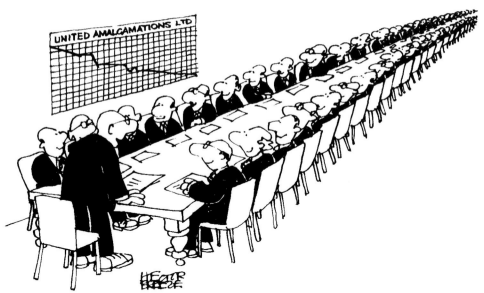

"Good news at last, gentlemen – we've made the work-force redundant!"

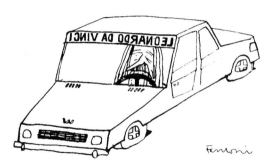

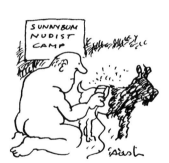

FORBIDDEN ALLIANCE

Written and drawn by 'Clara Sill' (Hislop and Newman), this parody of *Saturday Night Fever* and teen magazine love stories featured the newly formed Social Democratic Party and their doomed alliance with David Steel's Liberals. The SDP – the breakaway Labour centrist party – comprised the 'Gang of Four': charismatic David Owen, Shirley Williams, Roy 'Woy' Jenkins and Bill 'Bill Who?' Rogers. David Steel was often accompanied by political heavyweight Cyril Smith. Disco dancing and satire make strange bedfellows – as indeed did the SDP and Liberals (now the Liberal Democrat Party).

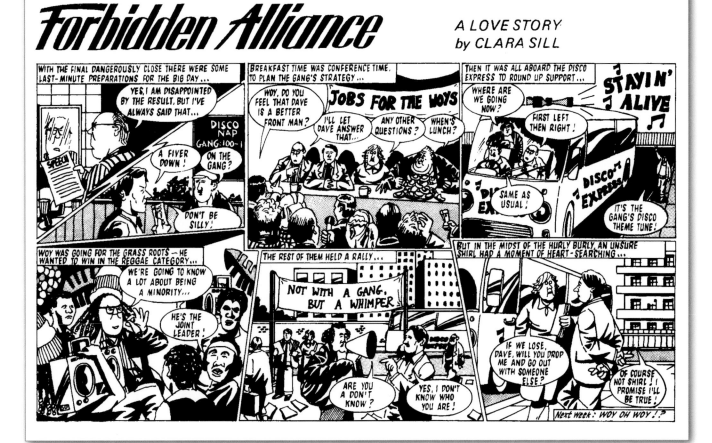

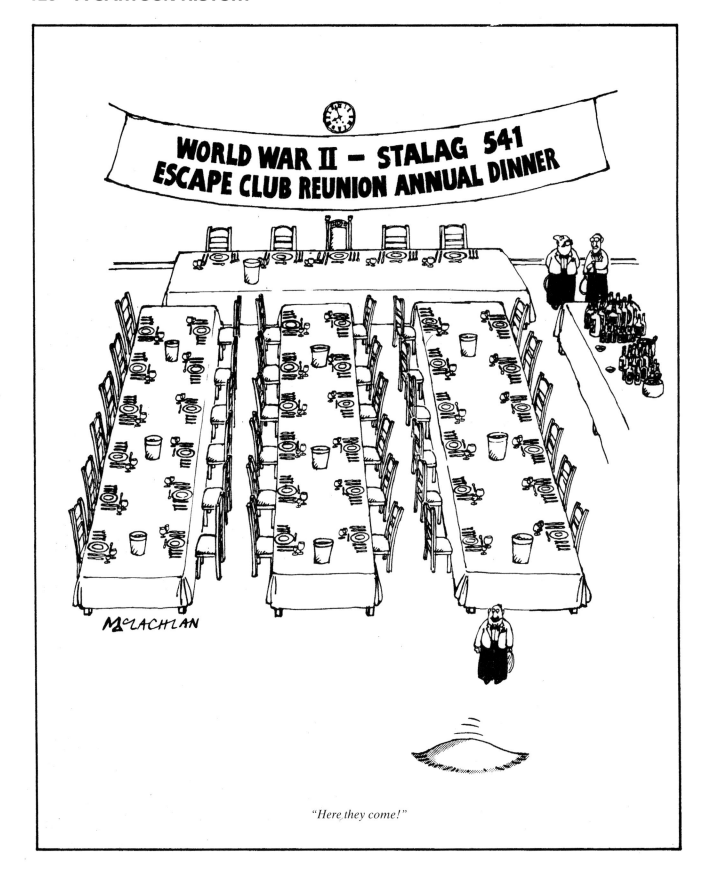

"Here they come!"

DE LA NOUGEREDE

Alan Nightingale de la Nougerede fled from accountancy to become a cartoonist in the 1960s. 'I figured cartooning had to be better,' he recalls. Born in India in 1932, he fell out with *Punch* magazine and began submitting to the *Eye*. He devotes a minimum of one hour a day to thinking of ideas. Influenced by Bill Tidy and Mike Williams, he went on to illustrate all editions of the Rev Blair's *St Albion's Parish News* (*see page 229*).

"Why is it you can never find a skinhead when you want one?"

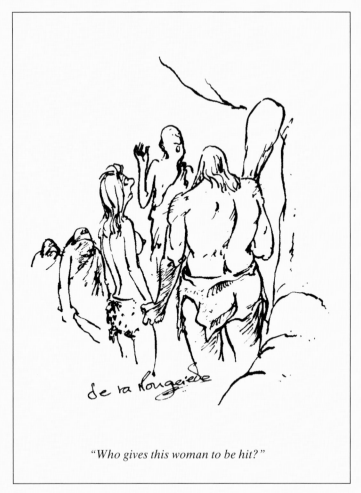

"Who gives this woman to be hit?"

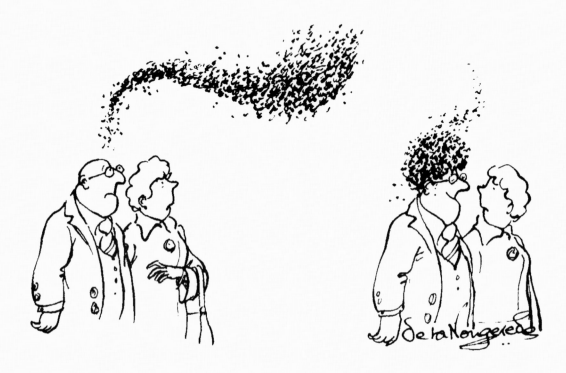

"Would you like a cup of tea before you start the exorcism, Vicar?"

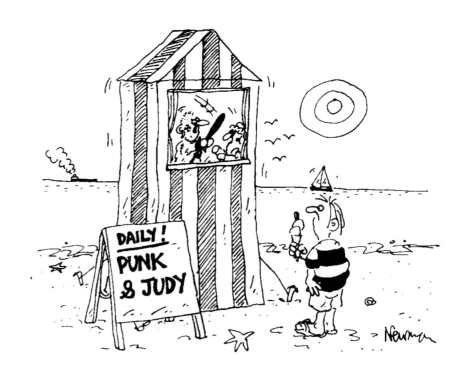

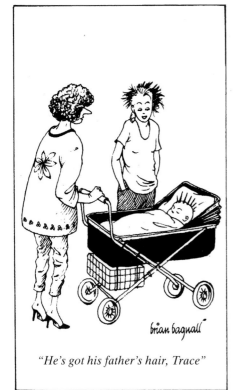

"He's got his father's hair, Trace"

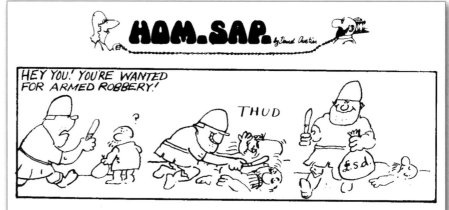

MAGGIE RULES OK

By 1982 Margaret Thatcher was already deeply unpopular – until the Falklands War saved her political career. Here, in the lead up to war following the invasion of the Falklands by Argentina, Maggie receives US Secretary of State General Alexander Haig, along with her Foreign Secretary Francis Pym.

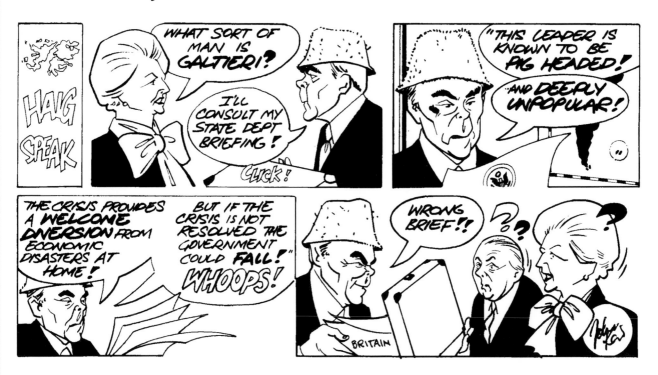

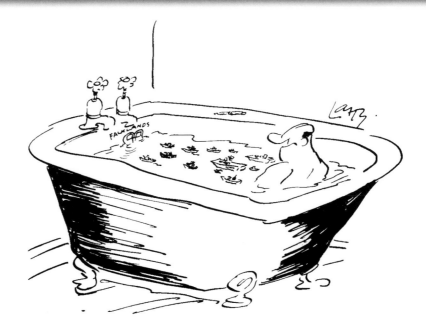

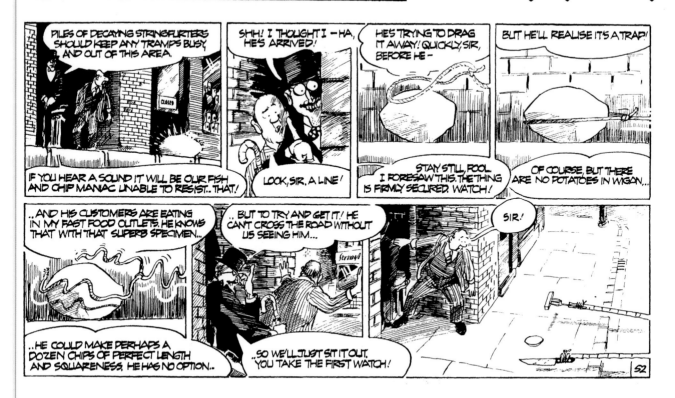

THE LAST CHIP SHOP IN ENGLAND

Bill Tidy's follow-up to *The Cloggies* raged against the influx of US fast food outlets.

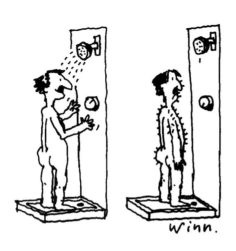

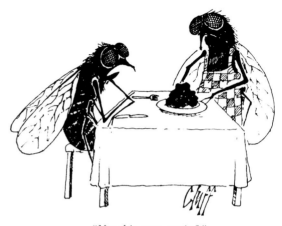

"Not this crap again?"

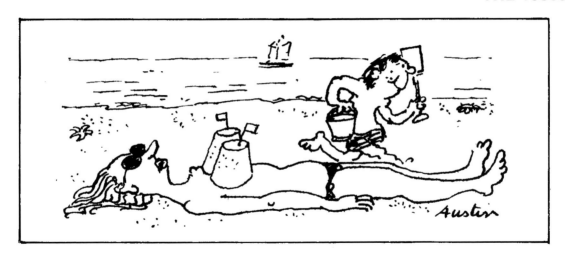

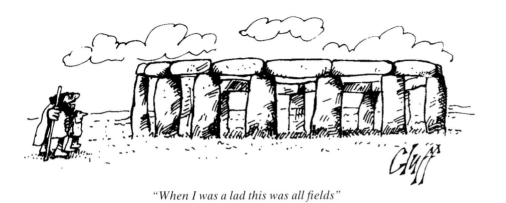

"When I was a lad this was all fields"

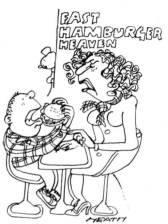

"Now, don't forget to bolt your food!"

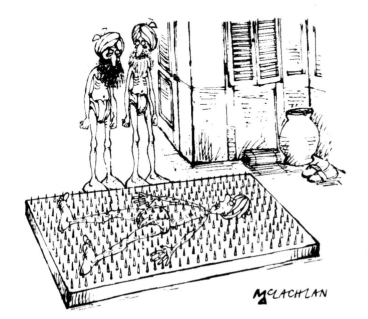

*"There, what am I always telling you . . . ? Young people today **are** soft!"*

"I'm disc jockey for Radio Frinton"

BATTLE FOR BRITAIN

Written by 'Monty Stubble', this was another Hislop and Newman collaboration, parodying the war comics of their youth. After victory in the Falklands, Thatcher was unstoppable in the 1983 election, and she proceeded to lurch further to the right. Would new Labour leader, plucky 'Taffy Kinnock', and his band of misfits stop Herr Thatcher? Definitely not. Kinnock was joined by MPs Eric Heffer, Roy Hattersley (caricatured with a turban because of criticism that he was pandering to ethnic minorities in his constituency) and Tony 'Barmy' Benn. Monty Stubble's epitaph on his death read 'I was Monty Stubble'.

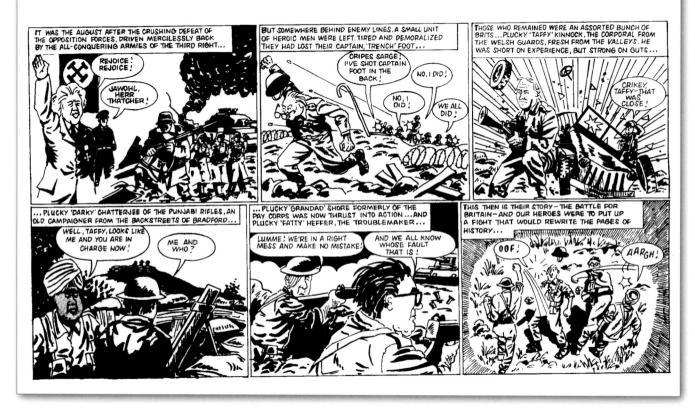

"... and this time get it right!"

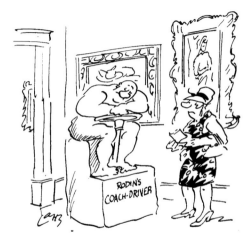

CLUFF – or John Longstaff – is another of the Northern School of cartoonists. Rarely seen south of Watford, Cluff was born in Darlington in 1949 and studied graphics at Teesside College of Art before working in local government and becoming a full-time cartoonist and artist in 1982. As John Longstaff, he is a much-exhibited painter.

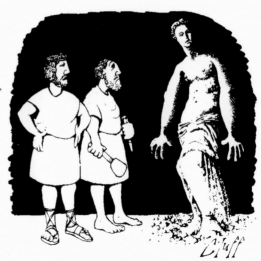

"Knock the arms off, and I'll give you 50 drachma for it"

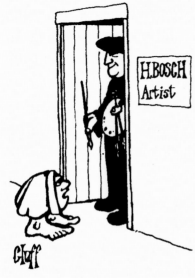

"The model agency sent me"

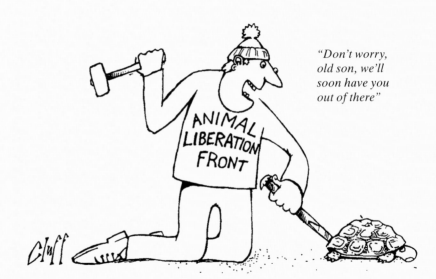

"Don't worry, old son, we'll soon have you out of there"

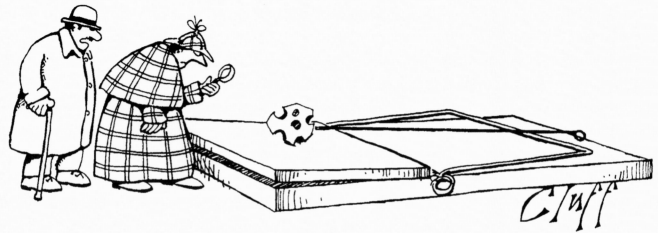

"Careful, Holmes, it may be a trap"

Lady Diana Spencer
Was not a member of Mensa.
Had she been brighter
She wouldn't have married the blighter.

CLERIHEW CORNER
Occasional series written by readers and
illustrated by Mikki Rain.

"The new manager is quite a 'go-getter', isn't he?"

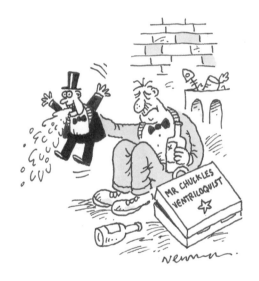

*"Sorry I snapped before, dear. I think it was a
touch of pre-minstrel tension"*

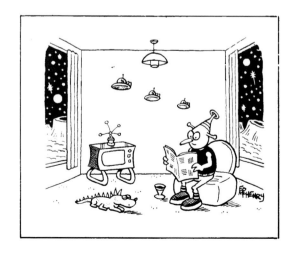

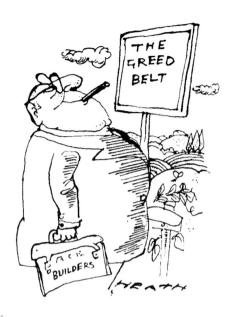

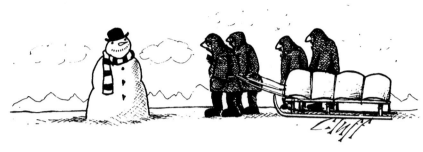

"I'm afraid Amundsen's beaten us to it"

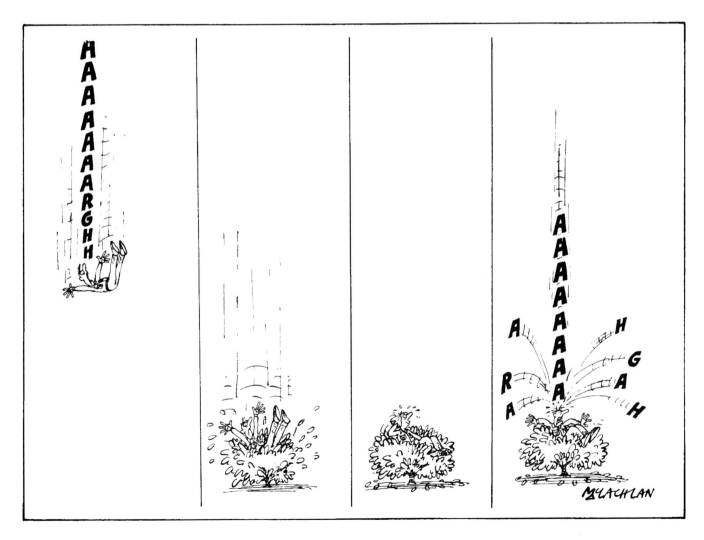

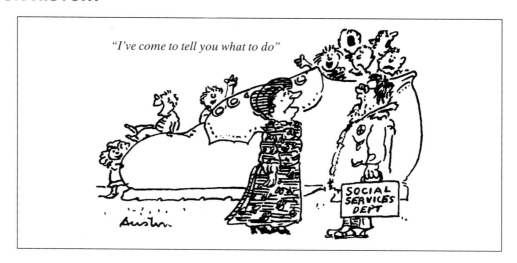

"I've come to tell you what to do"

"Hello, Samaritans?"

"Typical! You wait ages for Godot, then three come at once!"

"Her ladyship's dead, then"

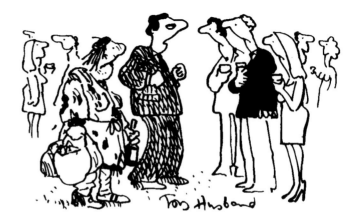

"Call my wife a tramp, would you, Batley?"

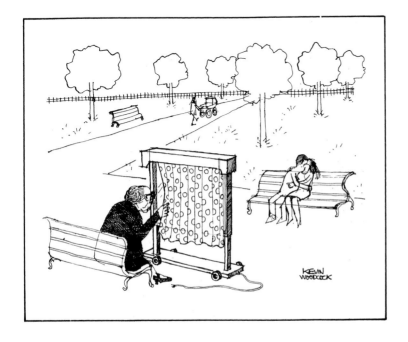

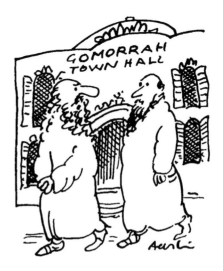

"I think we'll regret twinning with Sodom"

CAPT. BOB

In the mid- 1980s Robert Maxwell had bought the *Daily Mirror* and was about to launch the ill-fated *London Daily News*. At the *Mirror*, his crew included editor Mike Molloy (the parrot), Paul Foot, Joe Haines, Ann Robinson and Keith Waterhouse. When Capt. Bob finally fell off his yacht, *Guardian* hack Michael White's joke 'Capt Bob bob bob' earned him a punch from Alastair Campbell.

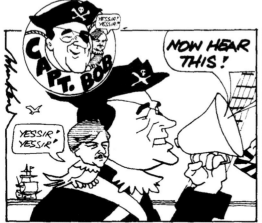

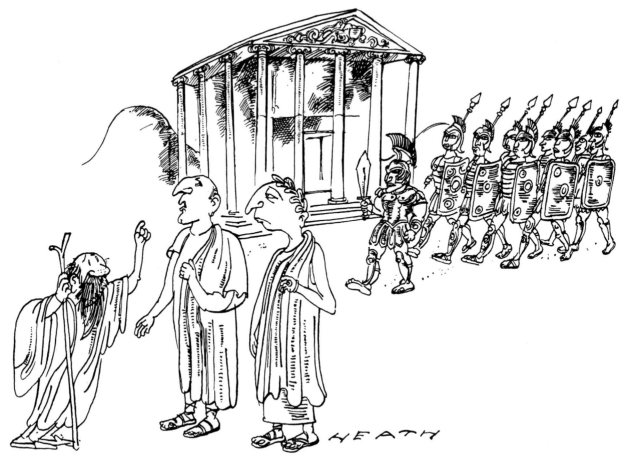

"Beware the march of AIDS"

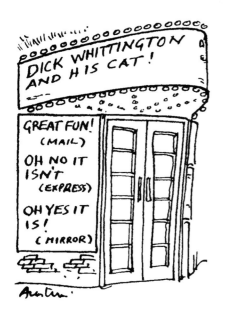

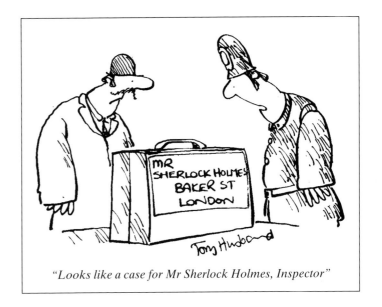

"Looks like a case for Mr Sherlock Holmes, Inspector"

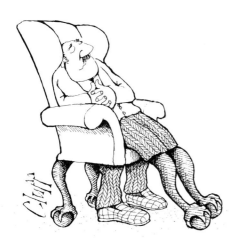

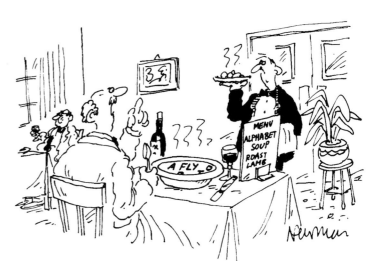

"Waiter . . ."

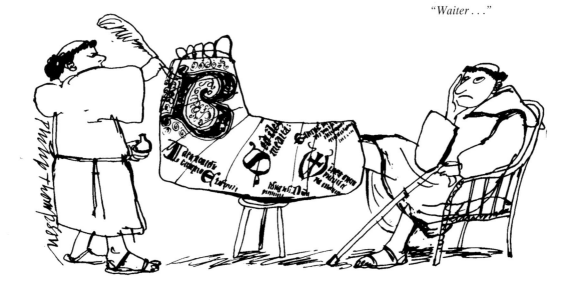

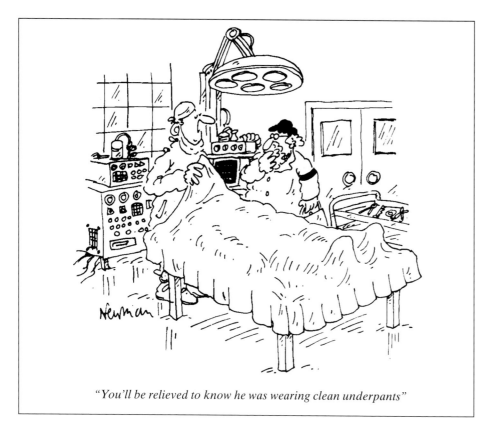

"*You'll be relieved to know he was wearing clean underpants*"

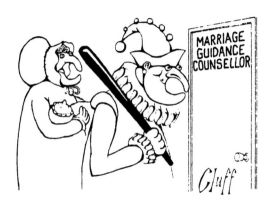

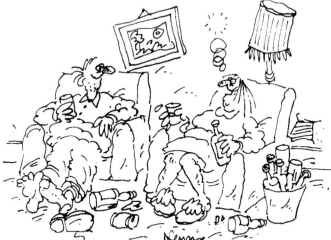

"Darling – marvellous news! I'm drinking for two!"

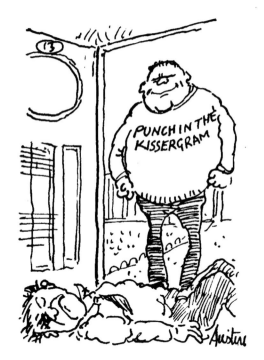

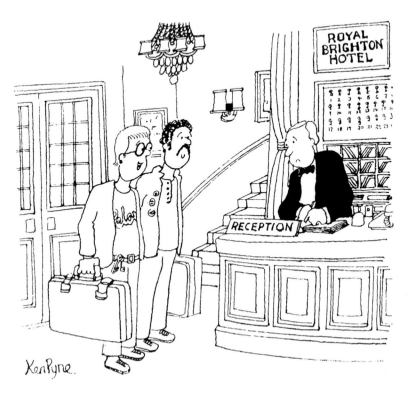

"Mr and Mr Smith"

WORZEL GUMMIDGE

John Kent perfectly captured new Labour leader Michael Foot in this parody of the popular children's TV show about a living scarecrow. Foot's hopeless leadership was marked by attacks on his sartorial style as much as his increasingly irrelevant left-wing politics. Here, mineworkers' union leader Arthur Scargill and Clive Jenkins of the ASTMS (*Association of Scientific, Technical and Managerial Staffs*) help tee up the punchline.

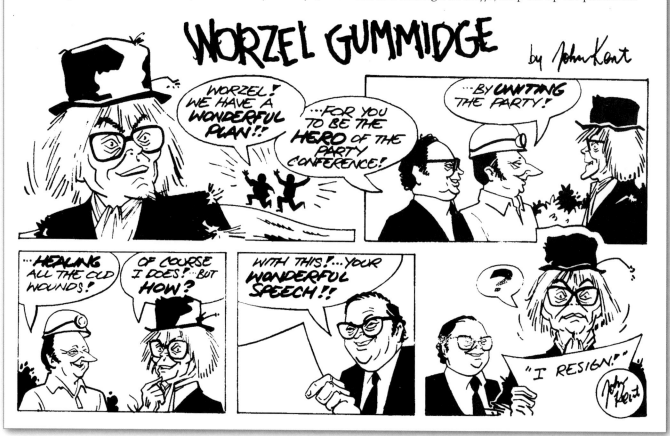

"They do a very good Ploughman's Lunch"

"Mrs Grimshaw? Here's your dicker balgsos."

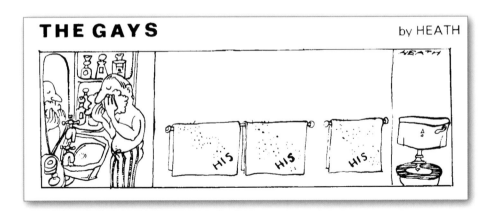

"These are the runners-up in the Pharaoh Tomb competition"

NB Neil Bennett taught English for 23 years before becoming a cartoonist. 'I tried when I was 18, was turned down and gave up until I was in my forties,' he recalls. In 1987, at the age of 46, he finally resigned to concentrate on cartooning. Born in 1941, the son of a headmaster, he read English at King's College London. His precisely drawn and often extremely literate cartoons bely his admiration for the *Beano*'s *Bash Street Kids* – 'A real work of genius'.

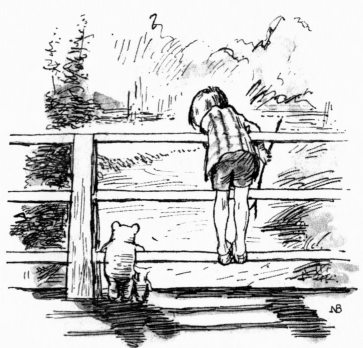

"I'm afraid he's got Odes, Mrs Keats"

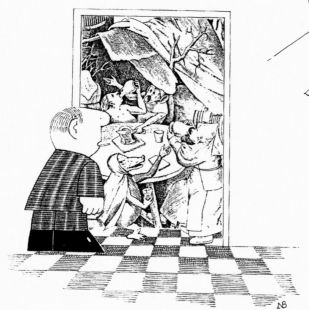

"Excuse me, is this Alcoholics Hieronymus?"

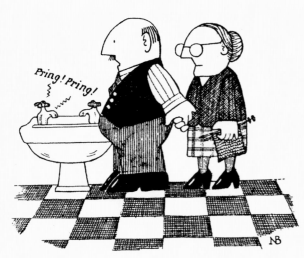

"Our tap's been phoned!"

"I'm fed up with Poohsticks. Let's go down the arcade and get ourselves tattooed"

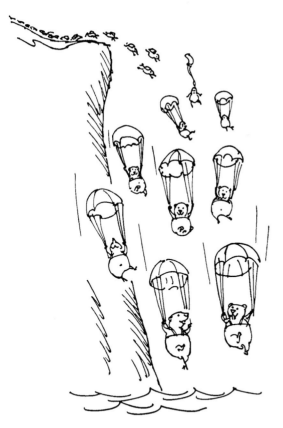

"That's the World Wildlife Fund for you!"

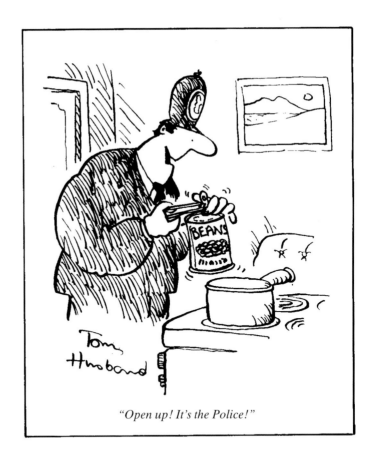

"Open up! It's the Police!"

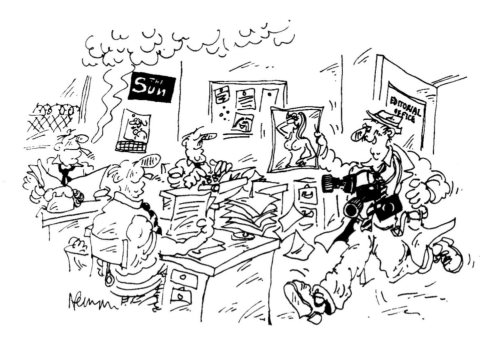

"Hold the third page"

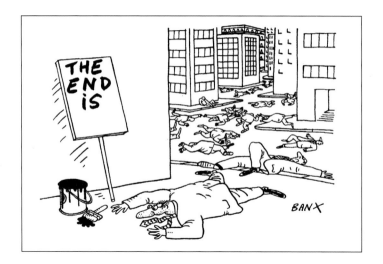

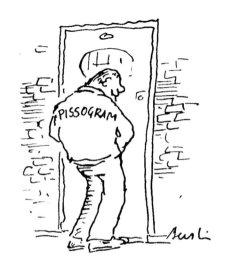

"Enjoy your trip to the circus?"

"OK. That's sorted out the homosexuals, now let's have a go at Estate Agents"

"Smoking or non-smoking?"

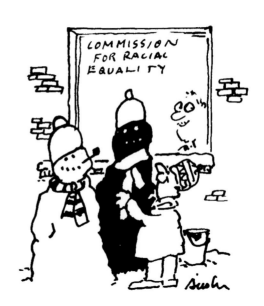

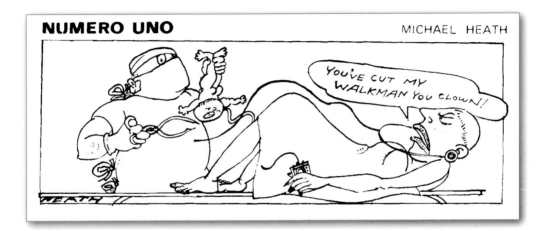

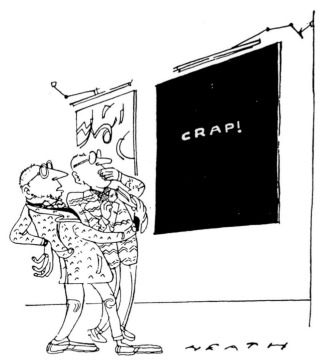

"What does it say to you?"

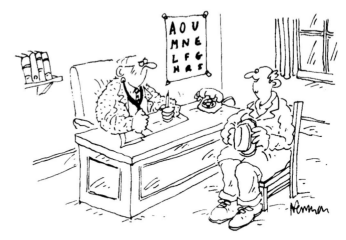

"This hypochondria – can you give me something for it?"

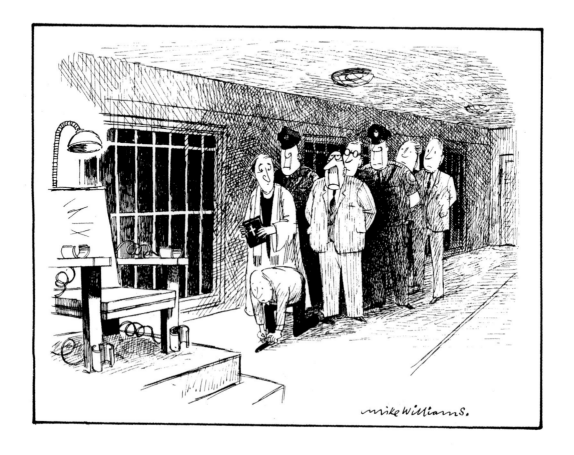

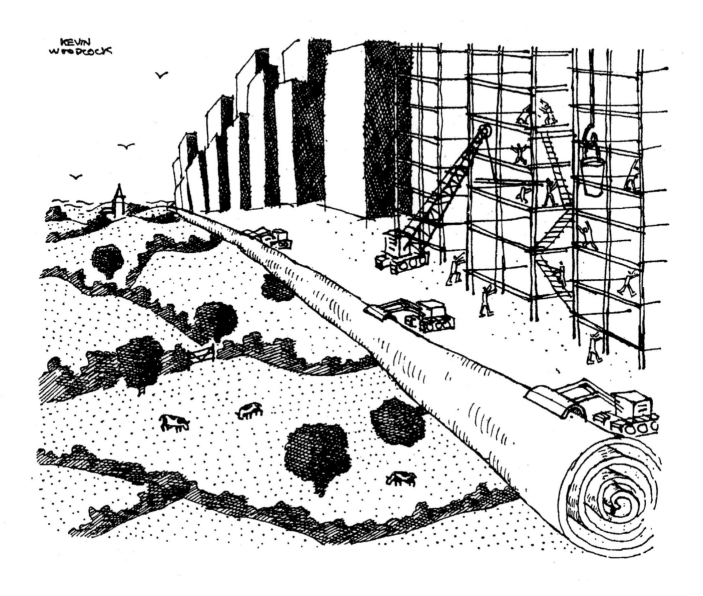

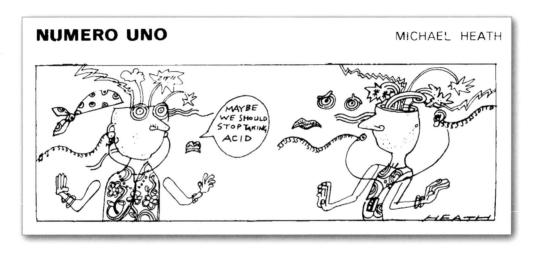

NUMERO UNO

MICHAEL HEATH

"Not another bloody sequel!"

"Yes, they did offer me a hook but I though an egg whisk would be more useful"

"It's something I'm saving for a rainy day"

"I'm the first surrogate Mother Superior!"

"I think it's only fair to tell you – I'm a notorious bedwetter"

"I swore I'd make him do something useful around the house some day,
so I put his ashes in the egg timer"

"Well, **somebody** has to tell him he's past it"

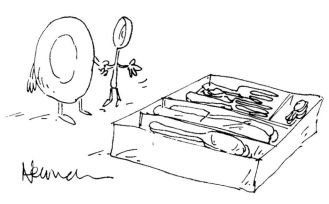

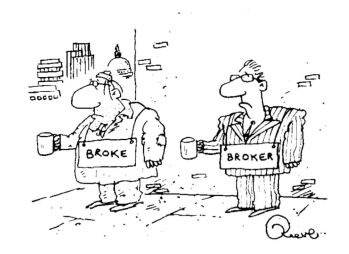

"I'd like you to meet the rest of my family"

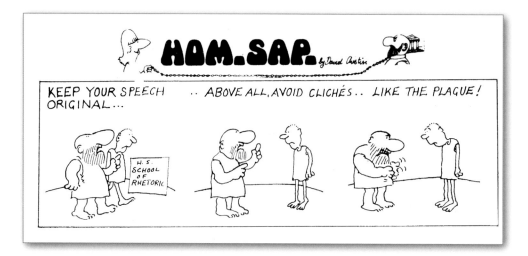

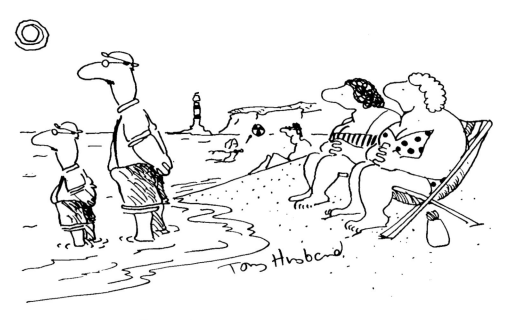

"Young Willy's very much like his father, isn't he?"

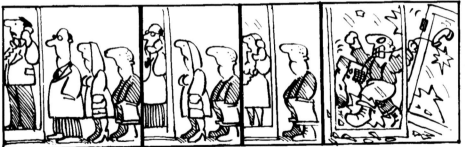

HUSBAND

YOBS Tony Husband's strip, based on his experience of being beaten up, has lasted 28 years and is still going strong. Very popular in Germany.

"It's his 'more socialist than thou' attitude that I can't stand!"

"You might as well get mother out now as well"

"I told you complaining to the chef would be pointless!"

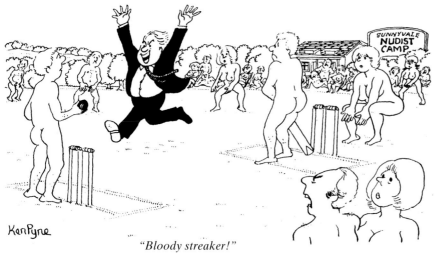

"Bloody streaker!"

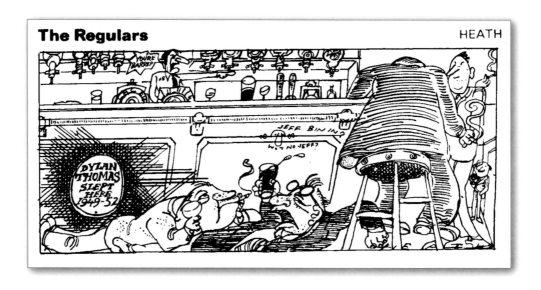

"Hello, I'd like to report an accident"

"Let me through – I'm the story after the break"

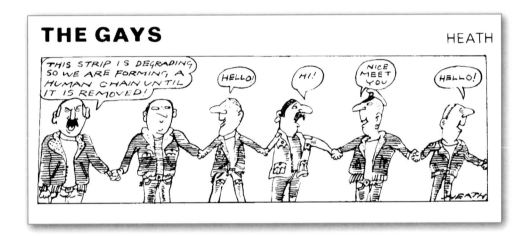

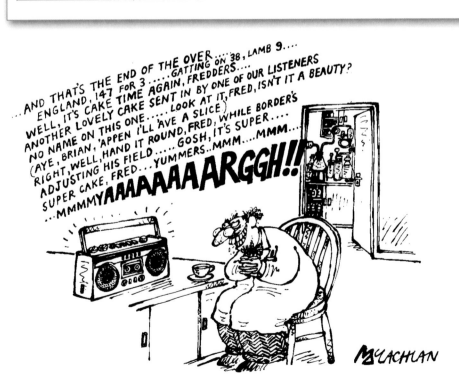

"Er . . . Hello, Goldilocks,
I'm Mother Bear's lover . . ."

"We got four pickpockets and an unlicensed
Punch and Judy show"

"Take an epistle to the Thessalonians, Miss Jones"

CELEB

Drawn by Charles Peattie and co-written by Mark Warren, *Celeb* charts the life and times of ex-rock star Gary Bloke and his family – wife Debs and children Pixie Frou-Frou, Rose-Drop Bunny-Petal and Troy. Any resemblance to rock stars living or dead is completely intentional. Peattie and Warren began collaborating on the cult strip *Dick*, which appeared in *Melody Maker*. Peattie studied at St Martin's School of Art before becoming a portrait painter, whilst Warren worked in advertising. Charles Peattie also co-created the *Daily Telegraph*'s '*Alex*' cartoon strip. Pete Townshend once wrote a letter of complaint to *Private Eye* when *Celeb* failed to appear (Peattie and Warren had forgotten the deadline). *Celeb* became a celeb in its own right as a BBC sitcom, starring Harry Enfield and Amanda Holden.

Celeb

LIGGER

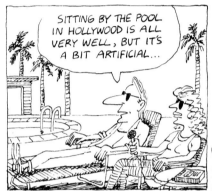
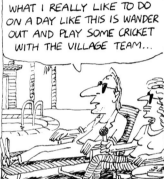
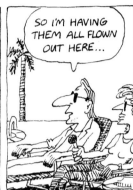
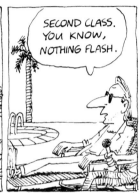

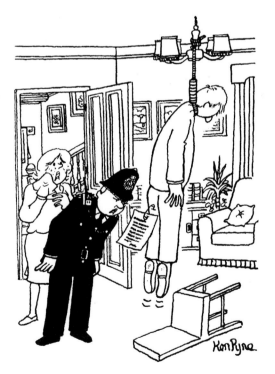

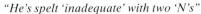
"He's spelt 'inadequate' with two 'N's"

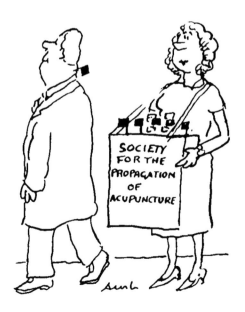

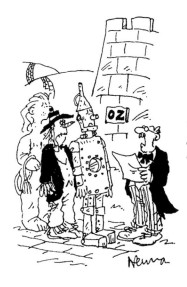

"I'm afraid there's a waiting list for heart operations"

"We're thinking of organising a famine to help ageing rock stars"

The Regulars HEATH

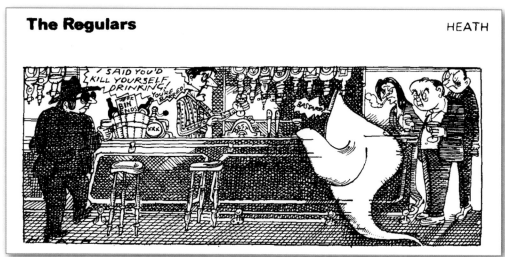

CORPORATION STREET

Ken Pyne's media cartoon soap opera featured the BBC bigwigs and pen-pushers of the day – Michael Checkland, Duke Hussey, John Birt and Paul Fox. The challenge from Rupert Murdoch's SKY TV had already begun.

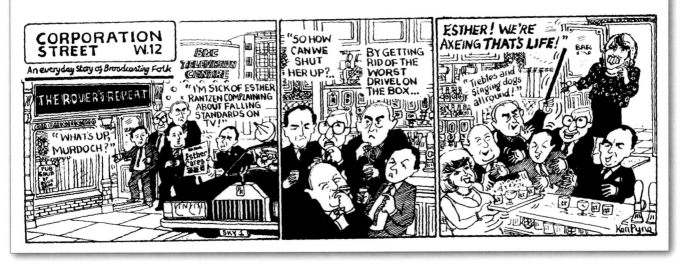

"I think you've got him beat"

"I'm going to sue that computer dating agency"

GREAT BORES OF TODAY

'Alternative' comedians and stand-up comedy were all the rage in the 1980s – and the loudest and most annoying of all was Ben Elton.

Great Bores of Today

" . . . good evening . . . all right . . . OK . . . yeah . . . well . . . Mrs Thatcher . . ! right know what I mean . . ? this is a live show OK . . . so here goes . . . why are the police like turds . . ? cos they are turds . . ! Ha Ha . . . what's the matter . . . all SDP are we . . ? can't laugh at the police . . ? OK . . . right . . . bit wishy washy . . ? know what I mean . . . seen that advert on the telly . . . nuclear family buys washing up liquid . . . sexist . . . all right . . . Thatcher . . ! seen that other ad on the telly . . . Rupert Murdoch . . . right . . . OK . . . starving people to death . . . give him a knighthood Thatcher . . ! Bastard . . . OK . . . any blacks in tonight right . . ? OK! it's a live show . . . OK . . . that'll show the middle classes . . . bastards . . . still not laughin then? bit liberal are we . . . too much politics for you right see that ad on the telly where the bloke wakes up to find a bloody helicopter overhead? OK know the one . . ? yeah, that'll happen in Thatcher's Britain . . . all right . . . still not laughing never mind Rik Mayall's on in a minute . . . don't forget goodnight I'm a socialist God bless . . . keep humour out of sexism God bless goodnight all right . . ."

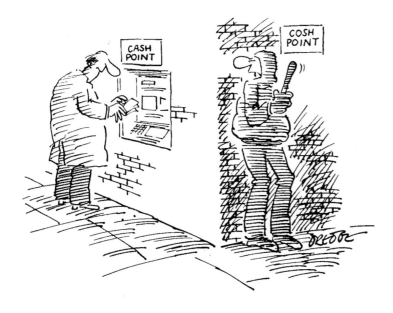

"It's nice out – let's go and stop someone doing something"

"Oh no! The Cow's burning up on re-entry!"

NEWMAN

Nick Newman was a business journalist on *Management Today* before getting published in the *Eye*. Born in 1958 and a contemporary of Ian Hislop's at Ardingly College, he drew for school and university magazines before selling gags to *Yachting Monthly*. Years of rejection ended when he finally had a drawing accepted by the *Eye*. 'I think Ian and I reminded Richard Ingrams of himself and Willie Rushton,' he says. Strip cartoons and a plethora of parodies followed, collaborating with Hislop both in the *Eye* and on iconic 1980s TV puppet show *Spitting Image*; many other subsequent TV and radio shows followed. Self taught and inspired by *Tintin*, and *War Picture Library* comics, he now co-writes the *Eye*'s joke pages and covers.

"Aye, hovermowers have a lot to answer for"

"Miss Trilby, I'm beginning to suspect there's a mole somewhere in the organisation . . ."

"Root of hemlock digg'd i' the dark, liver of blaspheming Jew, gall of goat, E202 . . ."

"We'll start with a round of general knowledge questions"

"I'm sowing my wild oats!"

"It's all changed since Dr Frankenstein went private"

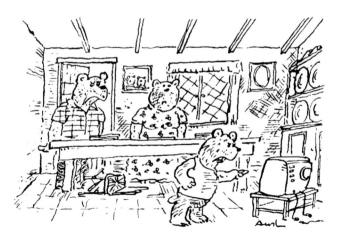

*"Never mind the porridge.
She's taken the video"*

"I'm afraid you've got footrot"

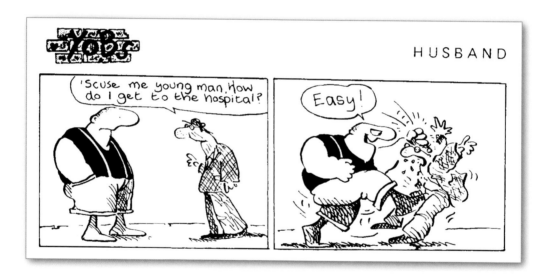

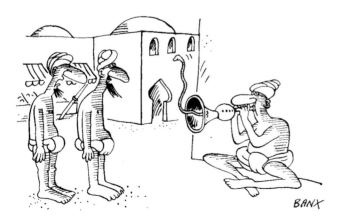

"I still say performing with a tapeworm is disgusting"

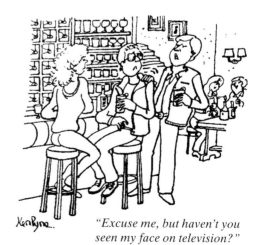

"Excuse me, but haven't you seen my face on television?"

SNIPCOCK & TWEED

Started off life as *Feeble and Feeble* in the *Literary Review* magazine, written and drawn by Hislop and Newman. When Auberon Waugh became editor of that title, Ingrams started up his own *Literary Review* and poached the strip – turning it into the *Eye*'s hopeless publishers *Snipcock & Tweed*. Snipcock bears more than a passing resemblance to Tom Rosenthal of Andre Deutsch, while Tweed bears all the tweedy hallmarks of Richard Ingrams.

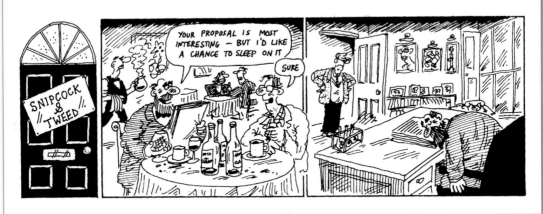

"Good morning, Mr Sigsworth, I'd like to talk to you about the Bible"

"The moon's always been a bit of a bugger"

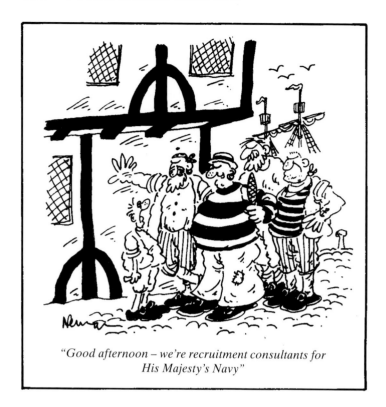

*"Good afternoon – we're recruitment consultants for
His Majesty's Navy"*

"I can get you onto Page Three of the Bible"

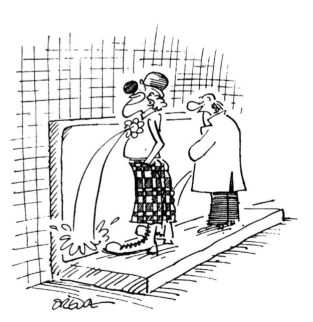

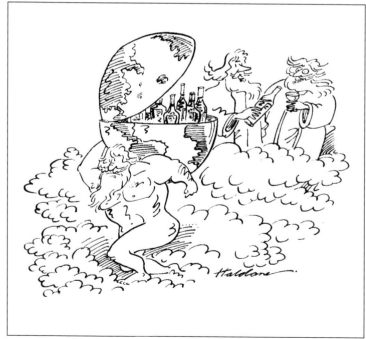

"It's desperate, sir – we're down to our last poet!"

"What's the matter with you? Haven't you seen a chartered accountant before?"

DAN DIRE

Based on the *Eagle*'s space hero Dan Dare, Hislop and Newman's sci-fi parody followed Labour leader Neil Kinnock in the disastrous aftermath of the 1987 election. With trusty sidekick Pigby (Roy Hattersley), he battled the evil Maggon, to no effect. Other equally useless characters were the Waste-Of-Time-Lord Dr Whoen (David Owen) and Blubba the Gutt (Chancellor Nigel Lawson, pre-diet).

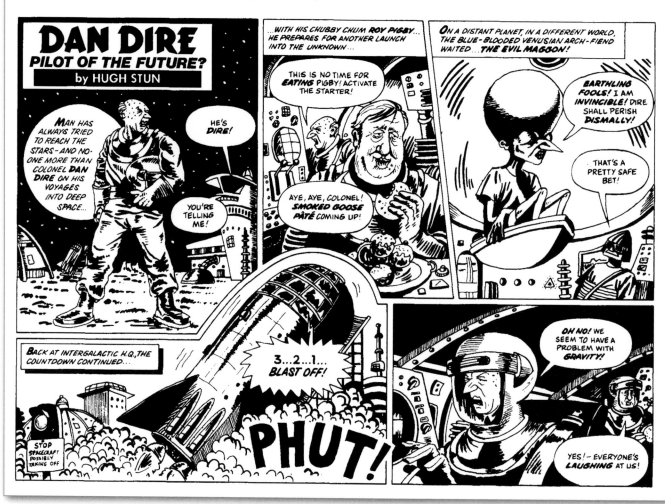

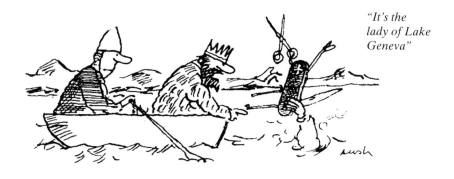

"It's the lady of Lake Geneva"

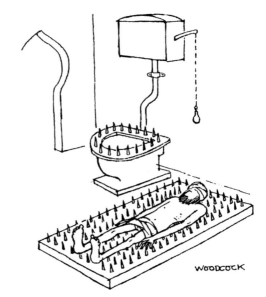

KJ LAMB

KJ Lamb is that relatively rare species – a female cartoonist. Kathryn Lamb was born in 1959, the daughter of the former British Ambassador to Kuwait and Norway. Lamb began drawing for student newspapers at Oxford before getting published in the *Eye* while still at university. Her whimsical strip *Lord Arthur And His Square Table* ran from 1979 until 1986. She also illustrated *Pseuds Corner (right)* and the *Sally Deedes* consumer column *(far right)*. More recently she has blossomed as a topical cartoonist. Her sister worked in Downing Street under Margaret Thatcher, and her nephew George Leigh (GL) now draws caricatures for the *Eye*.

LORD ARTHUR AND HIS SQUARE TABLE

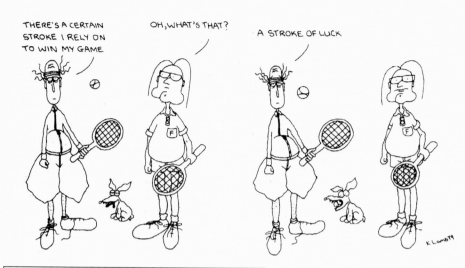

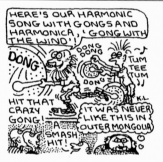

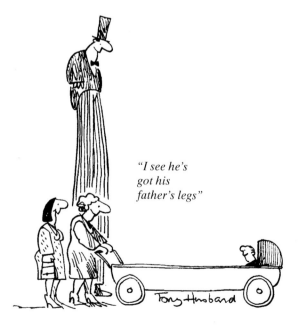

"I see he's got his father's legs"

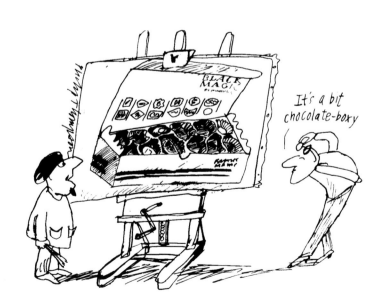

It's a bit chocolate-boxy

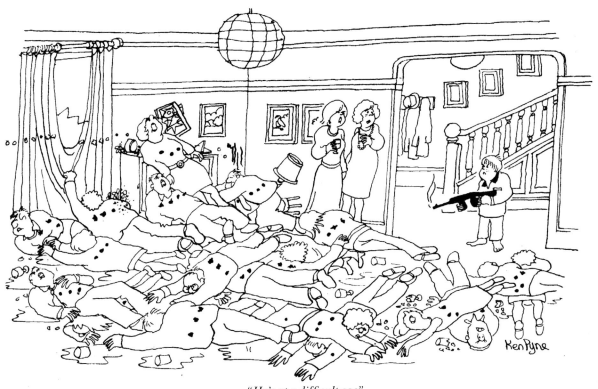

"He's at a difficult age"

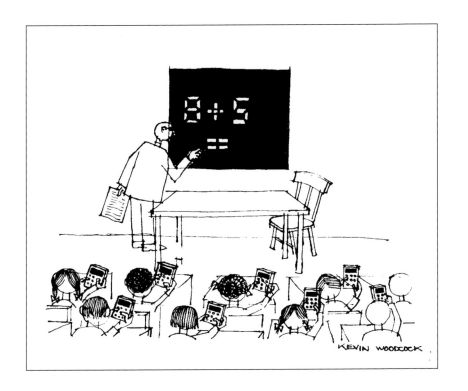

*"Looks like we're in
Beatrix Potter country"*

"Have you considered double glazing?"

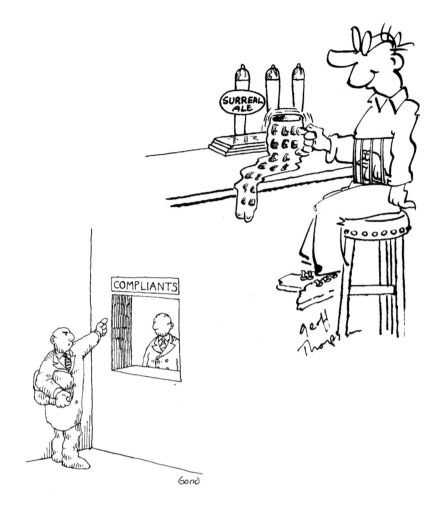

LORD ARTHUR AND HIS SQUARE TABLE

A WATCHED POT NEVER BOILS

STAND UP BILLY BUCKITT

Bill Tidy's last hurrah for the bygone world of northern club comedians – battling the inexorable spread of politically correct alternative comedy.

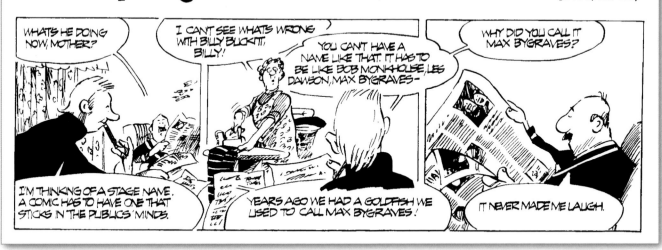

Stand up Billy Buckitt!

The story of Billy Buckitt's epic struggle to follow in the footsteps of Les Dawson and Bernard Manning . . . by Bill Tidy

"I must dash – I'm having a coronary at 3.30!"

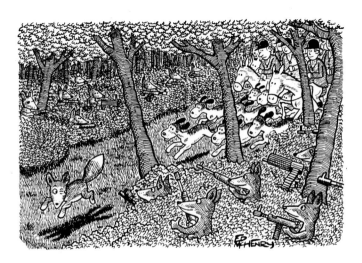

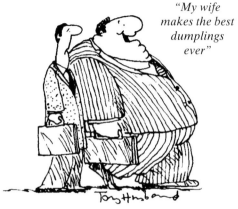

"My wife makes the best dumplings ever"

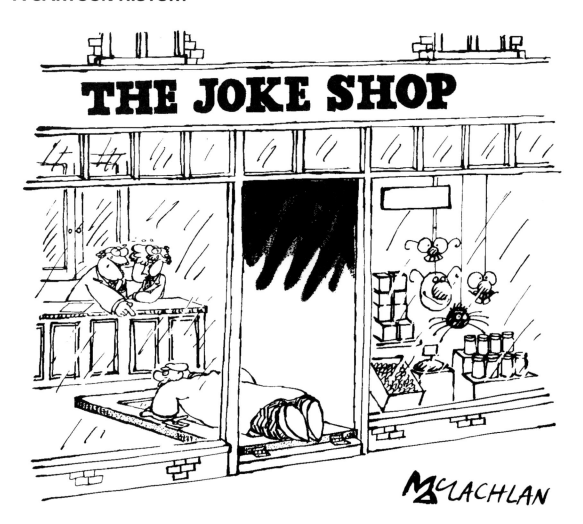

Majeux Tapestry
The Eve of the Battle of Hustings

Blairy **Batey** **Ginger** **Spoil-Sporty** **Posh**

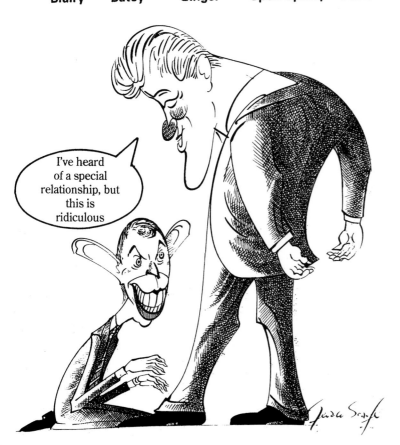

I've heard of a special relationship, but this is ridiculous

THE 1990s

As the first Gulf war heralded the 1990s, the grim reaper worked overtime throughout the decade, as Princess Diana joined Peter Cook, Willie Rushton and John Wells in the queue for the pearly gates. Meanwhile, the death of *Punch* magazine in 1992 saw a huge boost in cartoons in the *Eye*, as artists recognised there was no better showcase for their work. *Punch*'s Mike Williams was a noteworthy addition to the growing list of *Eye* regulars, joining new talent such as Pilbrow, the Thompson twins Robert and Geoff (no relation), Tony Reeve, Mike Barfield, RGJ and Kerber. The ousting of Margaret Thatcher as Tory leader and Prime Minister in 1990 failed to ignite a Labour revival. John Major was Glad to be Grey, as Britain drowned under a flood of mobile phones, mad cows, genetically modified crops, hosepipe bans, quangos, Viagra and lottery tickets. With the departure as Labour leader of Welsh windbag Neil Kinnock and the arrival of the people's premier Tony Blair, New Labour finally triumphed in 1997 – ending 18 years of Tory rule. For a fleeting moment, Britannia was cool. The disenchantment that quickly followed was reminiscent of the 1960s. Could things only get better? No.

The Death of Diana

*"I warn you – I'm a unit trust manager.
Things can go down as well as up"*

*"Viewers are warned that the next programme
has the word 'fuck' in it"*

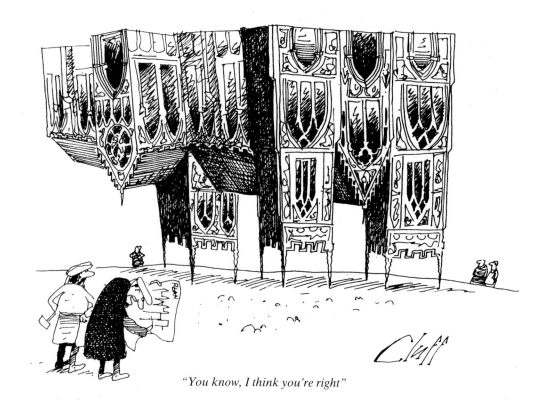

"You know, I think you're right"

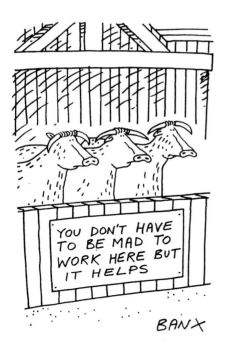

"Put 'em with the rest, then pop and fetch Inspector Morse out of the Lamb & Flag"

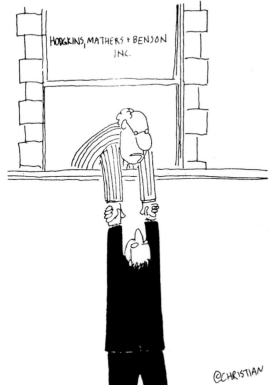

"I'm afraid we're going to have to let you go, Perkins"

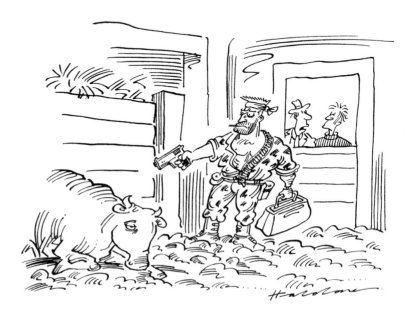

"He's a Vietnam vet"

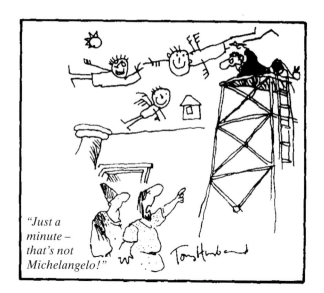

"Just a minute – that's not Michelangelo!"

"Damn it, batteries in the wrong way round!"

"And this is another one of us hunting . . ."

"I think I'll go mad and have the beef!"

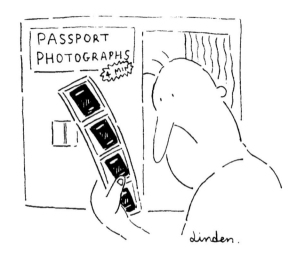

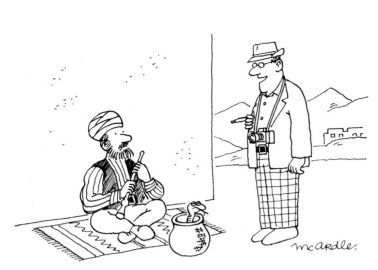

"The music was very good except for the background hiss"

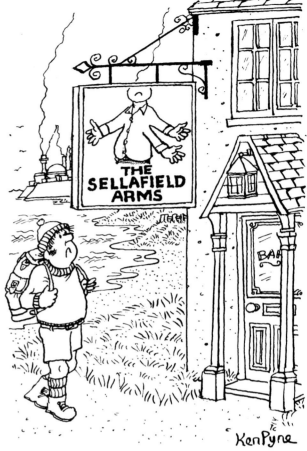

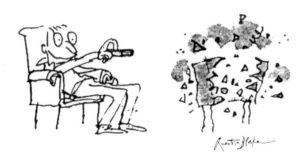

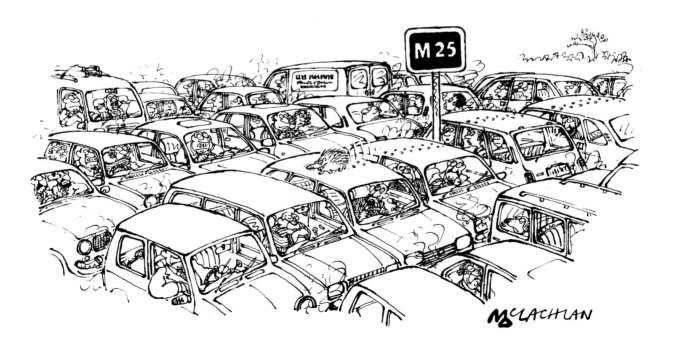

"Oh my God! We've had the police!"

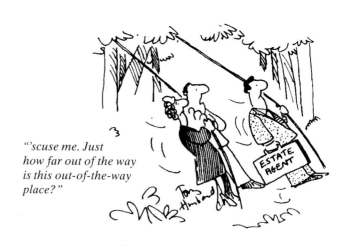

"'scuse me. Just how far out of the way is this out-of-the-way place?"

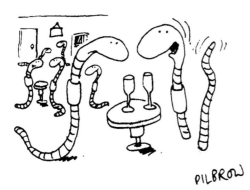

"Let me introduce my other half"

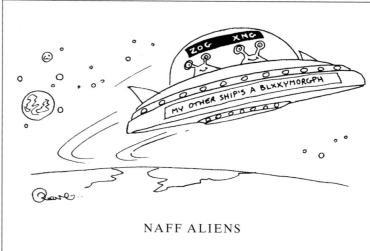

NAFF ALIENS

"You've swallowed a fly, perhaps you'll die"

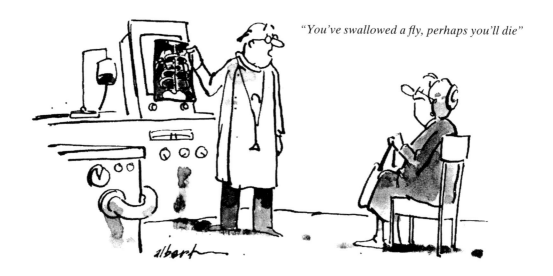

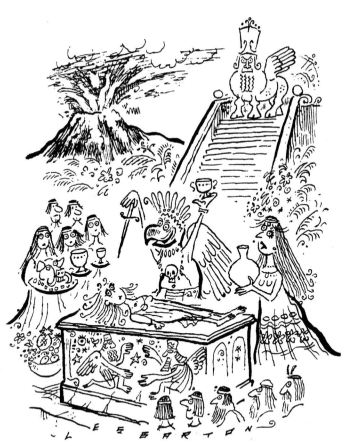

"*I suppose you know you spoil that god!*"

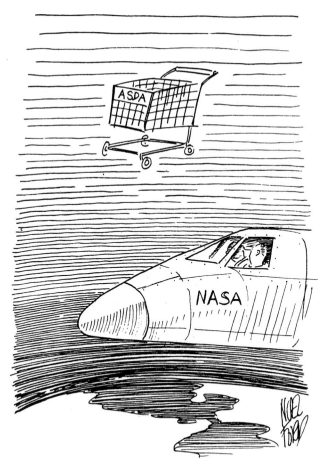

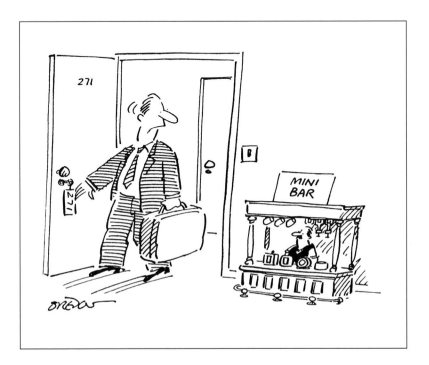

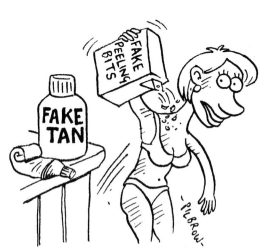

PILBROW

Giles Pilbrow was educated at Oxford before contributing to student magazines – and then the *Eye*. He quickly established a reputation as a versatile gagster and writer – taking over as producer of *Spitting Image* while still being potty-trained. He went on to form his own production company, producing satire cartoon show *2DTV* (using many of the *Eye*'s cartoonists) and winning a BAFTA for the TV version of *Horrible Histories*. He continues to write for programmes like *Have I got News For You*, while producing his own shows. Luckily, such distractions have not stopped him contributing to the *Eye* regularly – as both a cartoonist and writer.

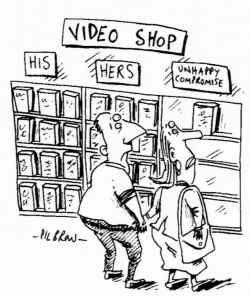

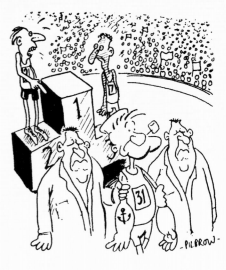

"They found traces of spinach in his sample"

"Are we there yet, Daddy?"

Public Swimming Pool Lanes

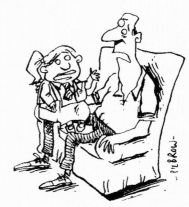

"Is this birds and bees chat going to take long? I'm late for my pre-natal class"

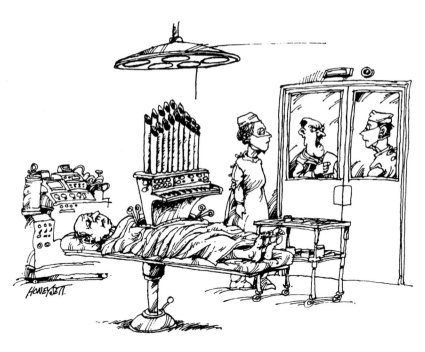

"We've had complaints about your organ transplants"

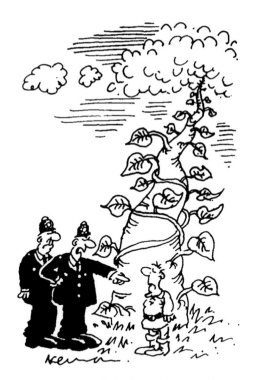

"Hosepipe Squad, Jack – you're nicked"

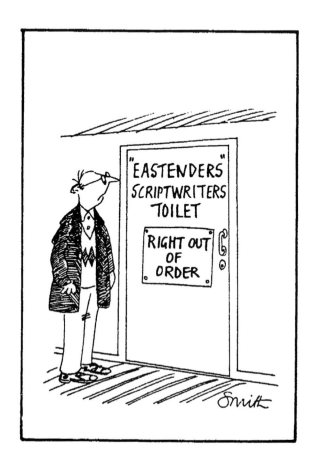

"They say the first quarrel is always the worst!"

"*Forget the critics, Max! You're a damn fine illusionist*"

"*Is that a multiphase destructor or are you just pleased to see me?*"

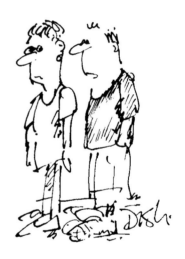

"*I would have passed my history exam – but I got the date wrong*"

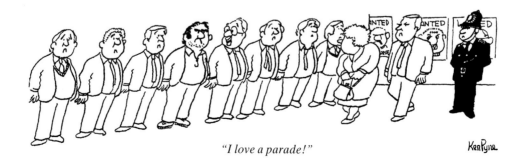

"*I love a parade!*"

MEN BEHAVING BADLY

The popular TV sit-com *Men Behaving Badly* spawned a host of groanworthy gags . . .

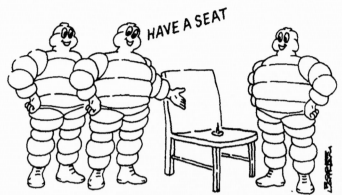

Michelin Men Behaving Badly

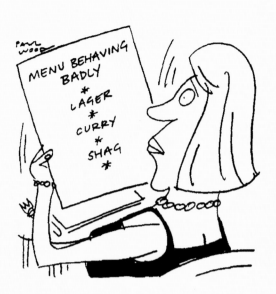

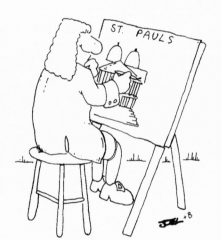

Wren Behaving Badly

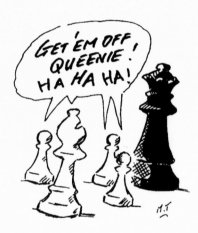

Chessmen Behaving Badly

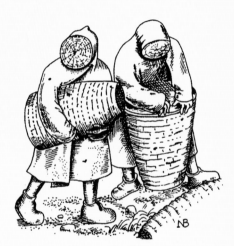

Bruegel's Men Bee-hiving Badly

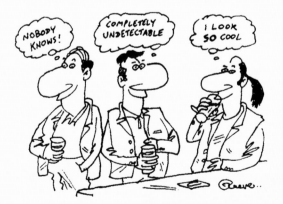

Men Behaving Baldly

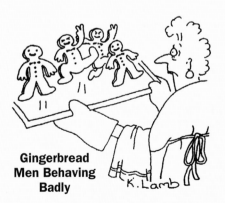

Gingerbread Men Behaving Badly

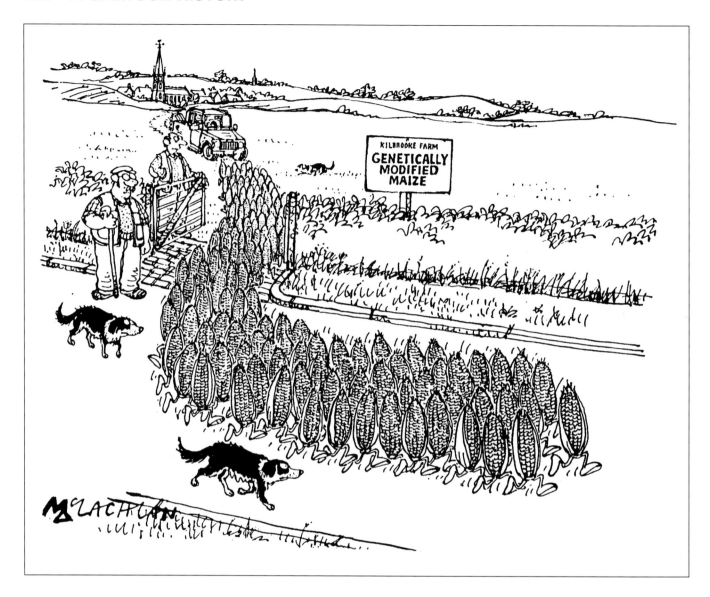

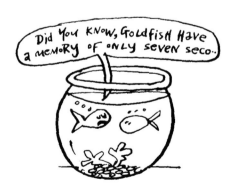

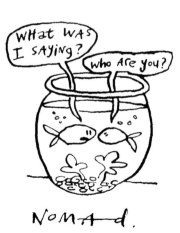

In Corporation Street, the BBC's new larger-than-life light entertainment boss Jim Moir was cracking down on bad language – as used by comedian Dave Allen.

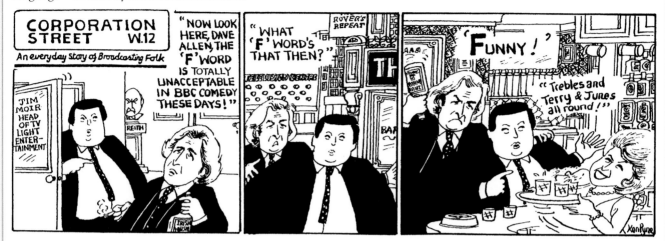

Ken Pyne continued by attacking Princess Diana's notorious *Panorama* interview with Martin Bashir – in which she broke the Royal taboo about talking about one's private life. Alan Yentob was suitably grateful.

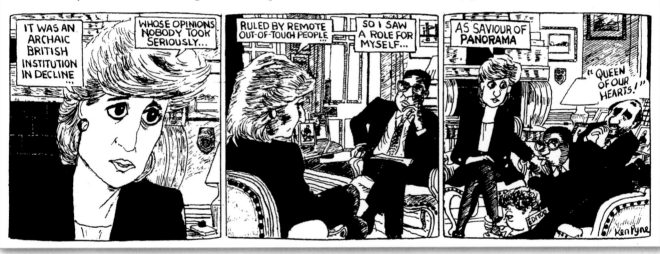

"Women! They're all alike!"

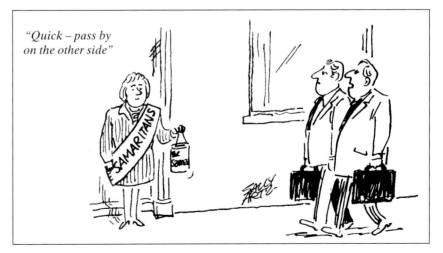

"Quick – pass by on the other side"

NUMERO UNO

MICHAEL HEATH

"The lack of tourists has driven him to it"

"My other wives don't understand me"

"Don't tell me, Old Macdonald, you've got all the vowels"

ROBERT THOMPSON

Robert Thompson specialised in illustration at art school before working at Camden Graphics greetings cards for 15 years. Born in 1960 and one of the *Eye*'s most inventive and elusive cartoonists, he works from home in Somerset, rarely comes to London and shares his office with a Jack Russell terrier called Trudy. When not busy avoiding social events organised by his wife, his creativity extends to growing vegetables (presumably of the amusing variety).

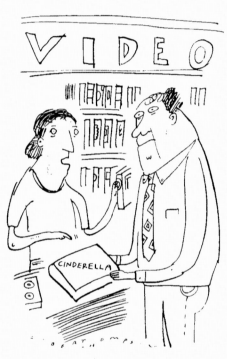

"Dad – what's a clone?"

"It's all rubbish – my old man smoked 300 a day, and he lived to be seven"

"... and that one's got to be back before midnight"

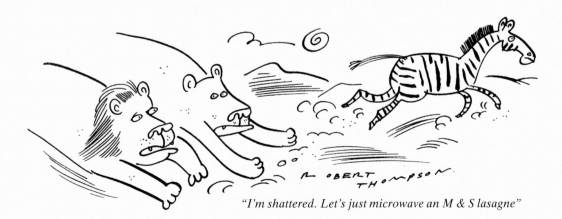

"I'm shattered. Let's just microwave an M & S lasagne"

THE DIRTY DIGGER

John Kent's strip was one of many he drew attacking press barons. Here, born-again Rupert Murdoch appoints *Telegraph* Chief Executive Andrew Knight as Chairman of News International.

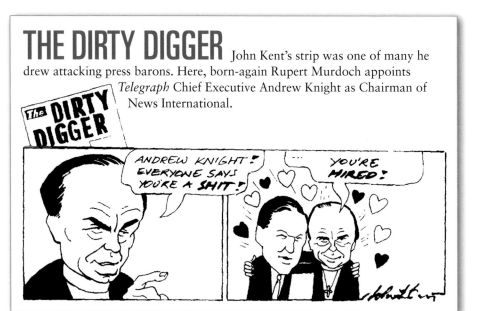

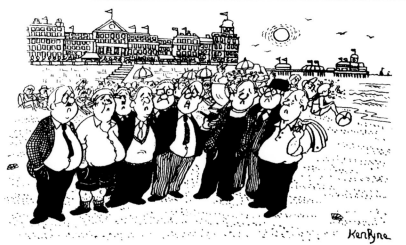

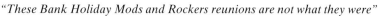

"These Bank Holiday Mods and Rockers reunions are not what they were"

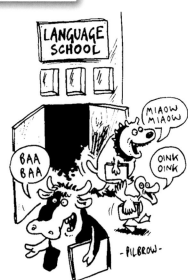

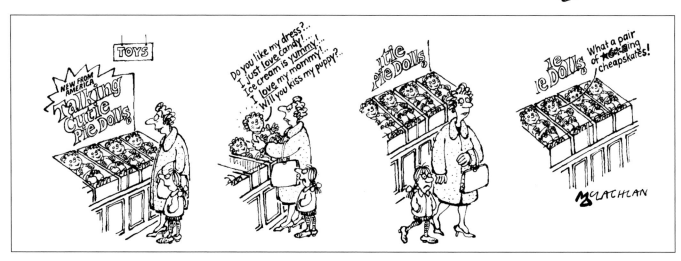

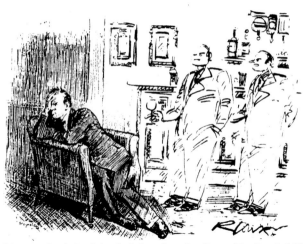

"No wonder he's sick – he's just drunk a litre of Indian ink!"

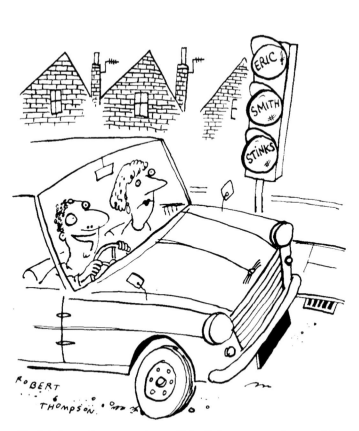

"Isn't it funny how sometimes all the lights seem against you?"

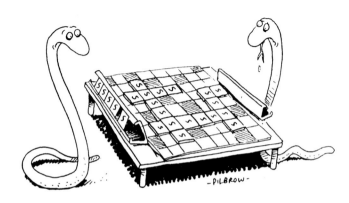

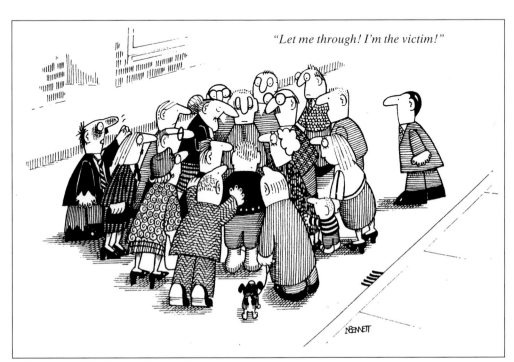

"Let me through! I'm the victim!"

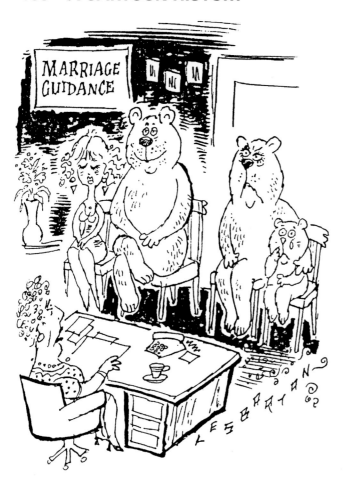

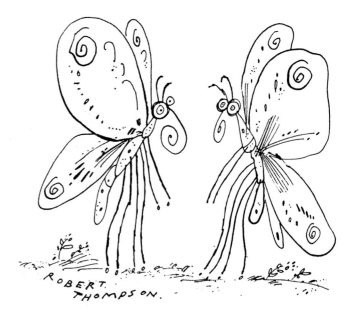

"Hi, what's your name, Happy Birthday, I love you,
let's have children, goodbye"

"I'm not Dr Jekyll – I'm Mr Hyde the accountant"

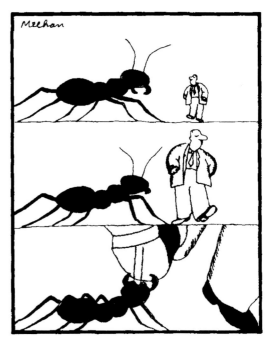

BY THE TIME THE ANT UNDERSTOOD THE RULES
OF PERSPECTIVE, IT WAS TOO LATE

QUENTIN TARANTINO
Directing prodigy Quentin Tarantino burst on to the Hollywood scene with his *uber*-violent and foul-mouthed classic *Reservoir Dogs*. The rest is effing history . . .

TINTIN TARANTINO

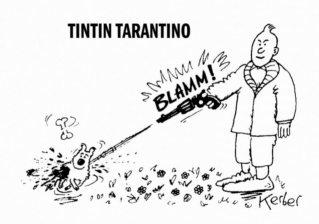

PHILIP LARKINTINO

THEY FUCK YOU UP, YOUR MUM AND DAD . . .

QUENTIN TARANTEATIME

"Shall I be motherfucker?"

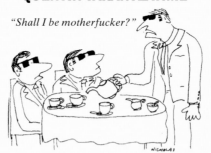

TARANTEENBAND

QUENTIN TARANTULA

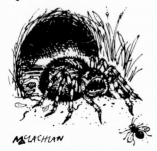

"Will you walk into my parlour, you fucking fuck?"

KEPT IN QUARANTINO

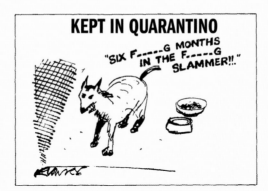

"SIX F-----G MONTHS IN THE F-----G SLAMMER!!"

IKE AND TARANTINO TURNER

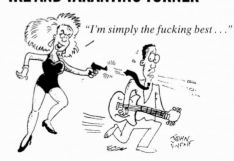

"I'm simply the fucking best . . ."

CHRIS TARRANTINO BREAKFAST SHOW

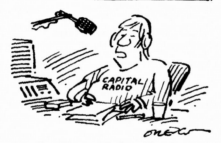

"Don't listen to fucking Chris Evans, you fucking fucks . . ."

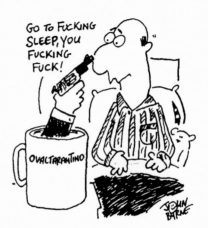

GO TO FUCKING SLEEP, YOU FUCKING FUCK!

DREDGE

Pete Dredge has worked for the *Eye* since 1977. Born in Nottingham in 1952, he was reared on the *Eagle* comic and the adventure strips of Frank Bellamy and Frank Hampson. He also wrote sketches for *Not the Nine O'Clock News*. Of his cartooning he says, 'Unfortunately I have no back-up career to fall back on. Please give generously.'

"Good morning, madam – Jehoover's witness"

"He's starting to talk, guv"

THE DIRECTORS

DREDGE

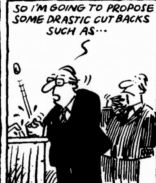
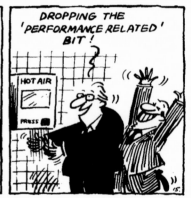

I FEEL OUR PERFORMANCE-RELATED PAY SCHEME NEEDS RE-THINKING ...

THE SHAREHOLDERS ARE DEMANDING WE TIGHTEN UP OUR WHOLE SALARY AWARD PROCEDURE ...

SO I'M GOING TO PROPOSE SOME DRASTIC CUT BACKS SUCH AS ...

DROPPING THE 'PERFORMANCE RELATED' BIT !

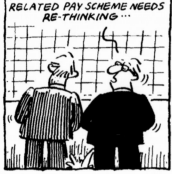
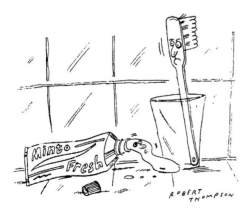

"Sorry I'm late, got stuck in the tube"

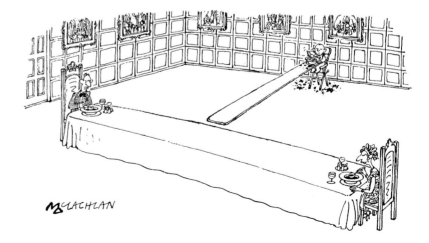

"I'm sorry, but we don't have facilities for the disabled"

"What would be its overall effectiveness against, say, the Anti-Christ?"

"This copier keeps chewing up paper"

DINOSAURS DIED OUT DURING THE PLATONIC PERIOD

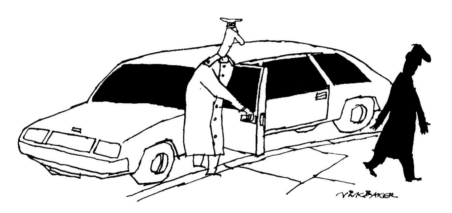

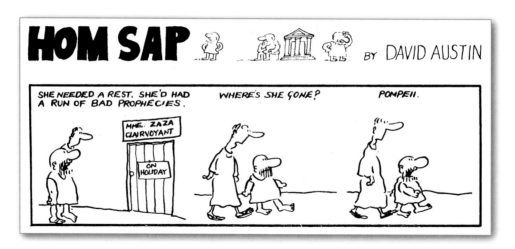

"Bill has managed to get it down to one a day"

"Do you mind if I go ahead of you? I'm bursting!"

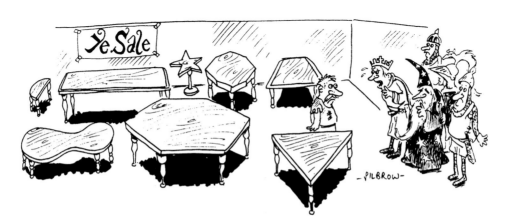

"We sort of had our hearts set on something round"

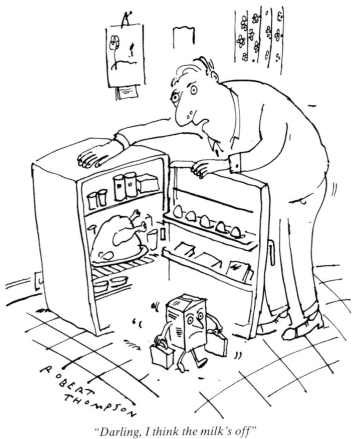

"Darling, I think the milk's off"

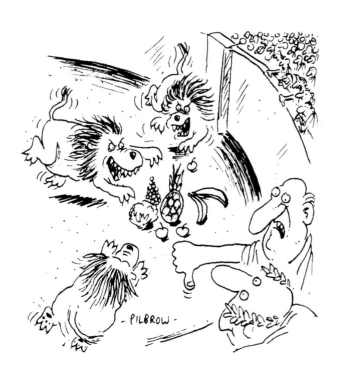

"Hello! Remember us? We met at St Tropez last summer and you said if ever we were passing your way we should look you up"

"Well, leave then, I don't care, because according to this letter from Reader's Digest, I might already have won £250,000"

"I preferred it before the lions went vegetarian"

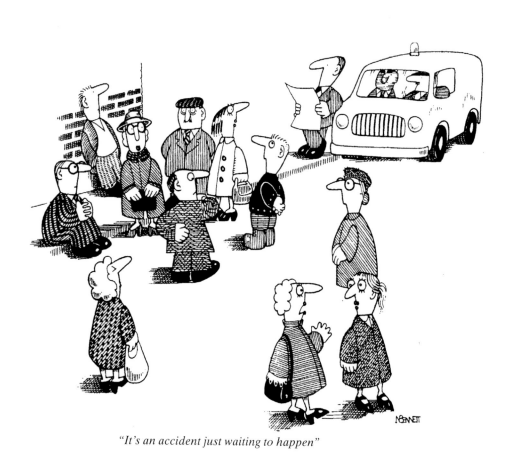

"It's an accident just waiting to happen"

"He's a solicitor"

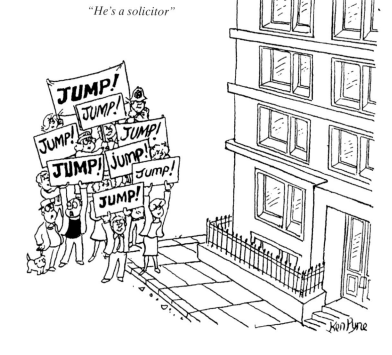

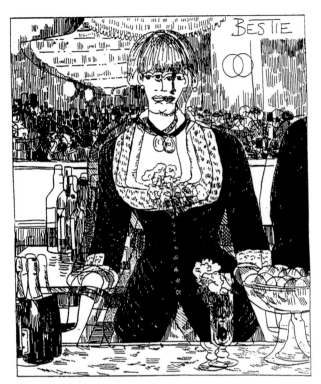

MANET MANAGED TO CAPTURE THE
EXPERIENCE OF PARISIAN BARS

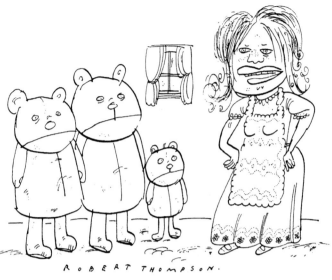

"Typical! You wait ages for a bear, then three come along at once"

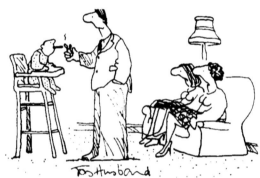

*"Nigel's one of the top salesmen at the
cigarette company"*

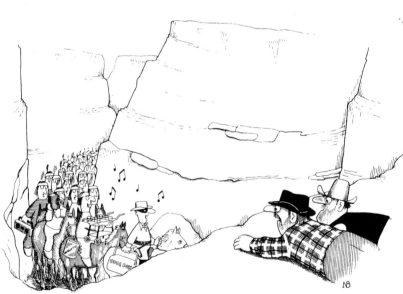

"Keep down! It's the Highly Gregarious Ranger"

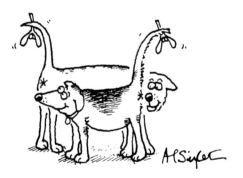

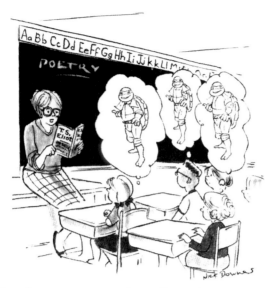

". . . the women come and go, talking of Michelangelo . . ."

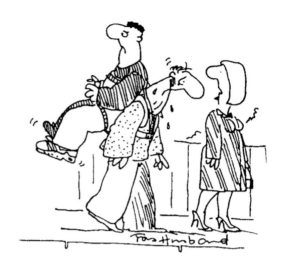

". . . and for your own sake too, Philip, you'll have to accept he's not a baby anymore . . ."

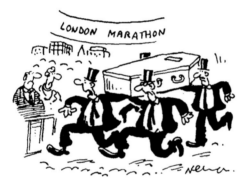

"He was determined to finish"

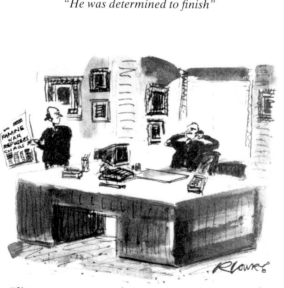

"I've got compassion fatigue – I've given a damn, a fig and two hoots already"

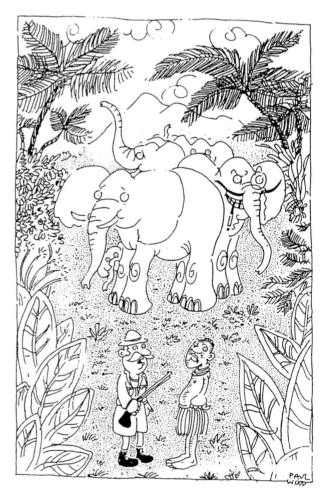

"Right, Matumbi, where's this rogue elephant?"

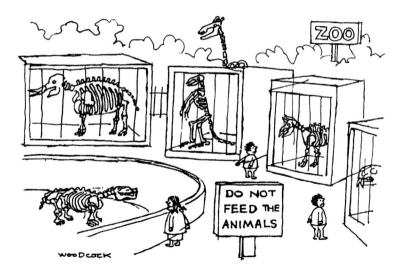

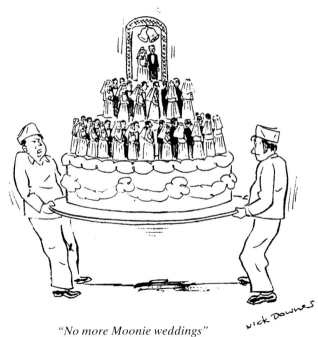

"No more Moonie weddings"

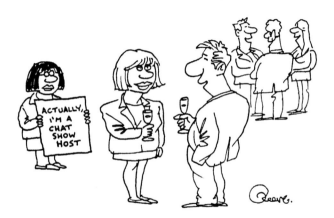

GEOFF THOMPSON

Yeovil-based Geoff Thompson came to cartooning after being made redundant by Westland Helicopters in the mid-80s. Born in 1954, Thompson has since enjoyed a variety of jobs to supplement his cartoonist's lifestyle, including delivering car parts. Influences include 'nearly everybody'.

"Oh no, the germs have got here first"

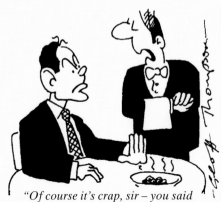

"Of course it's crap, sir – you said everything had to go through Mr Mandelson first"

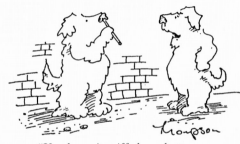

"You haven't sniffed any bottoms before, have you?"

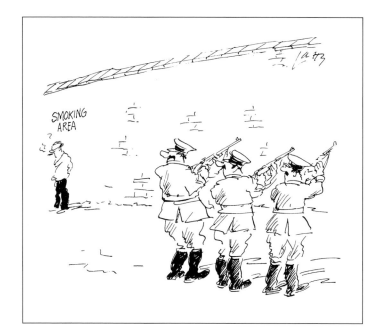

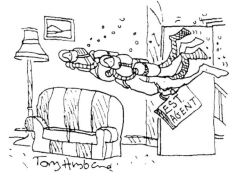

"To be honest, the damp's worse than I expected"

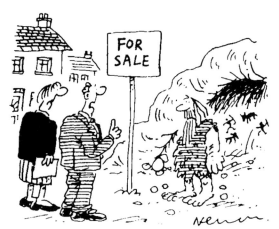

"Been on the market long?"

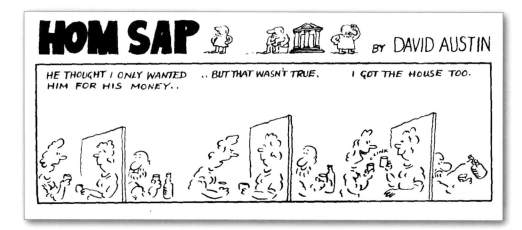

CHRISTMAS BELLS
The *Guardian*'s political cartoonist Steve Bell was commissioned to produce a series of Christmas cover cartoons in the 1990s, beginning with the *Adoration of the Major* (*top left*). Parodying the works of Bruegel the Elder, Bruegel the Younger and Raymond Briggs, they feature all the leading lights of 1990s politics – Thatcher, Major, Tebbit, Lamont, Heseltine, Clarke, Mellor (*sans* trousers), Aitken (then embroiled in arms sales), Currie, Portillo, Smith, Blair, Brown, Prescott, and Straw (amongst others). Bell's cartoons are remarkable (given their intricacy) for being drawn the same size as printed on the *Eye* cover.

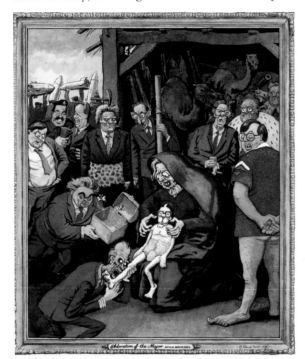
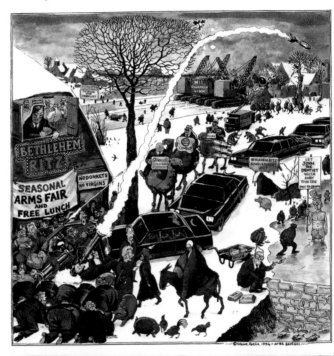
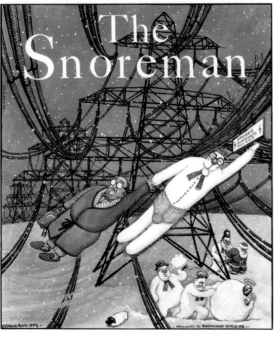
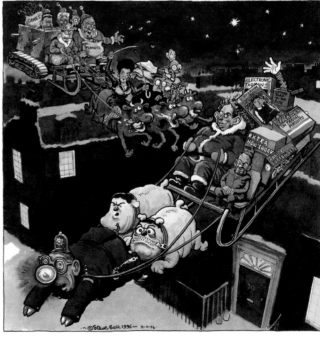

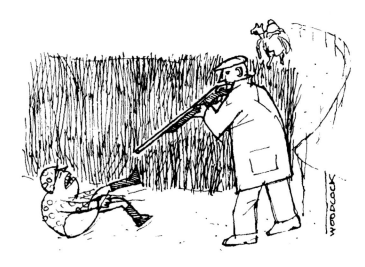

"Since he became a recording star, he employs that little man to have the blues for him"

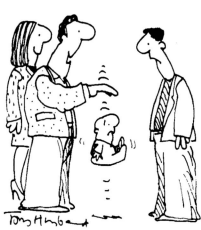

"He's what we always wanted – a bouncing baby boy"

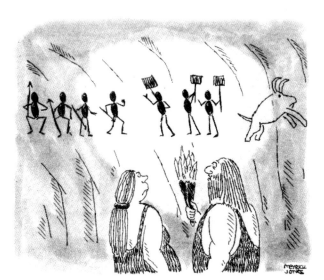

"Bloody hunt saboteurs"

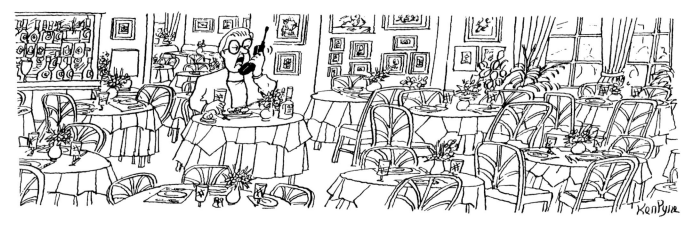

"I'll call you back in twenty minutes when the restaurant is crowded"

OLD MACDONALD

Albert Rusling's strip pilloried the greed of modern farmers.

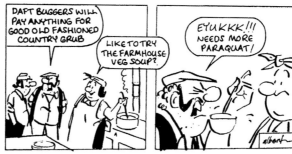

Old Macdonald — ALBERT

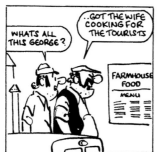

WHATS ALL THIS GEORGE?

..GOT THE WIFE COOKING FOR THE TOURISTS

FARMHOUSE FOOD MENU

DAFT BUGGERS WILL PAY ANYTHING FOR GOOD OLD FASHIONED COUNTRY GRUB

LIKE TO TRY THE FARMHOUSE VEG SOUP?

EYUKKK!!! NEEDS MORE PARAQUAT!

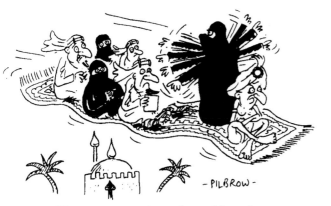

— PILBROW —

"The emergency exits are located here, here, here, here, here . . ."

*"Oh, Doctor – how **awful** to be expected to diagnose symptoms at a dinner party!"*

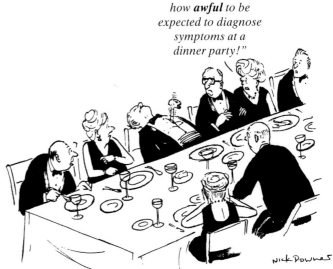

NICK DOWNES

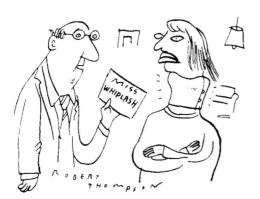

"Frankly, it's not the kind of whiplash I had imagined"

"I would advise him to forget King Lear and concentrate on balancing the beachball"

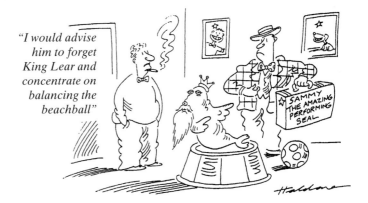

SAMMY THE AMAZING PERFORMING SEAL

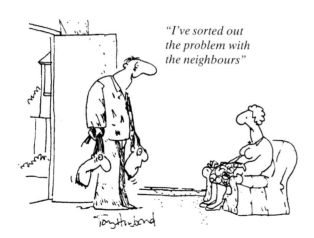

*"I've sorted out
the problem with
the neighbours"*

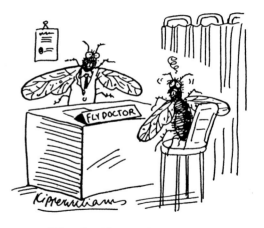

*"You should try and take things
easier, Mr Blue-Arse"*

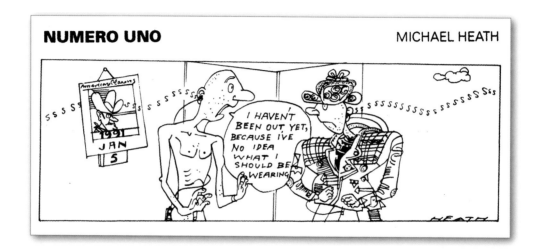

NUMERO UNO MICHAEL HEATH

"Him and his bleedin' silicone implants"

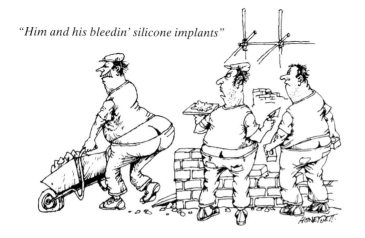

"Oh no! Not another new dress!"

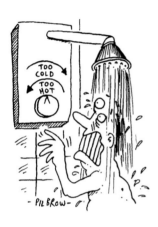

Great Bores Of Today.

"... I've had mine six months and frankly I don't know how I managed without it obviously it's 4x4 power-assisted steering and it's got a 760 bhp torque which will take you up the side of the Eiffel Tower no probs add in a heck of a lot of top-end grunt and you're talking about a very tasty package including the electronic toys and this one's got a voice activated monitor for everything from tyre pressure to headlight alignment amazing the main point is you're six feet above everyone else and you can see problems before they happen even cabbies give you a bit of respect when you're in one of these she's multi-terrain and she can take a flash flood or a twelve-foot snowdrift like a knife through butter we can get in the three kids the nanny and the spaniel and there's still bags of room for the shopping from Sainsbury's which is really when it comes into its own actually the only drawback is that you can't find anywhere to park the bloody thing in our road it's too big and it keeps getting broken into you don't want to buy it do you? 18K should be about right..."

Air Lute

*"Actually, they're King Charles the **First** Spaniels"*

RGJ

Richard Jolley is a self-taught cartoonist, raised in Cheshire, where he attended the local comprehensive and went on to study Philosophy, Politics and Economics at University College, Oxford. It was an education, he says, 'that was entirely wasted and resulted in no employment.' He has worked as a cleaner in a factory, as a sorter of ancient books in the Bodleian Library, as a production manager for accountancy training manuals, and as a barman, before becoming a freelance cartoonist in 1994.

"Must you always go topless on the beach?"

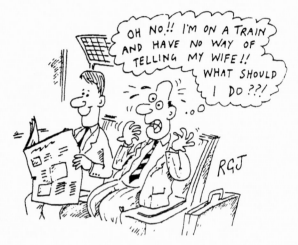

Life Before Mobile Phones

RGJ has become one of the *Eye's* most consistent contributors – moving from gags to strips. *Liz*, (*see right*), produced in collaboration with gag writer Cutter Perkins, combined *Viz*-style Geordie humour with Britain's favourite dysfunctional family – the Windsors. Quite bizarre, but very funny.

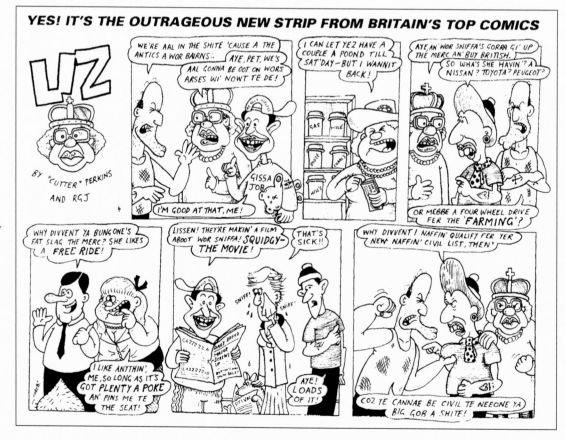

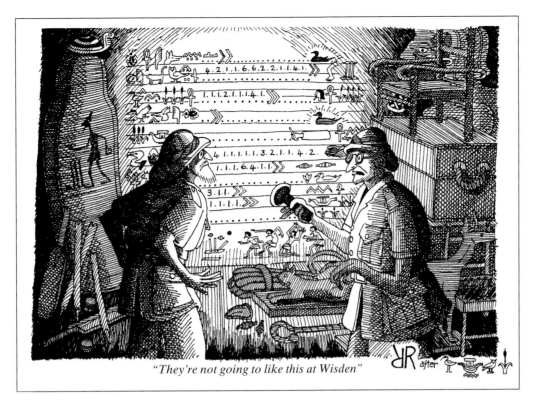

"They're not going to like this at Wisden"

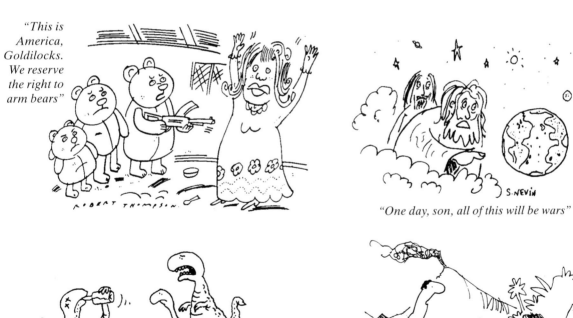

"This is America, Goldilocks. We reserve the right to arm bears"

"One day, son, all of this will be wars"

"He's a winosaur"

"Mum, Dad . . . I'm a homo sapien"

HI HONEY, I'M HOME

Perhaps the most clichéd line in the history
of terrible sit-coms is here celebrated
comprehensively – turning comedy lead into
cartoon gold – perhaps the *Eye*'s finest example
of the running joke . . .

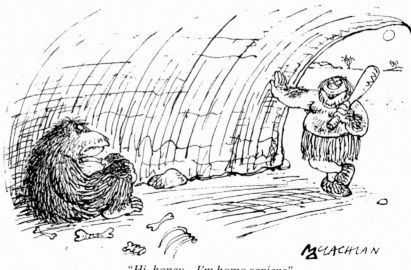

"Hi, honey – I'm homo sapiens"

"Hi honey – I'm home!"

"Money, I'm home!"

"Hi honey – I'm homunculus!"

"Hi, honey. I'm ho-ho-ho-home!"

"Hi honey – I'm Homicide"

*"Hi Honey,
I'm Lord Home"*

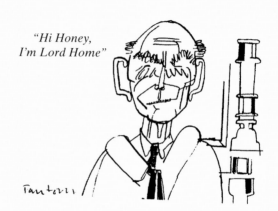

Heath's Private View

"*HETEROSEXUALS to serve in the armed forces?!*"

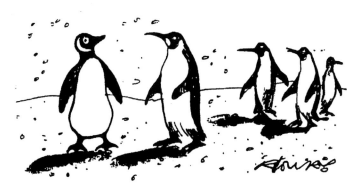

"*One's a Penguin Modern Classic, and the other one made his fortune selling biscuits, but I don't know which is which*"

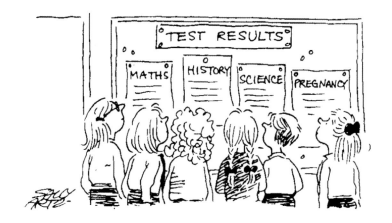

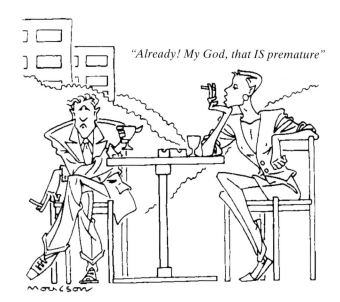

"Already! My God, that IS premature"

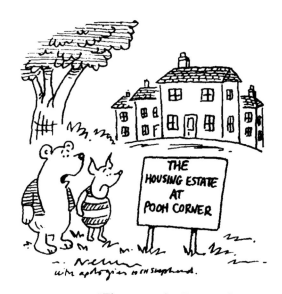

"There goes the Green Belt"

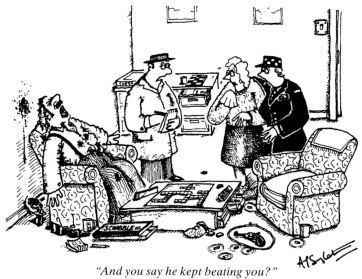

"And you say he kept beating you?"

JOHN MAJOR'S BIG TOP

John Kent's strip about Thatcher successor John Major eschewed jokes about his greyness in favour of jibes about his father's background in the circus. Major was soon being undermined by Thatcher loyalists Norman Lamont, Michael Portillo and Norman Tebbit.

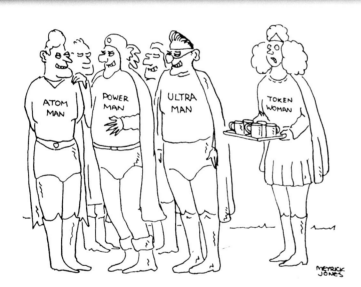

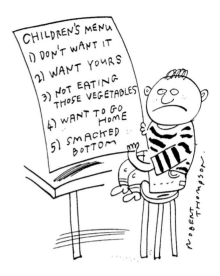

"I was watching that!"

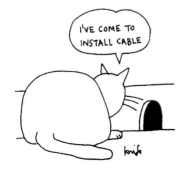

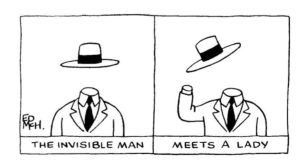

"You'll have to be patient – this could take an hour or more to fix"

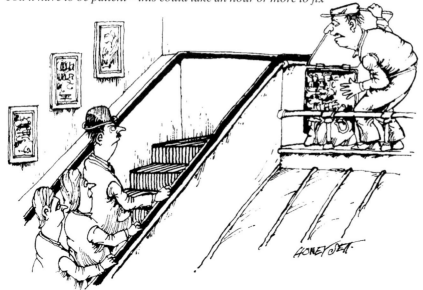

"It was a messy divorce"

"Will you stop arranging that bloody Feng Shui section?"

"I don't know much about art, but I know what I like to talk about in a very loud voice!"

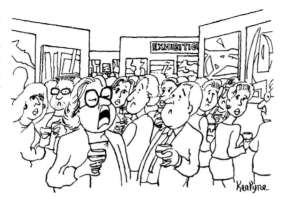

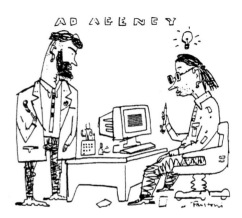

"I've just had a great someone else's idea"

TONY REEVE

Tony Reeve's all-too-brief cartooning career was plagued with health problems, which finally resulted in his death in 2011, aged just 50. However, his personal battle against Marfan Syndrome, which left him with poor eyesight and heart problems, never dampened his humour – and he contributed not only gags and strips to the *Eye*, but also scripts to ITV's satirical *2DTV* show (produced by Pilbrow). His time in hospital led to his collaboration with Steve Way on the strip Off Your Trolley (*see page 250*).

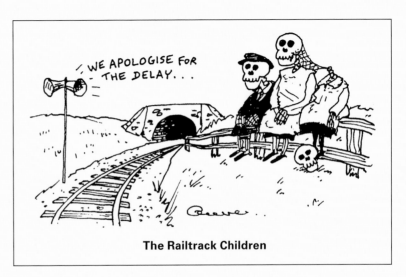

"More 'E', Vicar?"

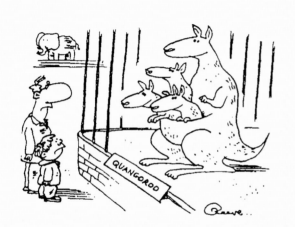

The Railtrack Children

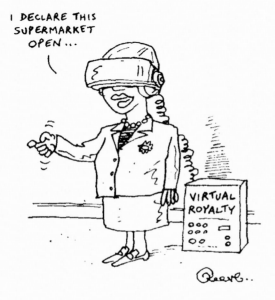

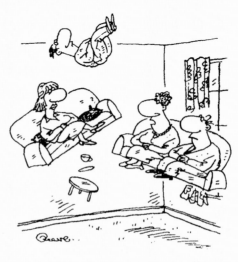

"We've had our gravity cut off"

101 USES FOR A JOHN MAJOR

Simon Bond's hit cartoon book *101 Uses for a Dead Cat* provided the inspiration for Patrick Wright's attack on our then new, useless Prime Minister.

101 USES FOR A JOHN MAJOR (8)
A WHEELCLAMP

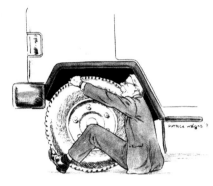

101 USES FOR A JOHN MAJOR (12)
A CLAPPER IN A BELL

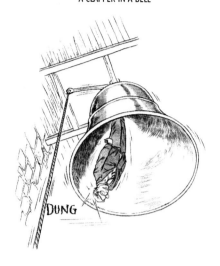

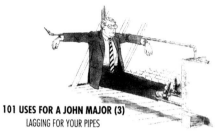

101 USES FOR A JOHN MAJOR (3)
LAGGING FOR YOUR PIPES

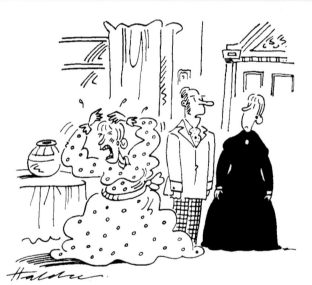

"She's going to need counselling – Gilbert and Sullivan have split up"

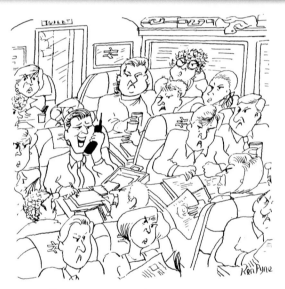

"I'm just ringing to let everyone know I'm an arsehole . . ."

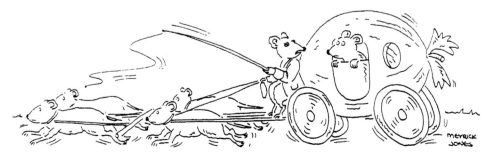

"I had that Cinderella in the back once"

HI HONEY, I'M HOME (AGAIN)

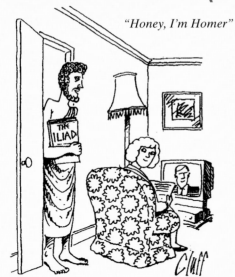

"Honey, I'm Homer"

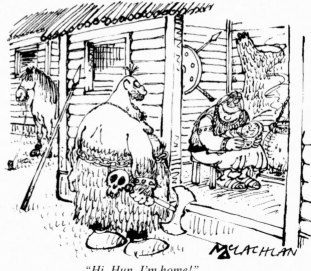

"Hi, Hun, I'm home!"

"Hey, nonny, I'm home!"

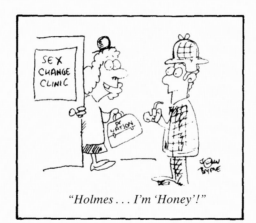

"Holmes . . . I'm 'Honey'!"

"Hi, Honey, I'm home for tea"

"Hi, ho, honey – we're home!"

"Honey, we're homeless"

"*Well, Goliath, I must congratulate you on your PR department*"

"*You'll meet a goldfish . . . Oh, sorry, this isn't my crystal . . .*"

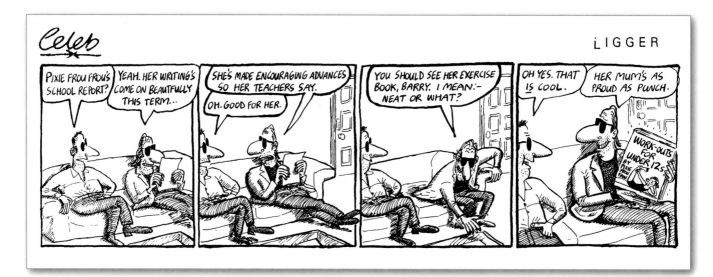

Celeb

LIGGER

PIXIE FROU FROU'S SCHOOL REPORT? | YEAH. HER WRITING'S COME ON BEAUTIFULLY THIS TERM...

SHE'S MADE ENCOURAGING ADVANCES SO HER TEACHERS SAY. | OH. GOOD FOR HER.

YOU SHOULD SEE HER EXERCISE BOOK, BARRY. I MEAN:- NEAT OR WHAT?

OH YES. THAT IS COOL. | HER MUM'S AS PROUD AS PUNCH.

WORK-OUTS FOR UNDER 12s

"*He's always got to go one better than the other lion-tamers*"

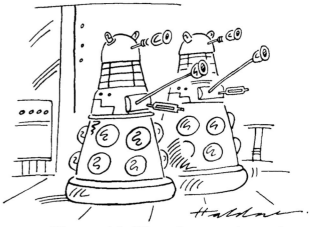

"*I've seen eight different Doctors and none of them will say what's wrong with me*"

THE CLINTSTONES

TV cartoon *The Flintstones* meets Bill Cinton's White House, where First Lady Hillary was assumed to wear the trousers. As opposed to Bill when in 'meetings' with intern Monica Lewinsky.

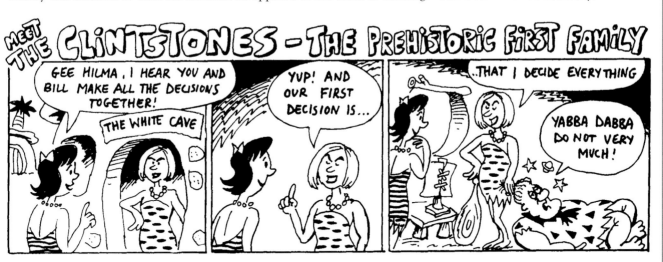

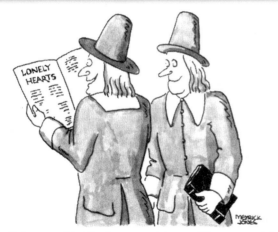

"Listen to this! Surly, superstitious celibate, non-drinker, non-smoker, no sense of humour, seeks similar mate"

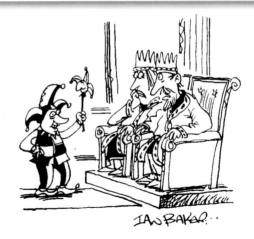

"Try to laugh, dear. He was in the Footlights, you know"

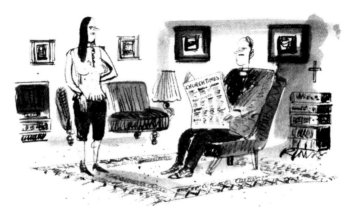

"And that's another thing – you're too ecumenical with the truth"

THE LOTTERY WINNERS MIKE TURNER

ANOTHER PILE OF BEGGIN' LETTERS.. 'HAVEN'T HAD A HOLIDAY IN YEARS'... 'HOUSE FALLIN' DOWN'.. 'DESTITUTE'. WHAT A WASTE OF TIME...

... DOESN'T YOUR MOTHER HAVE ANYTHING BETTER TO DO ?

THE LOTTERY WINNERS
Veteran cartoonist Mike Turner tapped into the latest encouragement to gamble – the Lottery.

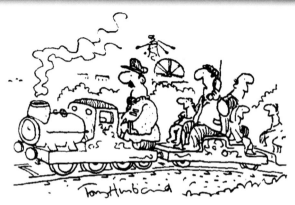

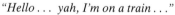

"Hello . . . yah, I'm on a train . . ."

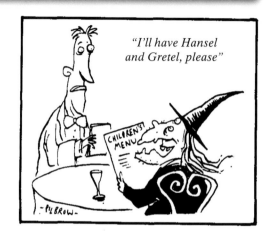

"I'll have Hansel and Gretel, please"

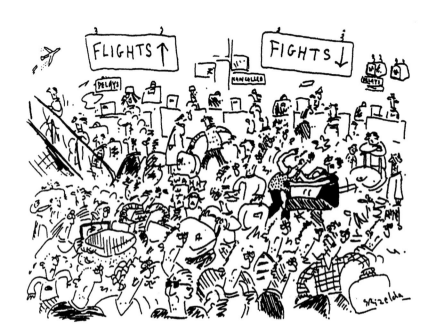

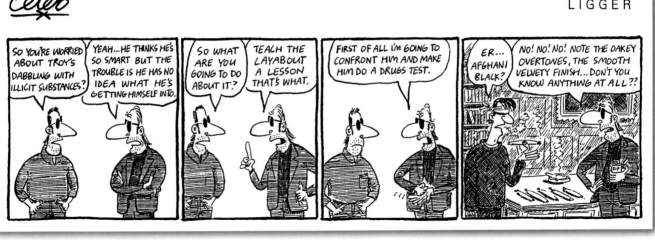

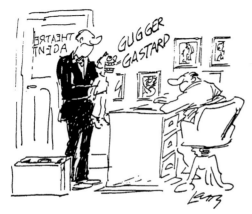

ALTERNATIVE VENTRILOQUIST

"We're not all racists – some of us are incompetent and corrupt"

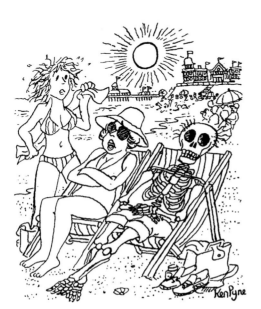

"He's the same every year – he peels terribly"

"Amazing! We still get mail for them, and they left years ago"

"Kevin! Must you put ketchup on everything?!"

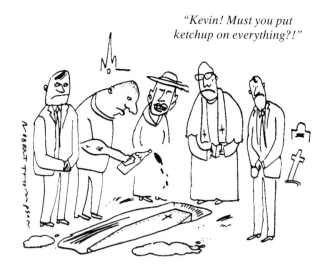

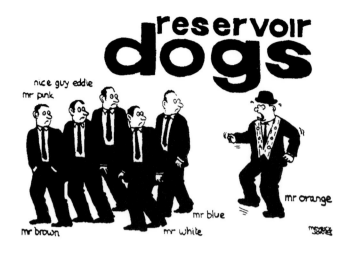

reservoir dogs

nice guy eddie
mr pink
mr brown
mr blue
mr white
mr orange

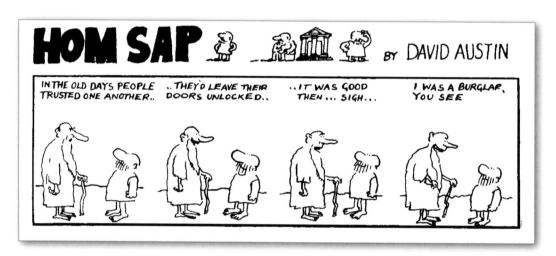

HOM SAP BY DAVID AUSTIN

IN THE OLD DAYS PEOPLE TRUSTED ONE ANOTHER..

..THEY'D LEAVE THEIR DOORS UNLOCKED..

..IT WAS GOOD THEN ... SIGH...

I WAS A BURGLAR, YOU SEE

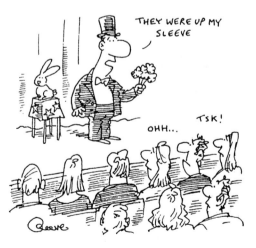

THEY WERE UP MY SLEEVE

OHH... TSK!

DISILLUSIONIST
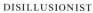

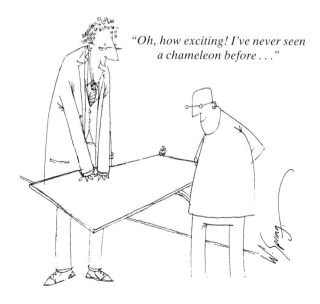

"Oh, how exciting! I've never seen a chameleon before . . ."

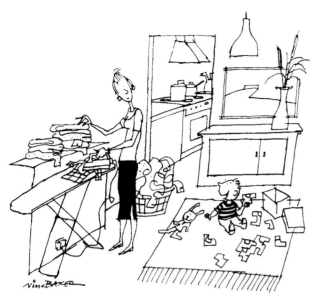

"Mummy said her first word to me today, Nanny"

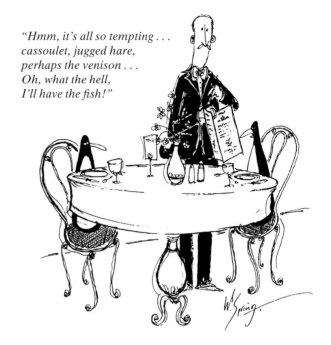

"Hmm, it's all so tempting . . .
cassoulet, jugged hare,
perhaps the venison . . .
Oh, what the hell,
I'll have the fish!"

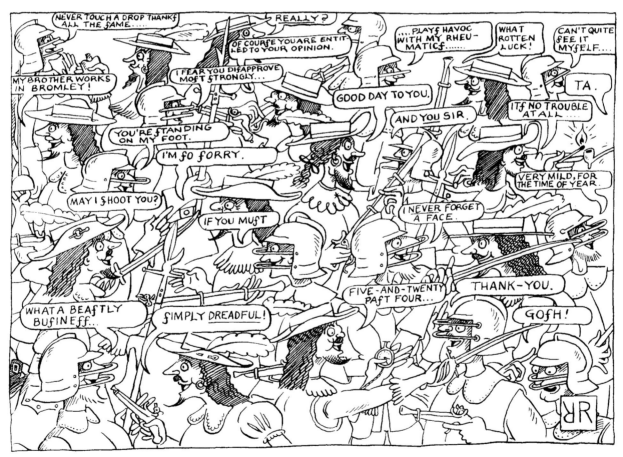

The Englifh Civil War

ROY OF THE FUGGERS

Mohammed Al 'Fuggin' Fayed's purchase of Fulham FC inspired a series of football strip parodies, drawn by *Roy of the Rovers* artist Cooper. Others included *Roy of the Losers* (about the England team under Kevin Keegan).

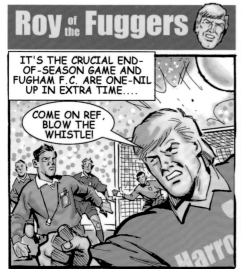
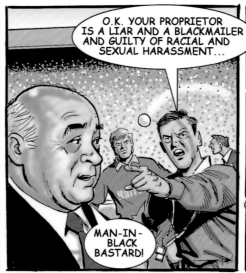
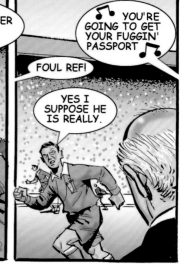

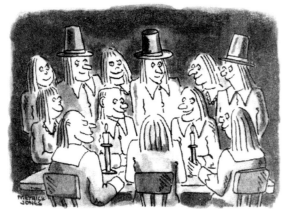

"OK, so every month we choose a book, read it, then we meet up to discuss whether it should be burned"

"I'm experimenting with Surrealist Cubism!"

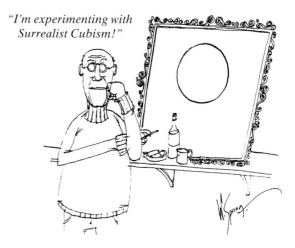

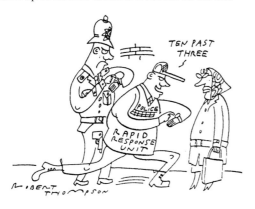

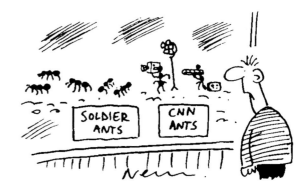

"Euston, we have a problem . . ."

"Watch out, genetically modified crops"

"I'm calling to protest about the most appalling blot on the landscape"

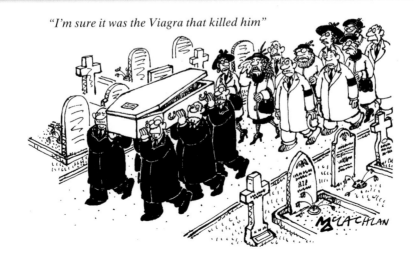

Celeb LIGGER

I'M SORRY I CAN'T BE WITH YOU TONIGHT ON THE FABULOUS OCCASION OF THE ANNUAL M.T.V. AWARDS...

I WANT TO THANK YOU ALL FOR BEING SO SPECIAL...

YOU'RE MY NUMBER ONE FANS AND I LOVE YOU ALL, CHEERS!

RIGHT, TIME FOR BED, GIRLS... DADDY WILL BE BACK IN THE MORNING...

WHIRR... EJECT...

"I'm sure it was the Viagra that killed him"

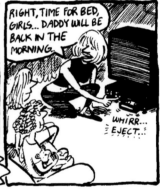

"She's pressing charges – seems she burnt her lips on your porridge"

"It's probably just road-rage"

THE DIRECTORS

DREDGE

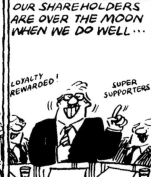
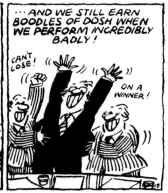

YOU KNOW GENTLEMEN— I'VE ALWAYS THOUGHT OF US AS A PREMIERSHIP FOOTBALL CLUB···

WE ALL HAVE TO PULL TOGETHER AS A TEAM TO GET RESULTS···

OUR SHAREHOLDERS ARE OVER THE MOON WHEN WE DO WELL···

···AND WE STILL EARN BOODLES OF DOSH WHEN WE PERFORM INCREDIBLY BADLY!

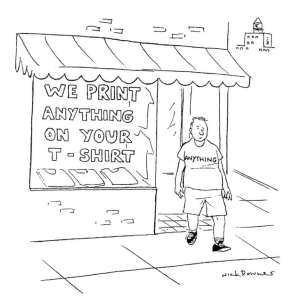

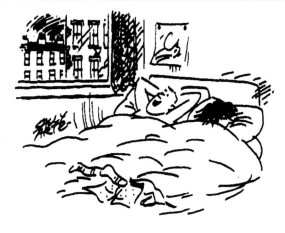

"Hear it? The Dawn Chorus? First the burglar alarms . . . then the car alarms and police sirens chime in . . ."

VIRTUAL REALITY

Cutter Perkins and Richard Jolley pinpointed the latest technological craze as ripe for satire.

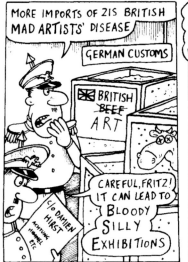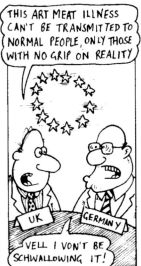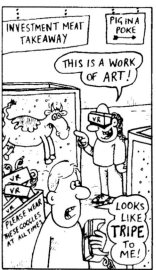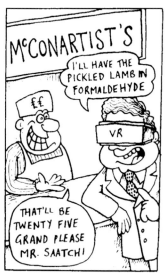

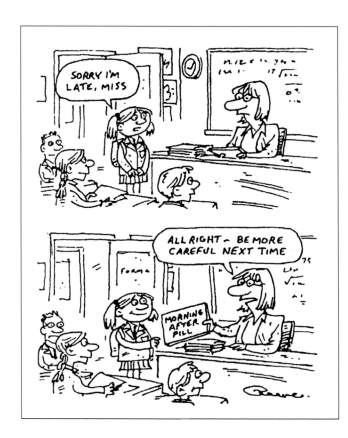

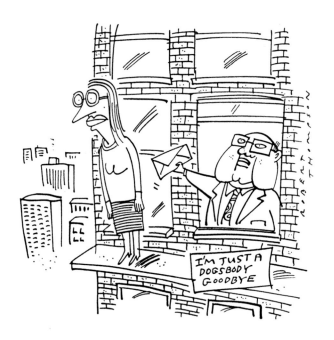

"Drop this into Accounts on your way down, would you, Miss Pemberton?"

IT'S GRIM UP NORTH LONDON

The emergence of Islington as London's trendiest borough was reinforced by the fact that Tony Blair lived there before his landslide election victory in 1997. Knife & Packer – Duncan McCoshan and Jem Packer – have been capturing its absurdity ever since. Jez and Quin are not-very thinly veiled self-portraits.

IT'S GRIM UP NORTH LONDON KNIFE & PACKER

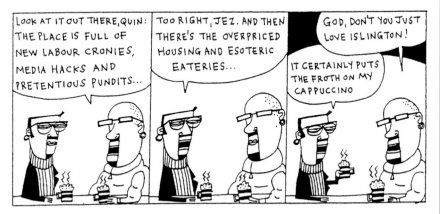

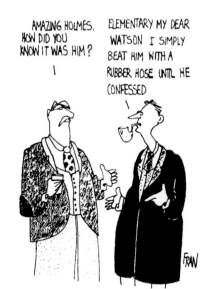

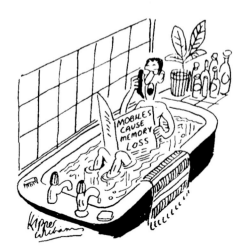

"I'm on the bus!"

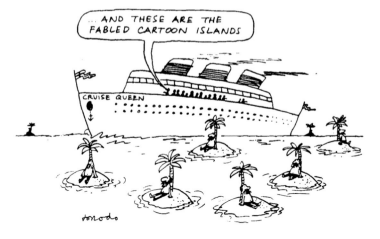

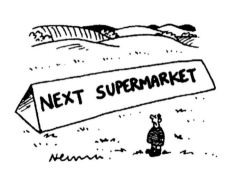

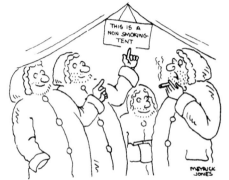

"All right, I'm going out now. I may be some time . . ."

Match of the Day *1066*

(Anglo-Saxons 0, Normans 1)

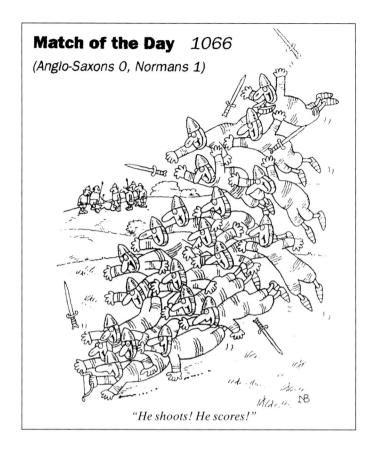

"He shoots! He scores!"

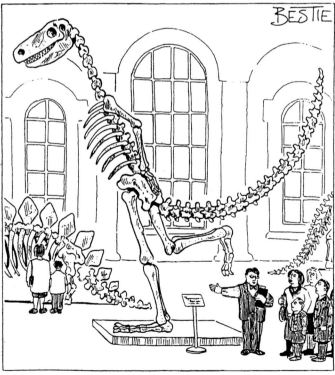

"We believe this one was around during the Ice Age"

PRE-SCHOOL NURSERY FACILITY RHYMES

Political correctness sent up by Neil Bennett, who went on to draw *New Old Sayings*. Collaborators included readers and the late Debbie Barham – a talented joke writer who tragically died of anorexia.

Pre-School Nursery Facility Rhymes

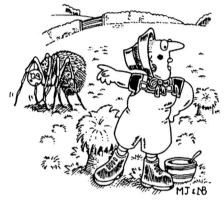

Little Ms Muffett sat on a tuffet
And complained she'd been
 sexually harassed.
The spider that eyed her
And sat down beside her
Legged it, severely embarrassed.

NEW OLD SAYINGS

Ask a silly question, get a daytime chat show

MIKE BARFIELD

Barfield is possibly the only *Eye* cartoonist with a first in Botany and Zoology and a writing credit on *Who Wants To Be A Millionaire?* Another cartoonist from Leicester, he was born in 1962, and worked for Radio 4's *Weekending* and ITV's *Spitting Image* before attempting to fill the retiring Gary Larsson's boots at the *Evening Standard*. The result was a cartoon strip that became the *Eye*'s *Apparently*. 'Of all the titles I suggested to Ian Hislop,' says Barfield, '*Apparently* was the least worst'. He was also runner-up in Radio Five Live's 2010 World Cup Song Contest – playing the ukulele.

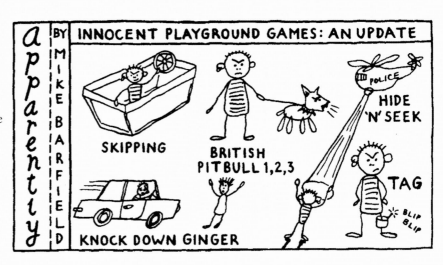

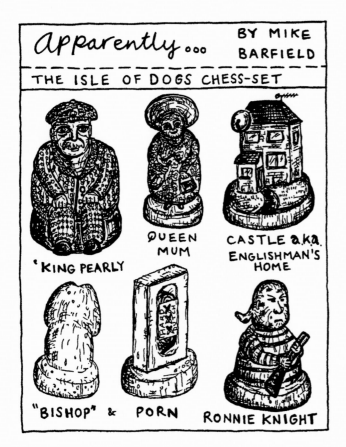

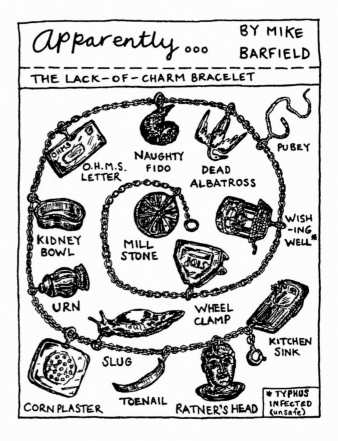

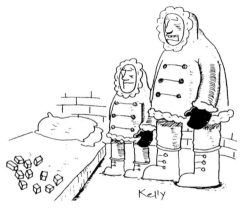

"You've wet your bed again, haven't you?"

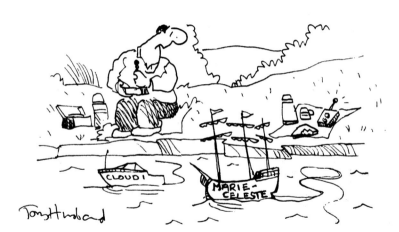

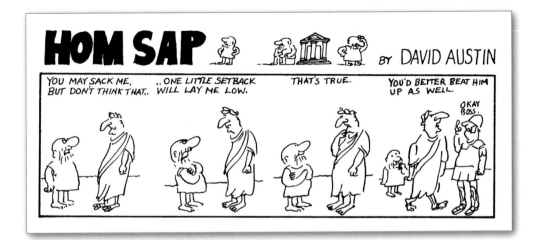

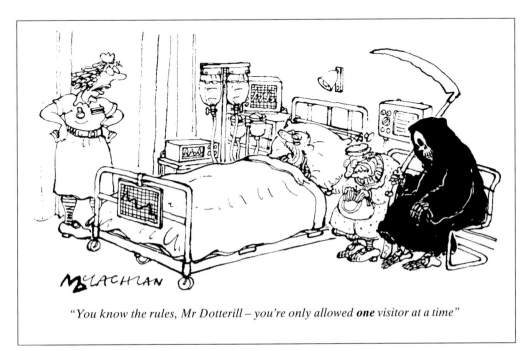

*"You know the rules, Mr Dotterill – you're only allowed **one** visitor at a time"*

HEATH'S PRIVATE VIEW

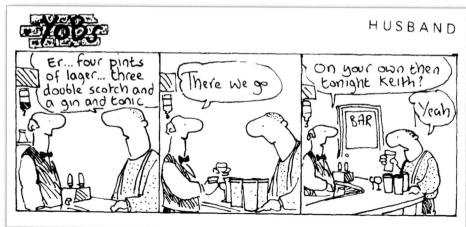

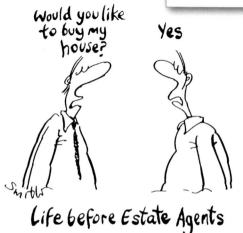

Life before Estate Agents

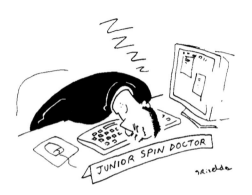

KERBER

Having started in the antique jewellery trade, Neil Kerber began cartooning aged 21 – first in the *Sunday People*. Born in 1967, his gags for the *Eye* led to his *Supermodels* strip – which has survived longer than most supermodels' careers. His ability to get a likeness of fantastically good-looking women (notoriously hard to caricature) while never deviating from his stick-man style is uncanny. Like his model subjects, he survives almost solely on caffeine.

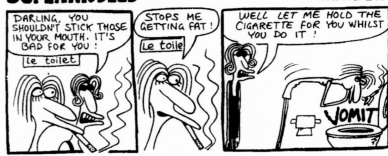

SUPERMODELS KERBER

DARLING, YOU SHOULDN'T STICK THOSE IN YOUR MOUTH. IT'S BAD FOR YOU!

Le toilet

STOPS ME GETTING FAT!

Le toile

WELL LET ME HOLD THE CIGARETTE FOR YOU WHILST YOU DO IT!

VOMIT

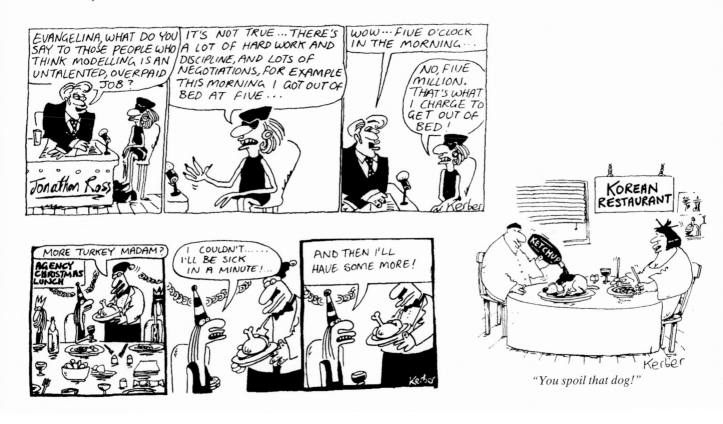

EVANGELINA, WHAT DO YOU SAY TO THOSE PEOPLE WHO THINK MODELLING IS AN UNTALENTED, OVERPAID JOB?

Jonathan Ross

IT'S NOT TRUE...THERE'S A LOT OF HARD WORK AND DISCIPLINE, AND LOTS OF NEGOTIATIONS, FOR EXAMPLE THIS MORNING I GOT OUT OF BED AT FIVE...

WOW...FIVE O'CLOCK IN THE MORNING...

NO, FIVE MILLION. THAT'S WHAT I CHARGE TO GET OUT OF BED!

Kerber

MORE TURKEY MADAM?

AGENCY CHRISTMAS LUNCH

I COULDN'T...... I'LL BE SICK IN A MINUTE!...

AND THEN I'LL HAVE SOME MORE!

Kerber

KOREAN RESTAURANT

KETCHUP

Kerber

"You spoil that dog!"

BEAT ME UP SCOTTY

Star Trek: The Dark Side

Jon Jacob

Mr Cameron rejoices in the knowledge that the sun is shining on him

The optimism of the new millennium was swiftly dispelled by 9/11 – and the subsequent invasion of Iraq and Afghanistan. Cartoonists themselves came into the firing line for drawing the Prophet – creating a clash of cultures which highlighted the power of the pen but also the dangers of wielding it. Governments came and went. Tony Blair, who entered on a wave of euphoria, exited on a tide of disillusion. Gordon Brown's Incredible Sulk won him the PM's job – but not the backing of the electorate; and the Coalition seemed to prove what gainsayers warned – that consensus politics achieves little. Jeffrey Archer did his best to cheer everyone up by going to jail and, as smoking was banned in pubs, the Dome and Boris Johnson emerged as new comic characters. Comedically, the 2012 Olympics failed to win any medals – proving a triumph. As the Queen soldiered on, the internet and mobile phones took over the world. The march of new technology was reflected in the *Eye*'s use of colour and matched by the new cartooning talent drawn to the *Eye* – including Grizelda, Royston, Wilbur, Alexander, Len, Pearsall, Ian Baker, Rupert Redway and Link. After fifty years, the *Eye* continues to mine a rich seam of graphic gold, which shows no sign of being exhausted.

101 Uses For A Dome

The world's biggest turkey

LEVESON INQUIRY

"Sorry, I can't remember a thing"

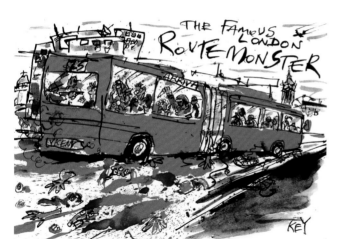

WHERE CARTOONISTS HIDE

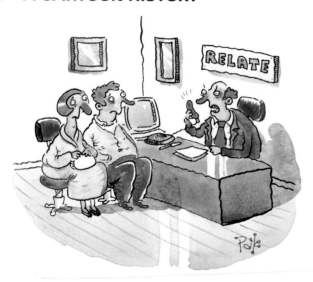

"I'm at work, you stupid cow!"

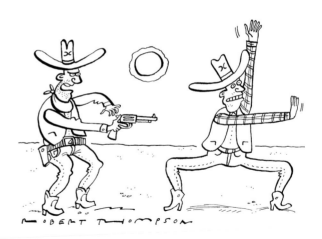

*"When I said 'Dance!', Kincaid,
I didn't mean contemporary"*

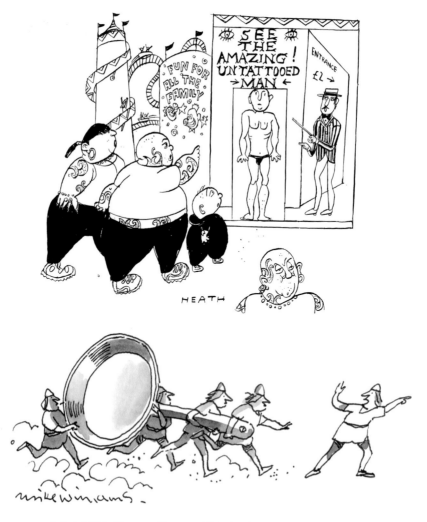

"Quick! It's Humpty Dumpty! We think he's going to fall!!"

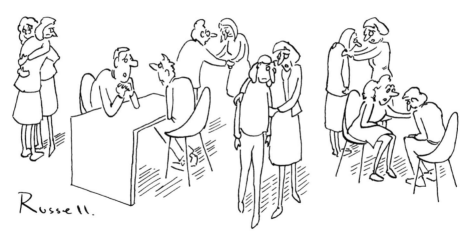

COUNSELLORS COMING TO TERMS WITH NOT HAVING BEEN CALLED TO THE DISASTER

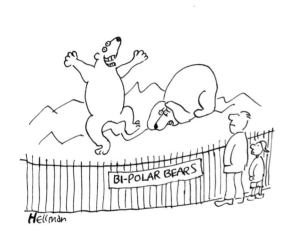

"Do you mind? This is a quiet coach!"

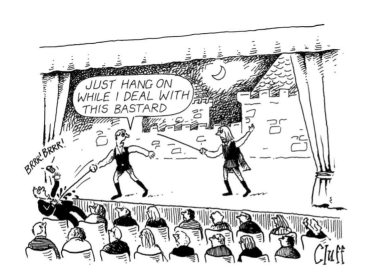

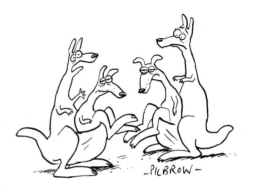

"I'd really hoped they'd leave home after Uni"

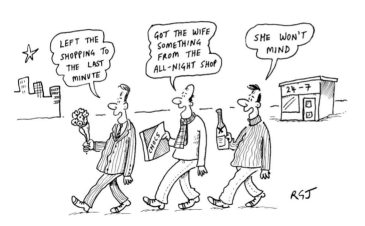

THE THREE INCREDIBLY UNWISE MEN

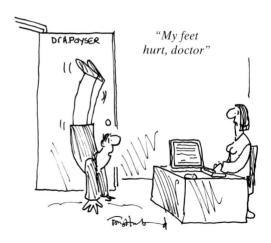

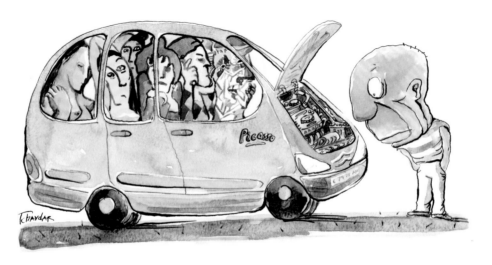

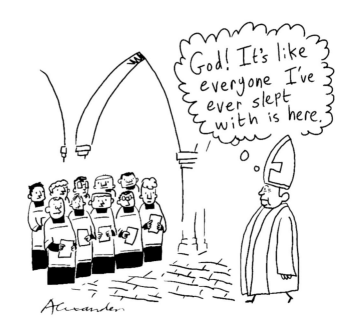

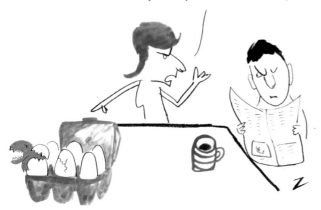

"I TOLD you they were WELL out of date!"

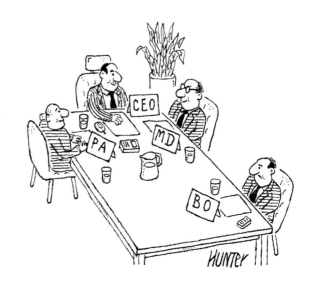

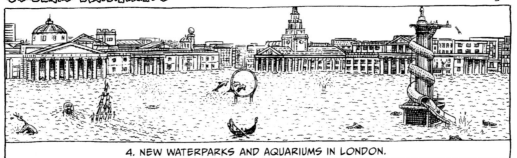

Artists in Residence Sioux Bradshaw

Vincent van Gogh

Henri Rousseau

Bridget Riley

Tracey Emin

"I'm going to be late. I'm having a bad nose hair day"

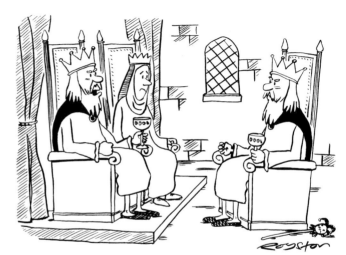

"When did we permit the Jester to start doing impressions?"

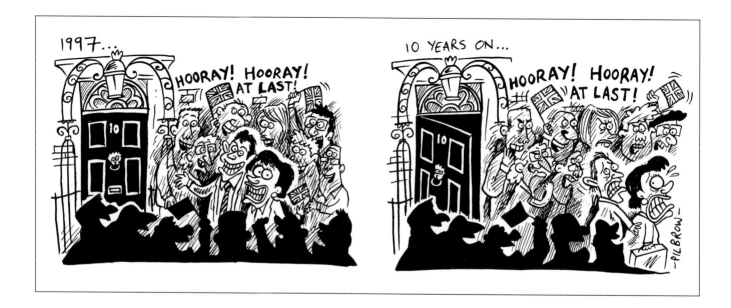

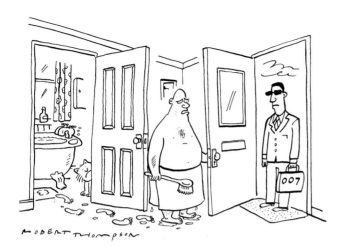

"Ah, Mr Bond . . . I wasn't expecting you"

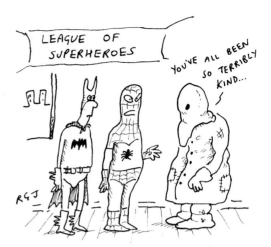

"Remind me, Elephant Man . . . what are your super powers again?"

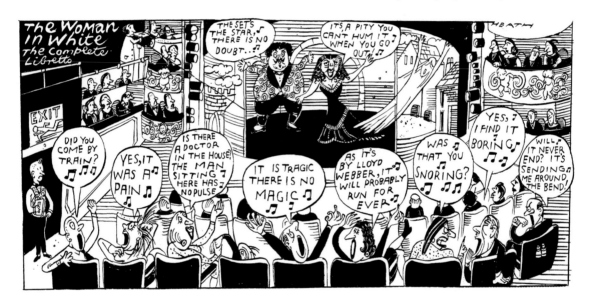

"Am I pleased to see you!"

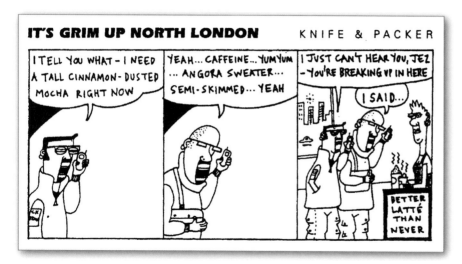

"When I grow up I want to be undead"

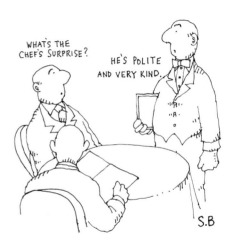

"I knew him when he was just in Mine Disposal"

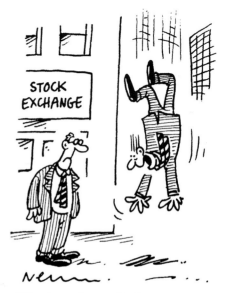

"Thank goodness – I'm bottoming out!"

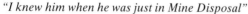

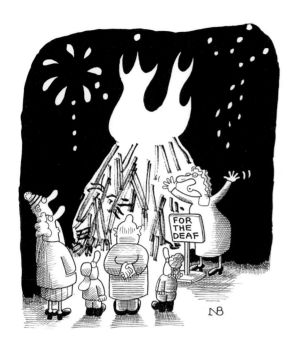

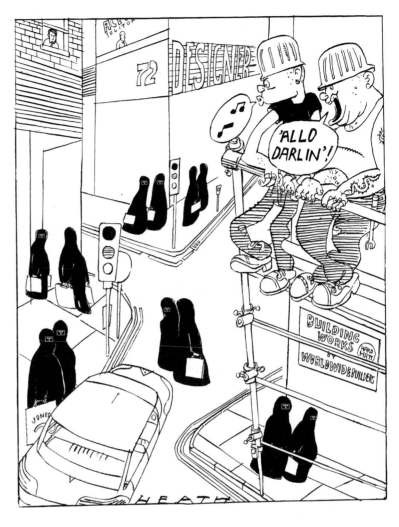

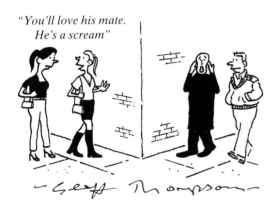

"You'll love his mate. He's a scream"

FACE IT HELEN!
I'M A HUMAN NOW,
AND NOBODY CAN EVER
KNOW WHAT HAPPENED
BETWEEN US!

NOW, HOW ARE THE KIDS?

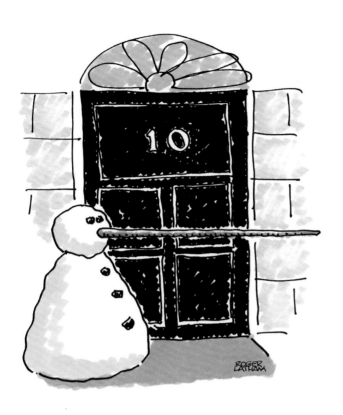

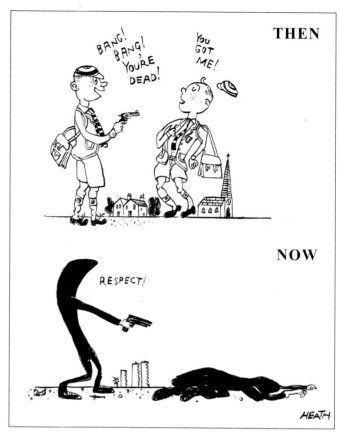

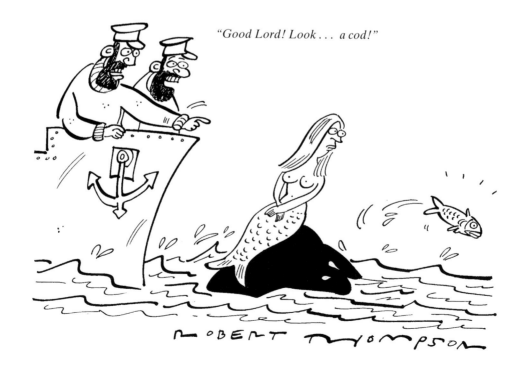

"Good Lord! Look . . . a cod!"

MIKE WILLIAMS

Mike Williams is perhaps best known for his work for *Punch* – but he has contributed to the *Eye* throughout his career and even more so following *Punch*'s final demise in 2002. Born in 1940, he attended Quarry Bank High School, along with John Lennon, before working in commercial art studios in Liverpool and following in the footsteps of his father George and brother Pete by turning to cartooning, influenced in the main by American humour. But his historical gags are quintessentially English – and his penmanship is second to none. He subsists on a diet of liquorice torpedoes.

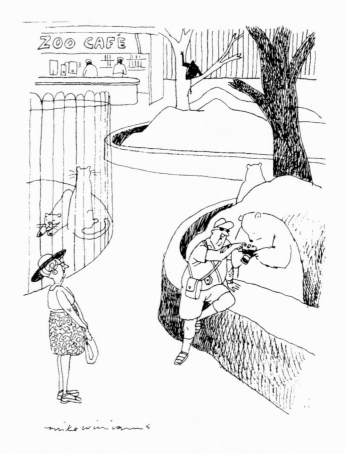

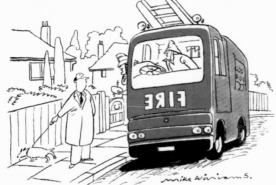

"EXCUSE ME, SIR, COULD YOU DIRECT ME TO CULPEPPER ROAD?"

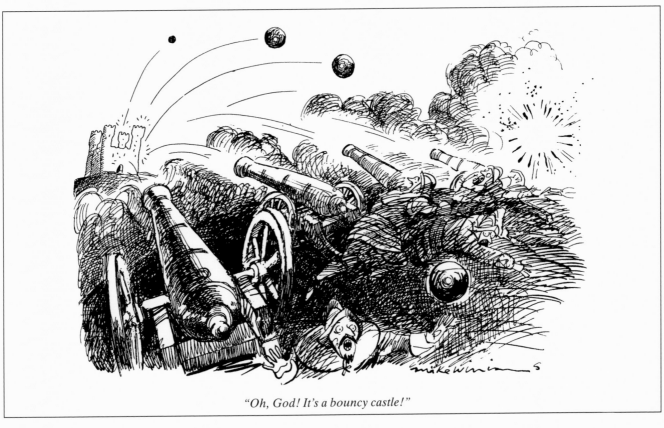

"Oh, God! It's a bouncy castle!"

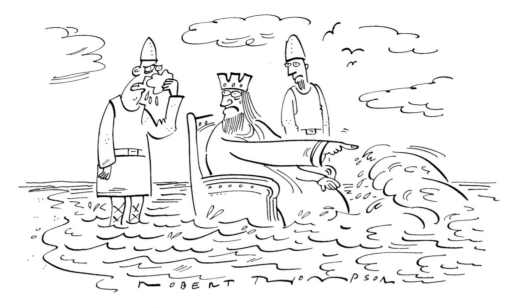

"Sorry, Sire, I think I've got a cnut allergy"

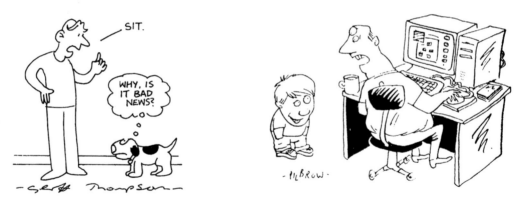

"How do you put this child-lock on the internet?"

HUSBAND

CAMOUFLAGE TROUSERS

Junior Dr Who

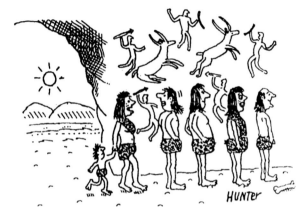

"Is this the queue for the café?"

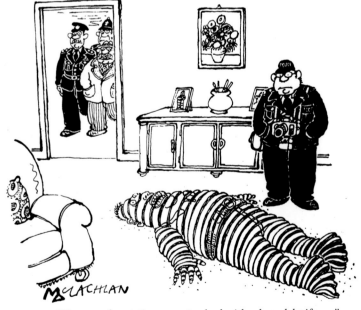

"You say the victim was attacked with a bread-knife . . ."

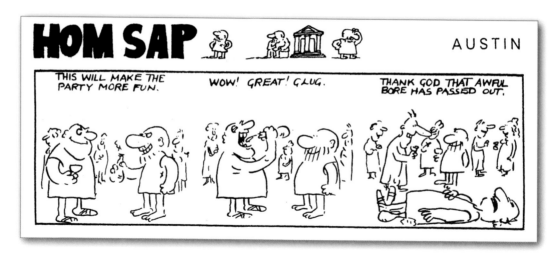

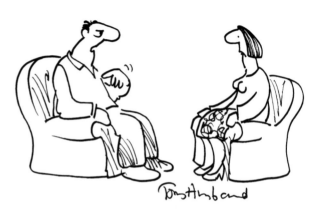

"I'll say whether I'm a control freak or not!"

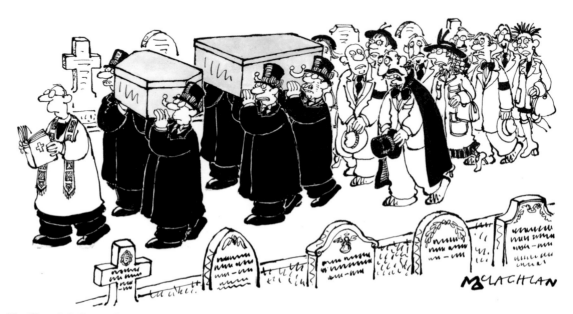

"I still can't believe it happened – you couldn't wish for a more competent and beautiful magician's assistant"

THE HAS-BEANO

Drawn by John Kent, this occasional parody of the *Beano*'s *Numbskulls* strip took us inside the head of the then Tory leader Iain Duncan Smith, famous for his cough and quietness. It also introduced Boris Johnson as a would-be *Dennis the Menace*. The *Beano* theme was continued in Dave Snooty and his Pals.

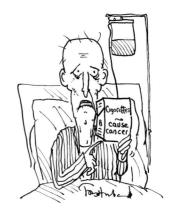

"It does what it says on the packet"

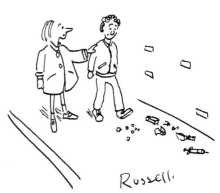

"Careful! It's bad luck to tread on the crack on the pavement"

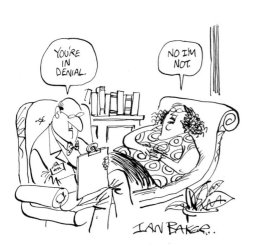

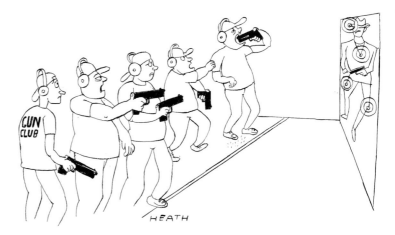

"I warned them he was depressed"

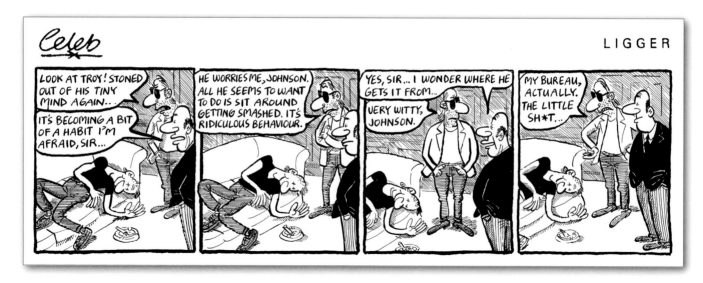

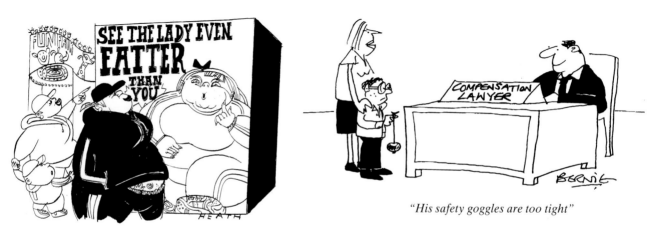

"His safety goggles are too tight"

"Forget it, Bell – no one's going to want a mobile telephone
that takes photos and plays music"

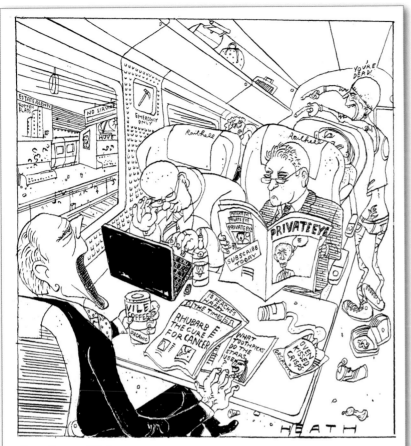

Great Bores of Today

"Yes I used to read it in the old days when Peter Cook was the editor but if you ask me it went downhill when they got rid of that Bores of Today feature they used to do you're too young to remember it but every week they'd have some bloke banging on about something that really interested him I remember they did one once about this couple who'd just had double glazing put in and there was another one about a man who was done for speeding the drawings were brilliant as well the detail that went into them Gerald Scarfe used to do them first thing I turned to"

Forgotten Moments in Music History

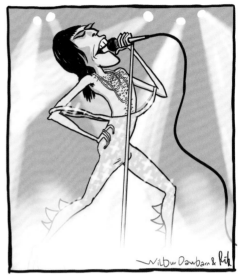

In the 1970s, Freddie's sexual orientation was a closely guarded secret

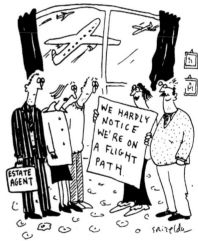

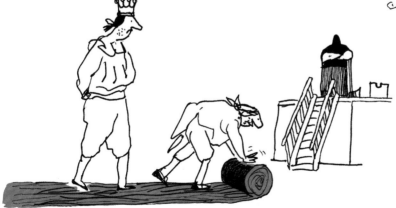

SALLY ARTZ

Sally Artz – or Phillips
– was born in 1935 and began selling cartoons to
the *Weekend Mail* in the late 1950s. Apart from
cartooning, she plays the melodeon at pub sessions
on a Wednesday night.

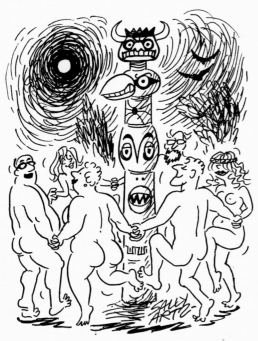

*"Then, like you, I began to feel the
C of E had lost its way . . ."*

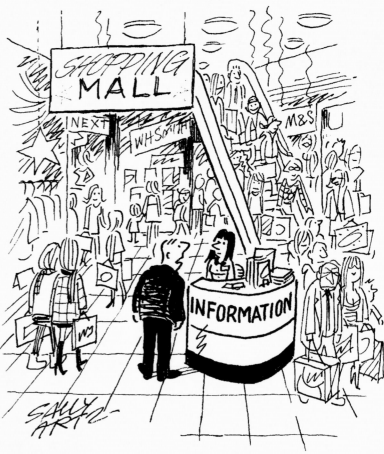

"Am I in Leeds, Bristol or Milton Keynes?"

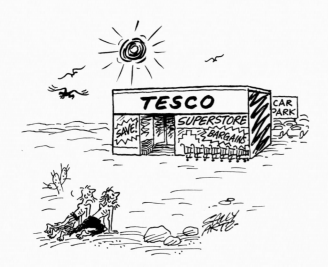

"Hang on . . . I don't think it is a mirage"

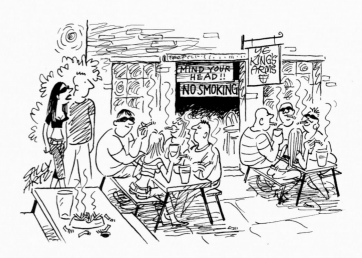

"Let's go inside – I can't stand the smoky atmosphere"

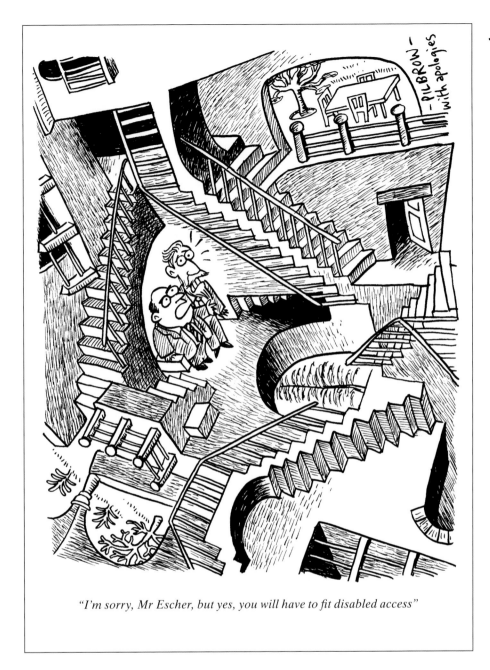

"I'm sorry, Mr Escher, but yes, you will have to fit disabled access"

— MODERN NEWTON —

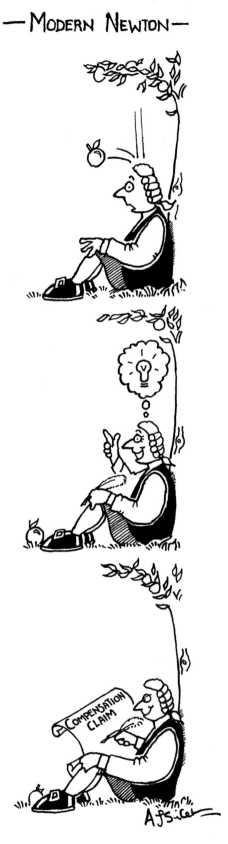

ARCHERSICKOFHIM

Disgraced former peer Jeffrey Archer has always been a popular *Eye* target, both as a successful novelist and as a Tory grandee who in 2007 ended up in jail for perjury. *Snipcock & Tweed* rarely missed an opportunity to insert the literary boot.

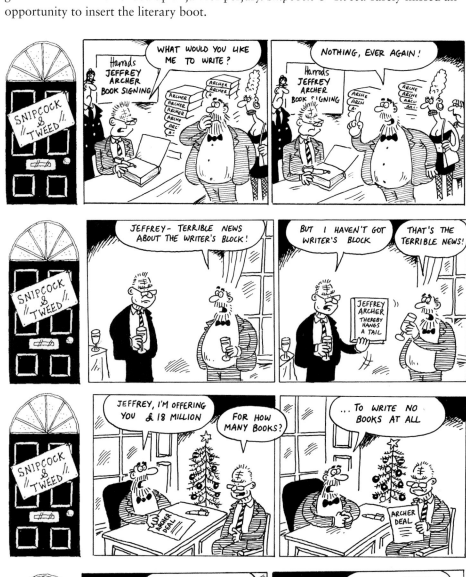

Some figs

fig.1

fig.2

fig.3

Pearsall

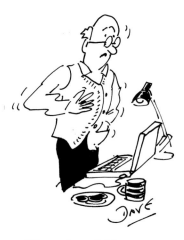

"Now where did I put my memory stick?"

SCENES YOU SELDOM SEE
Barry Fantoni's acute observation of annoying behaviour.
Scenes You Seldom See: someone failing to laugh at *Scenes You Seldom . . .*

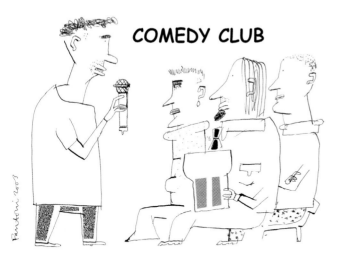

"Hi! I'm Sean and instead of making fun of the audience, I've prepared some material"

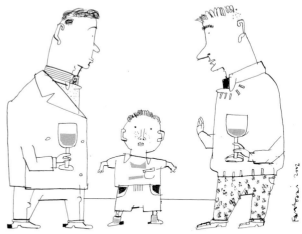

"Ben's not very bright for his age"

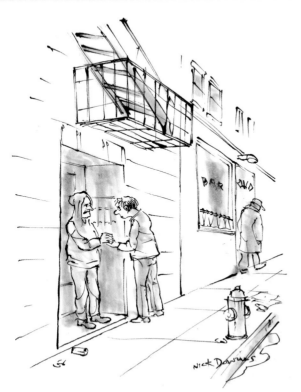

"Customers who bought this item also bought speed, crack, smack, blow and weed"

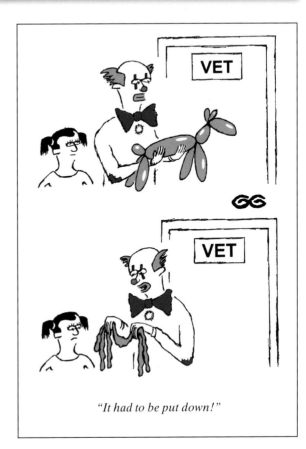

"It had to be put down!"

OFF YOUR TROLLEY

Tony Reeve and Steve Way's NHS strip reflects the amount of time Reeve spent in hospital, before his untimely death in 2011. Steve Way was already an *Eye* regular before becoming cartoon editor of *Punch* in 1989, which restricted his contributions. The last days of the relaunched and ailing *Punch* saw his return as a more regular contributor – often working with Tony Reeve. Steve Way is also one of the elite breed of British cartoonists to have been published in the *New Yorker*.

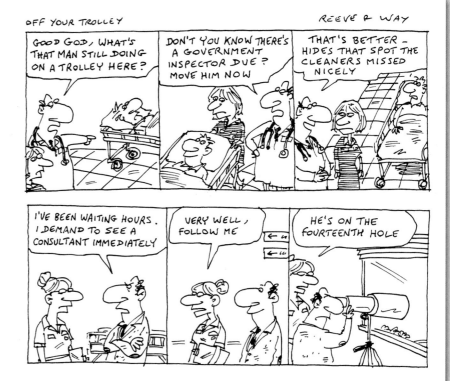

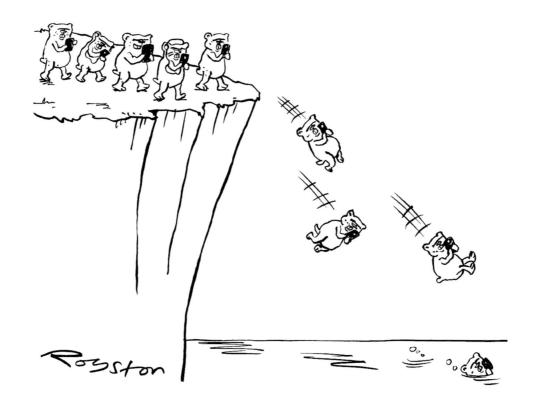

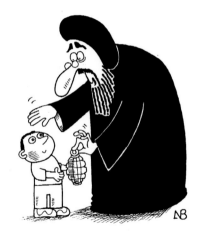

"If only I could go to Paradise with you –
but, alas, I'm needed here on Earth"

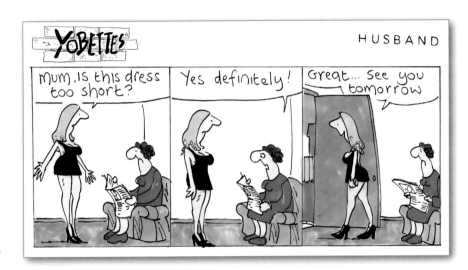

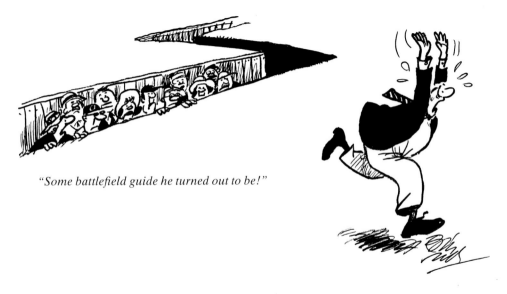

"Some battlefield guide he turned out to be!"

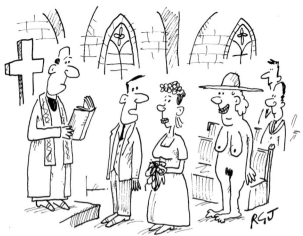

"In retrospect, perhaps it wasn't such a good idea to get
married in your mother's dress"

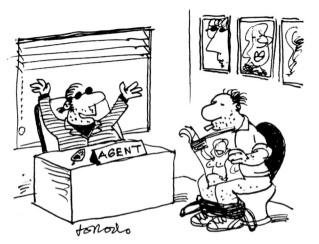

"I love it! Can you dumb it down for TV?!"

HEATH'S PRIVATE VIEW

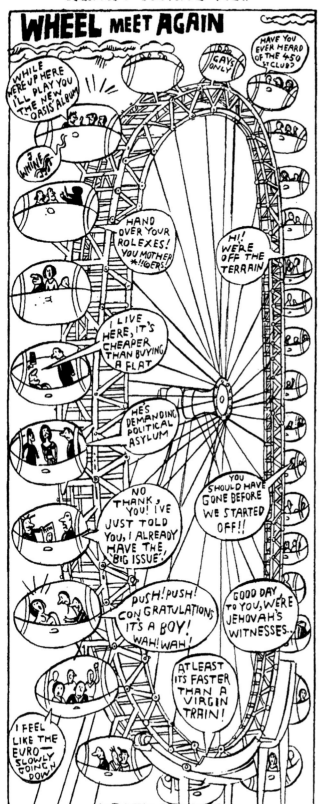

"Jesus Christ, what now? I'm trying to write my fucking sermon!"

"You're married, aren't you?"

MEYRICK-JONES

Simon Meyrick-Jones was born in 1953 and attended art college, before an ad for cartoons in a motorcycle magazine lured him into cartooning. 'Rejection always hurts. So you have to develop a thick skin, which, while useful, prevents you enjoying any success you have.' His favourite published gag (*see* monster *below*) comes from life. 'I was at a ticket barrier at Waterloo. In another queue was a stereotypical crop-headed thug whose ticket was twice rejected by the machine. He instinctively took a step back and clenched his fists before thinking a bit more and asking the ticket inspector. I wondered who or what he wouldn't have a go at . . . hence the cartoon.'

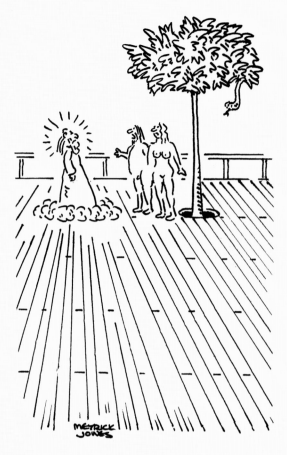

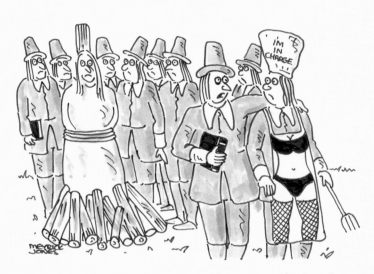

"Brother Nathaniel, burning a witch is a serious business"

"The serpent said that decking would give a more contemporary feel to the garden"

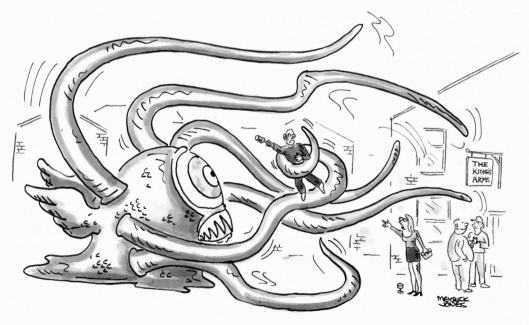

"Leave 'im Gary – ee's not worth it!"

OI! ARE YOU LOOKING AT MY BIRD? Popular pub-brawl wind-up.

"Oi! Are you looking at my bird?"

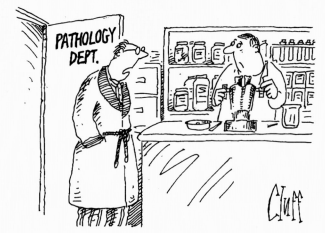

"Oi! Are you looking at my turd?"

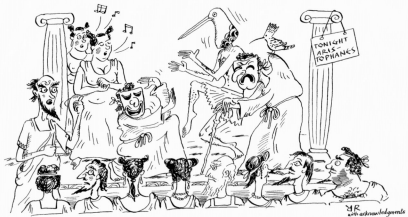

"Oi, are you looking at my Birds?"

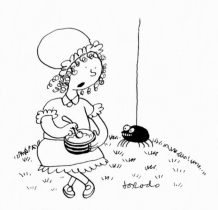

"Oi, you looking at my curd?"

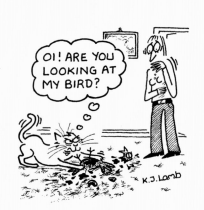

OI! ARE YOU LOOKING AT MY BIRD?

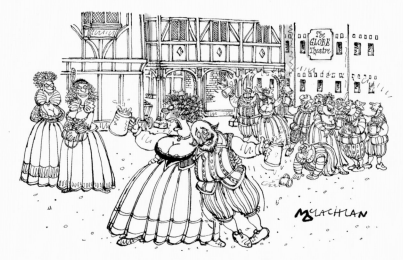

"Oi! Are you lookin' at my bard??!"

(A CASE OF MISTAKEN NONENTITY.)

"I don't get you! We come to the beach and you sit in the shade all day!"

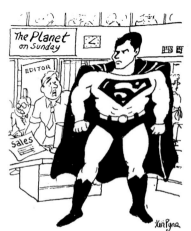

"When disaster threatens we'd like you to turn into a reporter"

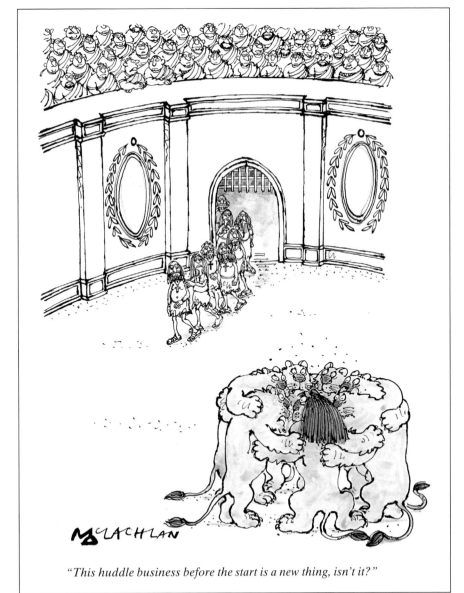

"This huddle business before the start is a new thing, isn't it?"

YOUNG BRITISH ARTISTS

YBA is a shocking affront to modern art – because unlike most Young British Artists, Andrew Birch can actually draw. The strip was first published after the opening of Tate Britain and the huge surge in hype for contemporary art – with the likes of Damien Hirst, Banksy and Tracey Emin. Birch himself lives in Spain. Here, he marks the opening of a major Francis Bacon exhibition.

YOUNG BRITISH ARTISTS — BY BIRCH

That whole dissolute bohemian Soho thing is just *so* passé...

But now that his prices have soared into the stratosphere...

Everyone agrees that Francis Bacon was our most important 20th century painter.

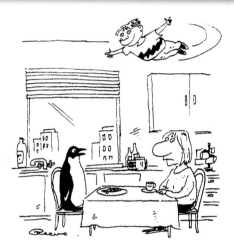

*"Well, he doesn't get it from **my** side of the family"*

"More HRT, Vicar?"

"Must dash . . . I want to spend some time on my social-networking websites"

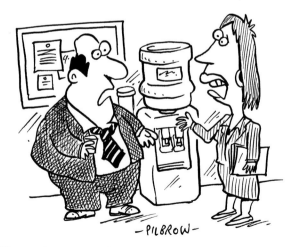

"You can't say it's 'political correctness gone mad' – it's 'political correctness gone mentally challenged'"

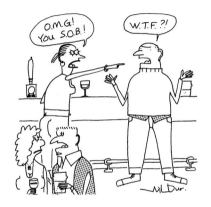

"Oh dear, it's getting very acronymious"

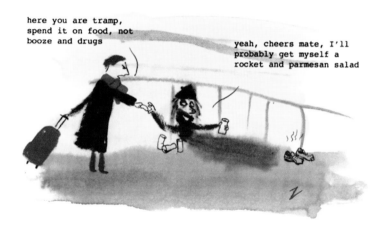

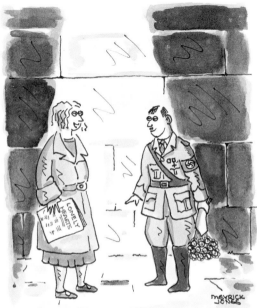

"So you must be 'Vegetarian non-smoker, amateur artist, likes Wagner'?"

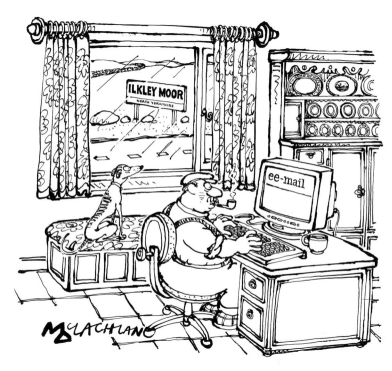

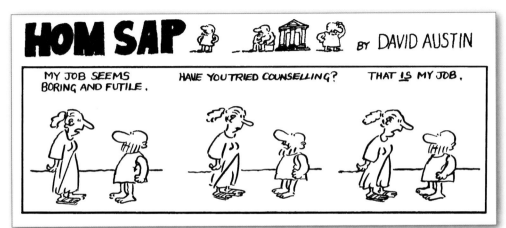

Every compendium of cartoonists should include a tree surgeon, and ꓤR – or Rupert Redway – is the *Eye*'s. Born in 1964, his first submission to *Punch* in 1993 following England's Headingley Ashes victory produced an equally unlikely result: it was accepted. '"How easy is this?" I thought. And I've been bitterly twisted, frustrated and demoralised ever since.' In the Noughties his detailed, intricate drawings have done much to promote stand-alone gags, and the cartoonist's art.

"It didn't take the Ad men long, did it?"

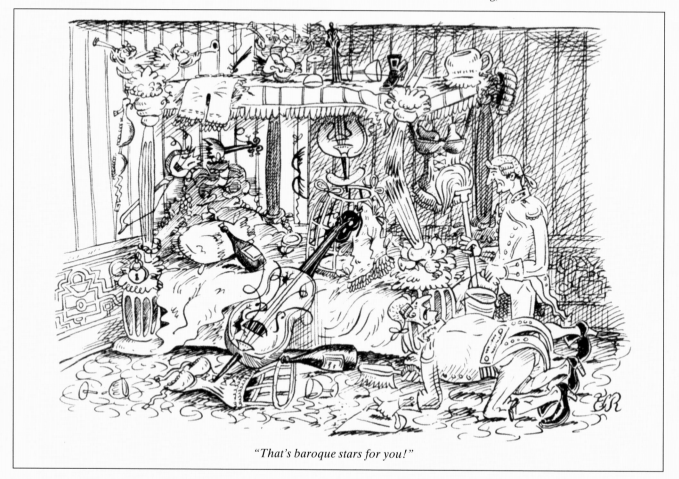

"That's baroque stars for you!"

Celeb — LIGGER

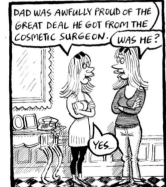
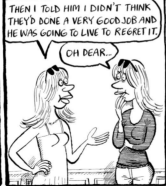
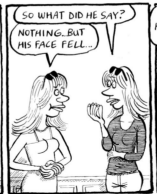
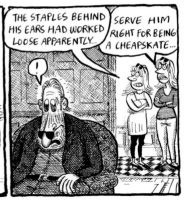

DAD WAS AWFULLY PROUD OF THE GREAT DEAL HE GOT FROM THE COSMETIC SURGEON.

WAS HE?

YES...

THEN I TOLD HIM I DIDN'T THINK THEY'D DONE A VERY GOOD JOB AND HE WAS GOING TO LIVE TO REGRET IT.

OH DEAR...

SO WHAT DID HE SAY?

NOTHING...BUT HIS FACE FELL...

THE STAPLES BEHIND HIS EARS HAD WORKED LOOSE APPARENTLY...

SERVE HIM RIGHT FOR BEING A CHEAPSKATE...

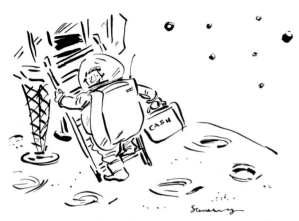

"One small step for man . . . one giant step for offshore tax avoidance . . ."

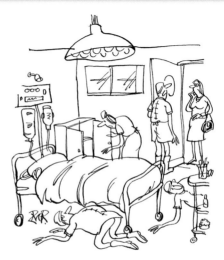

"I'm afraid we've lost him"

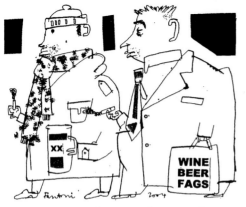

Scenes You Seldom See

"I'm bursting for a piss, but since there are no toilets around here, I'll just have to hold on till I get home"

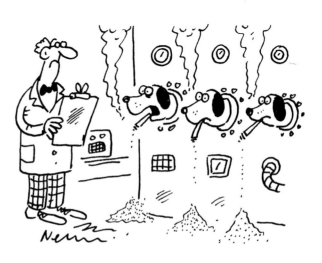

"If they ban smoking in the workplace, we've had it"

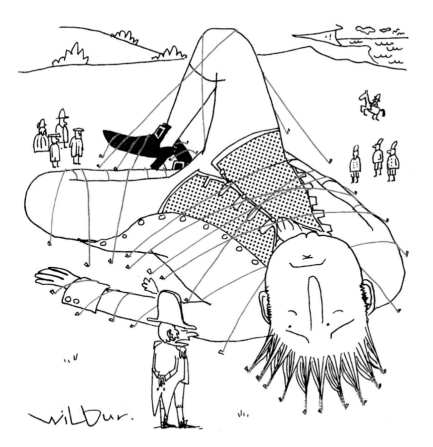

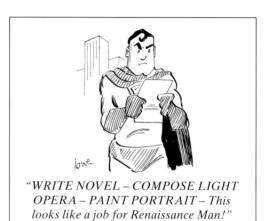

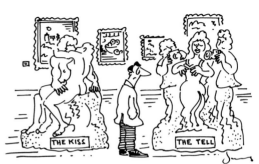

"Immigration controls – sorry about all the red tape"

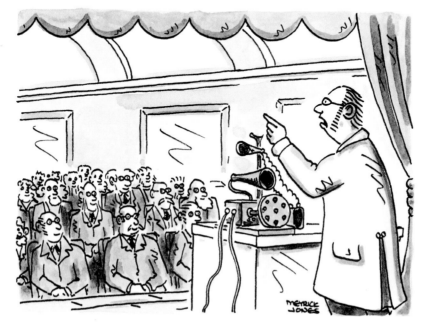

". . . As for the future, it is not too fanciful to suggest that one day, using a telephonic apparatus, man will be able to send images of his genitals across the world at the click of a button"

THE BROON-ITES

Drawn by *Beano*, *Dandy* and *Marvel Comics* artist Henry Davies and written by regular *Eye* joke writers Tom Jamieson and Nev Fountain. Jamieson and Fountain have become gag-writing pillars of the *Eye* over the past decade, having written for *Weekending*, *The News Quiz* and *Dead Ringers*, amongst others. Fountain is also a *Dr Who* aficionado and novelist. In collaboration with Davies, *The Broonites* is a note-perfect parody of the popular Scottish cartoon strip *The Broons* published in *The Sunday Post*. It perfectly captured the dourness of Gordon Brown's uncharismatic clan, including Alistair Darling and Yvette Cooper (*see below*).

*"Personally, I think horoscopes are a load of rubbish,
but I would say that – I'm a Virgo"*

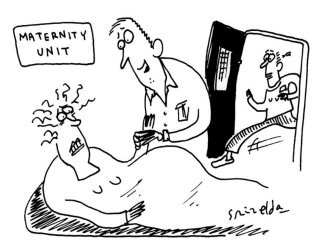

"Congratulations! It's a midwife!"

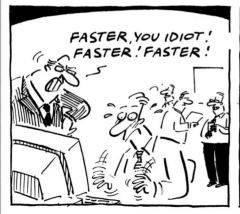
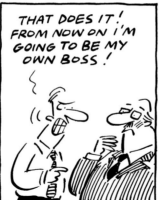
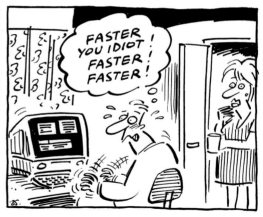

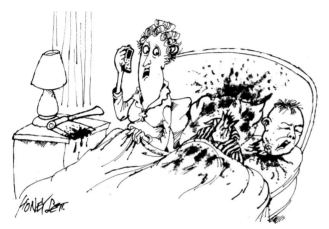

"And would you believe it, he's still snoring"

"I thought we were through with all these super-injunctions"

"Have you tried turning it off and on again?"

EU-phemisms

THE FRAUD INVESTIGATION WILL TAKE SOME TIME

I WILL NEED A LARGE TEAM TO ERADICATE NEPOTISM

I AM THE MAN TO ROOT OUT CORRUPTION

Long enough to move your money Switzerland

I have a lot of cousins to employ

Give me a lucrative sinecure

"They made a good job of his hip replacement in Germany"

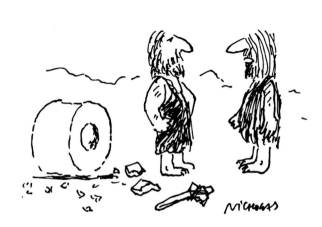

"That's all very well, but what will you do when the stone runs out?"

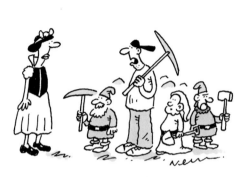

"I'm doing off-to-work experience"

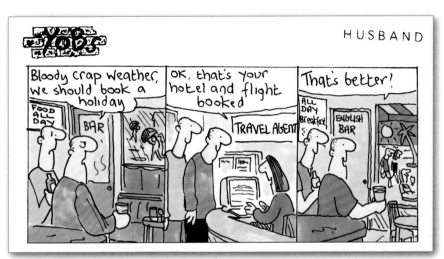

HUSBAND

Bloody crap weather, we should book a holiday

OK, that's your hotel and flight booked

That's better!

DAVE SNOOTY AND HIS PALS

Hislop and Newman's parody of the *Beano's* '*Lord Snooty and his Pals*' cartoon strip sends up the childishness of modern politics, alongside new Tory leader David Cameron's Old-Etonian status. The Tories' triumph in the Henley by-election anticipated Gordon Brown's election defeat. Here, Snooty's pals include Michael 'Oiky' Gove, George Osborne, David Willetts, Oliver Letwin, John 'Redweird' Redwood and Boris the Menace Johnson. Following the 2010 election, Snooty was joined by his New Pals – the Liberal Democrats.

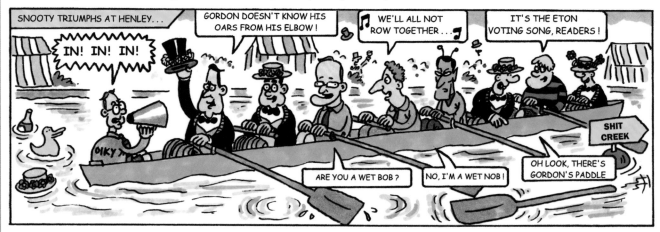

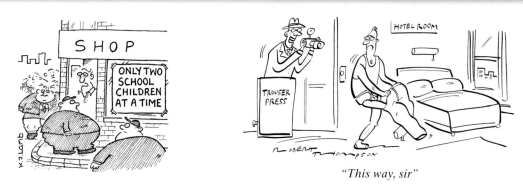

"This way, sir"

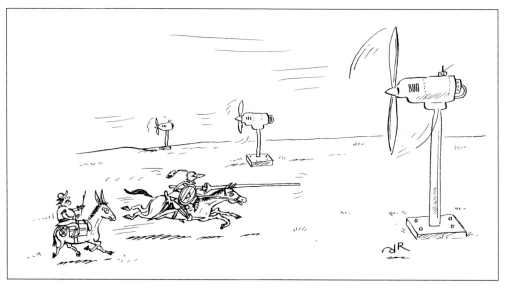

HEATH'S PRIVATE VIEW

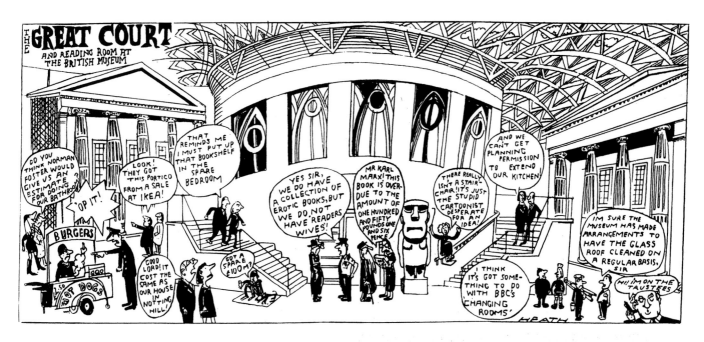

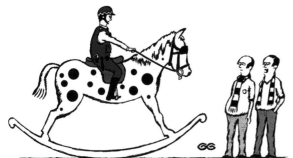

"Is it me, or are policemen getting younger?"

PEARSALL

Born in 1963, Simon Pearsall is an actor (*Doctor Who*, *Grange Hill*, *The Bill*). Rivals urged him to take up cartooning. Like many cartoonists, working methods involve watching *Loose Women* and *Murder She Wrote*. He says 'Someone told me it's best not to meet cartoonists, as they can be mad. Or bitter. Or hopelessly inept, socially. Or even dangerous nutters. Not true. I've met a few and I can think of only three that are dangerous nutters.' His *First Drafts* strip has run since 2002.

First Drafts

Samuel Beckett

First Drafts

**Marcel Marceau's
autobiography**

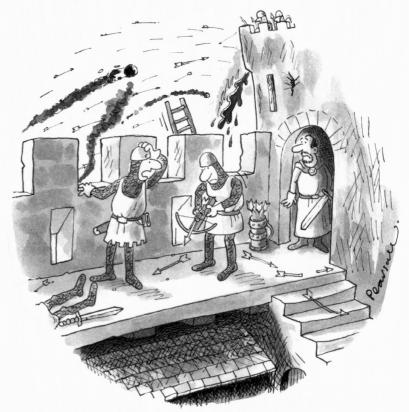

"Sire, the Gifte Shoppe has fallen!"

"To evict Scott call 0901 443321, to evict Oates call 0901 443322, to evict Bowers call 0901 443323, to evict Evans call 0901 443324 . . ."

"We're in trouble – the parents like us!"

Real Pirates

"We're going to download all your sea shanties without paying"

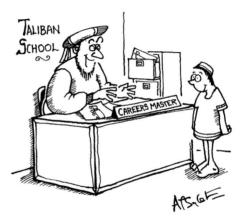

"And what would you like to be when you blow up?"

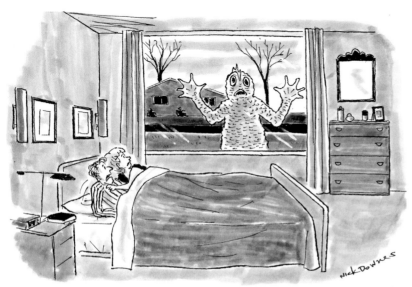

"Oh great – now I'll never get back to sleep!"

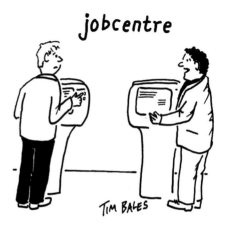

"It's nice, work. If you can get it"

GOOD CALL RGJ's interpretation of an intensely annoying modern expression.

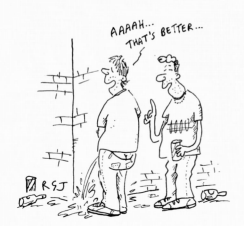

"Good call of nature"

"Good curtain call"

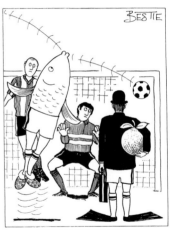

THIS MADE THE SCORE
BARCELONA 0 SURREAL MADRID 2

"Good calling a spade a spade"

"Good call of a duck"

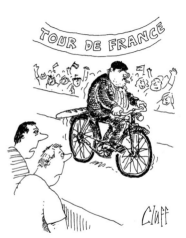

*"He's the only rider left
who hasn't failed a drugs test"*

"Good call of the sirens"

*"I had second thoughts
about a heart . . ."*

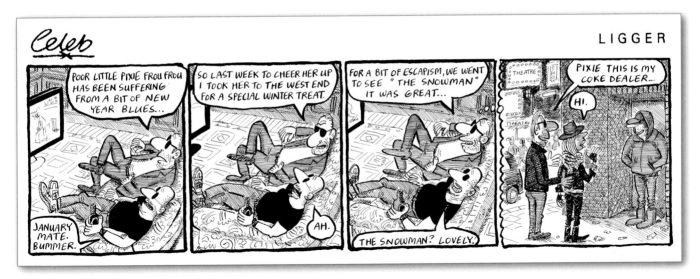

"I try to keep the room just as it was the day he died"

"Jill, what time is my wife's funeral?"

DESPERATE BUSINESS

Created by Jon Link and Mick Bunnage, co-creators of the *Modern Toss* comic, which was also turned into a TV series by Channel 4.

DESPERATE BUSINESS

and I see you went to Cambridge

yeah I had to drop something off for someone, I was back by half six

JON & MICK / MODERN TOSS

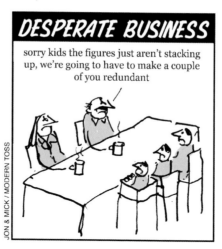

DESPERATE BUSINESS

sorry kids the figures just aren't stacking up, we're going to have to make a couple of you redundant

JON & MICK / MODERN TOSS

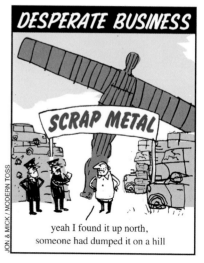

DESPERATE BUSINESS

SCRAP METAL

yeah I found it up north, someone had dumped it on a hill

JON & MICK / MODERN TOSS

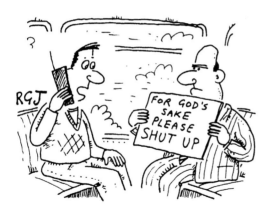

"Hang on . . . I'm receiving a text message"

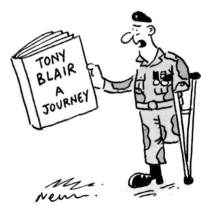

"It cost me an arm and a leg"

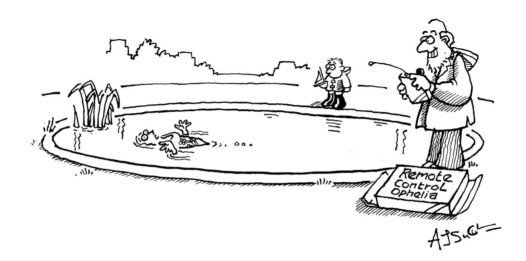

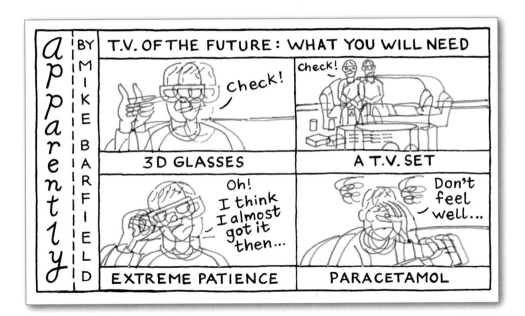

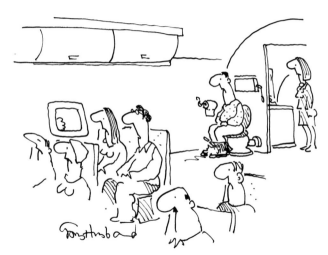

"I sometimes think these no-frills airlines go too far"

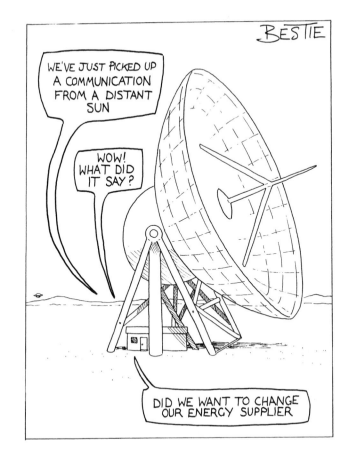

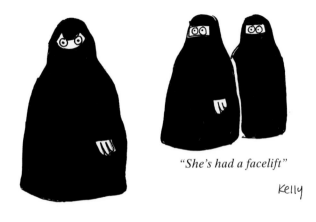

"She's had a facelift"

Kelly

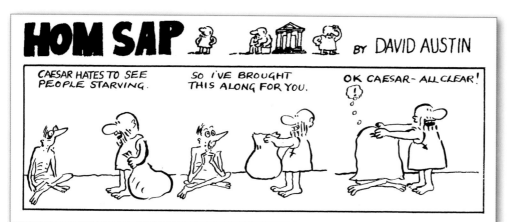

"Will that be all, sir?"

"Sorry, I'm having a senior moment.
I've completely forgotten why I've come here"

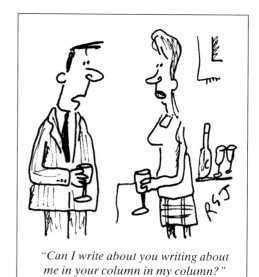

"Can I write about you writing about
me in your column in my column?"

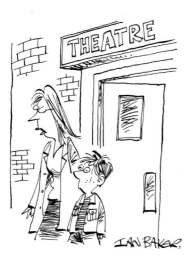

"No dear, it wasn't a 3D film, it's what's known as a 'Play'"

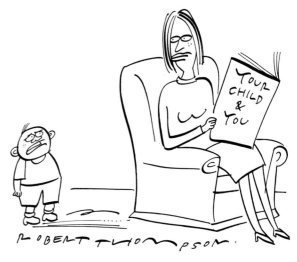

"You never play with me, all you ever do is read
good parenting books"

GRIZELDA

Grizelda Grizlingham can't remember when she was born, due to the fact that it was an incredibly long time ago (it wasn't). She studied English and Drama at university, but had been entertaining friends with her cartoons from the age of 12. Encouraged by her sister to submit to the *Eye*, she was first published at the age of 16. Having worked briefly at UCL, she's now an *Eye* regular. She has produced countless topical and stand-alone gags as well as the strip cartoon *The Commuters* (subsequently cancelled, ironically). 'I don't understand why there aren't more women drawing cartoons,' she says. 'It's not exactly hard manual labour. And it's a great job to fit around other things, like kids.' Any would-be female cartoonists please take note.

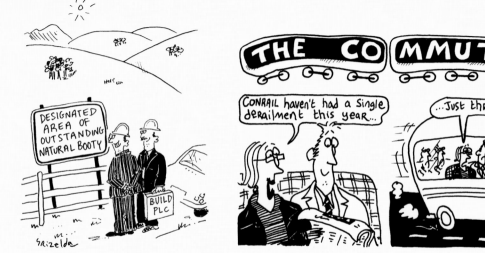

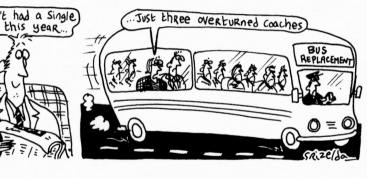

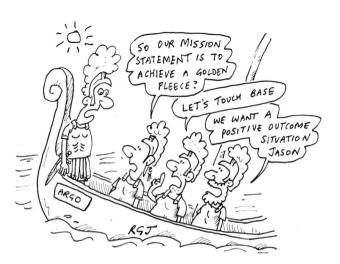

"Oh, no! Jargonaughts!"

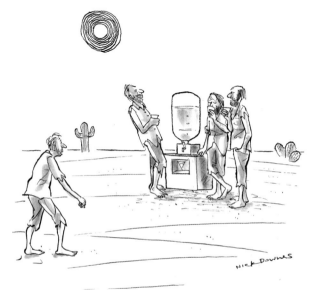

THE DIRECTORS

DREDGE

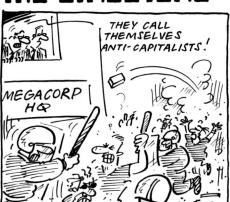
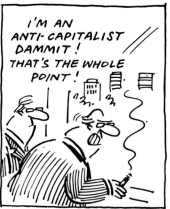
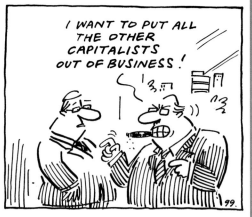

MEGACORP HQ

THEY CALL THEMSELVES ANTI-CAPITALISTS!

I'M AN ANTI-CAPITALIST DAMMIT! THAT'S THE WHOLE POINT!

I WANT TO PUT ALL THE OTHER CAPITALISTS OUT OF BUSINESS!

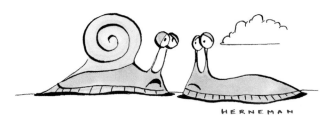

"It's alright for you – I'm stuck at home all day"

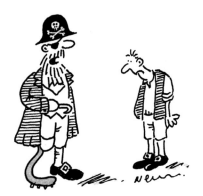

*"Aye, Jim lad, I can outrun any
Captain in the Royal Navy"*

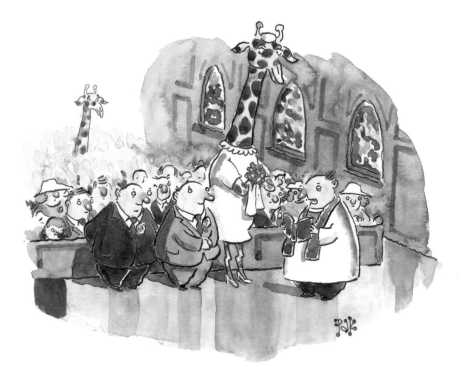

". . . knows of any lawful impediment . . ."

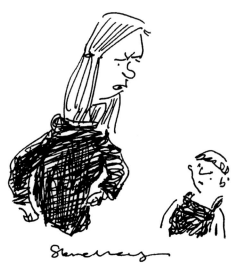

*"Bad boy, just wait until my article
on parenting is in the Guardian . . ."*

"No more worrying about speed cameras!"

"Just how hot are your curries?"

"We want our money back"

THE ADVENTURES OF MR MILIBEAN

Another Fountain/Jamieson/Davies collaboration – picking up on the remarkable similarity of Labour Leader Ed Miliband to Rowan Atkinson's bumbling *Mr Bean* TV cartoon character. Miliband had just had an operation to remove his adenoids.

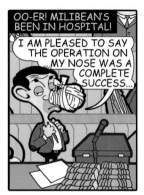

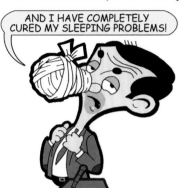

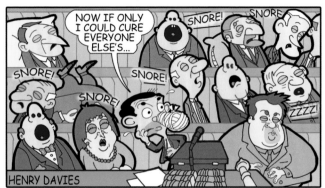

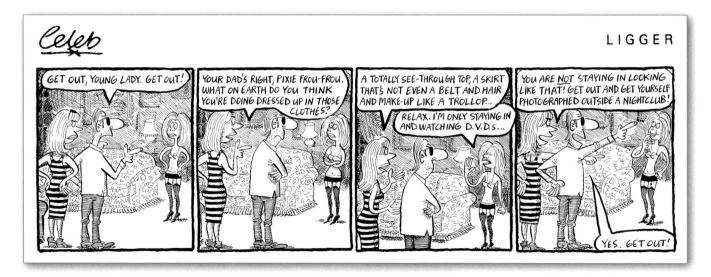

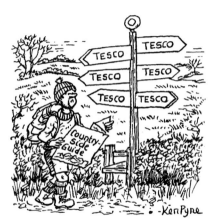

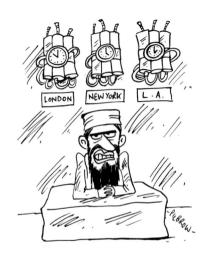

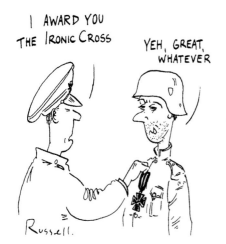

I AWARD YOU
THE IRONIC CROSS

YEH, GREAT,
WHATEVER

Russell.

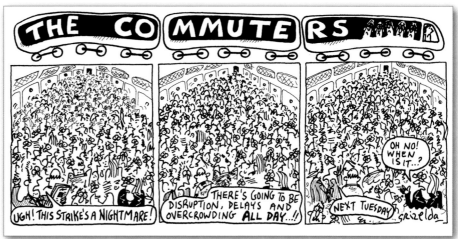

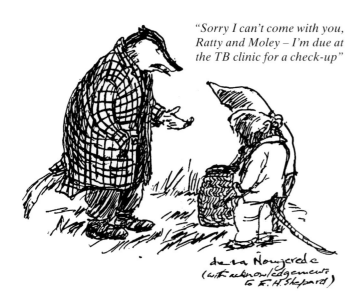

"Sorry I can't come with you,
Ratty and Moley – I'm due at
the TB clinic for a check-up"

"There's been the most terrible accident!
Has anyone got a camera phone I can use?"

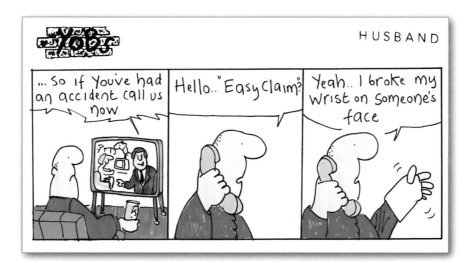

DOES MY BUM LOOK BIG IN THIS? Derived from TV's *Fast-Show* catchphrase.

"Does my bomb look big in this?"

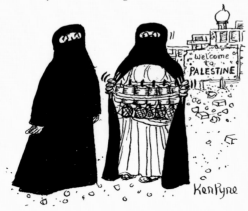

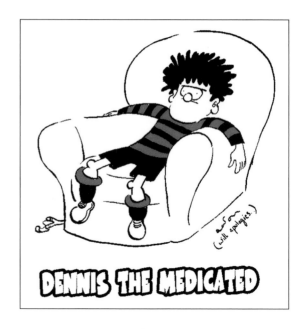

DENNIS THE MEDICATED

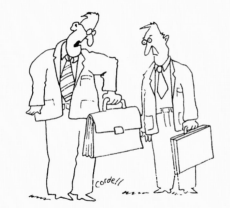

"Be honest – does my bumph look big in this?"

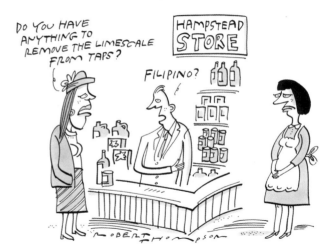

"Does my drum look big in this?"

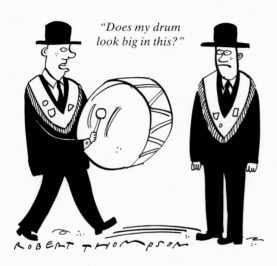

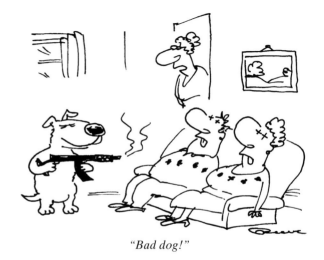

"Bad dog!"

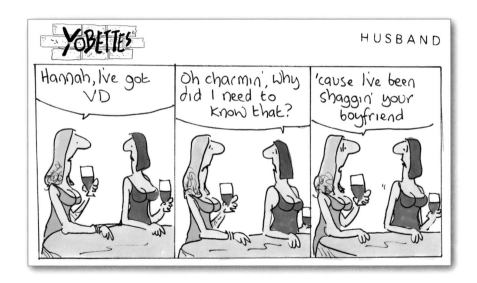

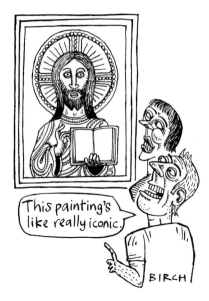

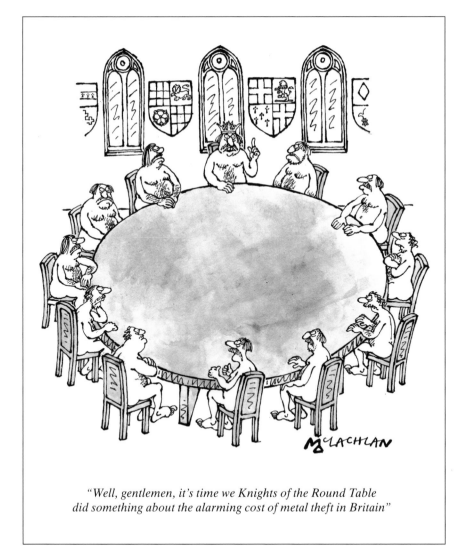

*"Well, gentlemen, it's time we Knights of the Round Table
did something about the alarming cost of metal theft in Britain"*

"Nice day for it"

LEN Len Hawkins is, at just 45, one of the younger cartoonists (a sad but true fact). His cartooning career had a couple of false starts – first published in 1988, then giving up; the same story a decade later. Ten years on, he gave it a proper go – and his success is self-evident. Unlike most other cartoonists, he is unable to draw with pen and ink on paper – preferring an obsolete bit of computer software and an ancient graphics tablet connected to a PC. The result is indistinguishable from a pen and nib. 'When PC hardware no longer supports this old kit, that'll be my cartooning over,' he says. Also, unlike most other cartoonists, he has a full-time job, in IT support. 'The glamour of the work means I will never leave it.'

"Well, that was embarrassing – we didn't get them anything"

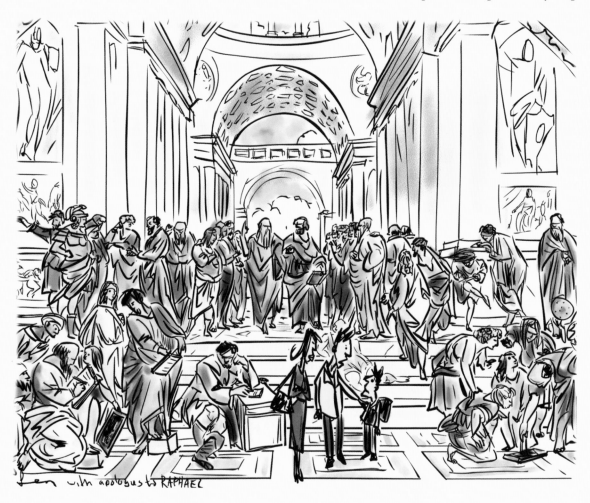

"Don't forget – if anyone asks, you've always lived within the School of Athens catchment area"

"Until we come up with a format to rival Big Brother – one person gets axed every week"

Modern last words

"I wish I'd recycled more"

YOU CAN'T BEAT A WALK ON CHRISTMAS MORNING

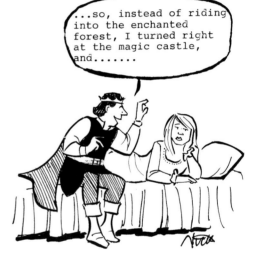

...so, instead of riding into the enchanted forest, I turned right at the magic castle, and.......

PRINCE BORING

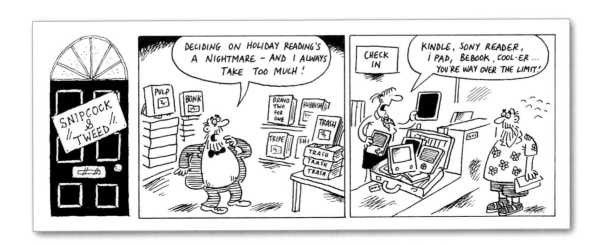

SNIPCOCK & TWEED

DECIDING ON HOLIDAY READING'S A NIGHTMARE – AND I ALWAYS TAKE TOO MUCH!

CHECK IN

KINDLE, SONY READER, i PAD, BEBOOK, COOL-ER ... YOU'RE WAY OVER THE LIMIT!

FALLEN ANGELS

Fran Orford's take on modern nursing. Orford was born in the same street as Ken Dodd in Liverpool, and is a qualified gym instructor.

"Luckily he has dementia, so he's got some imaginary friends coming in to look after him"

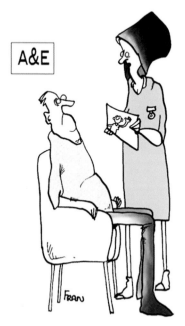

"The policy says you have to see a doctor within four hours . . . This is him on holiday in Tunisia last summer"

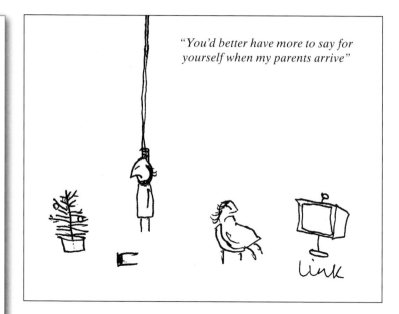

"You'd better have more to say for yourself when my parents arrive"

"His biblical age is 977 but sometimes he acts like a stupid 562-year-old!"

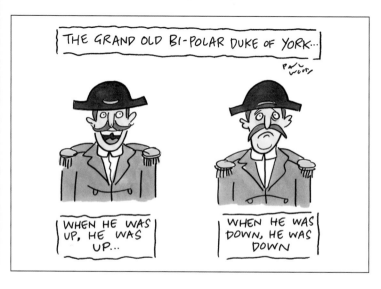

THE GRAND OLD BI-POLAR DUKE OF YORK...

WHEN HE WAS UP, HE WAS UP...

WHEN HE WAS DOWN, HE WAS DOWN

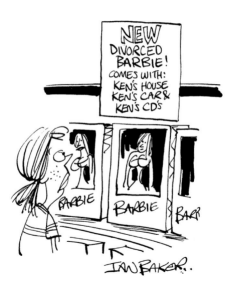

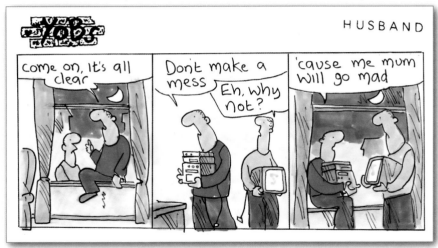

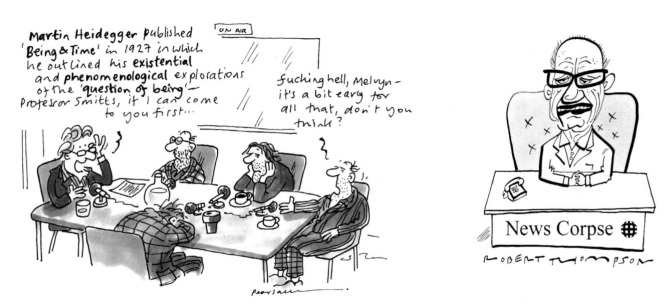

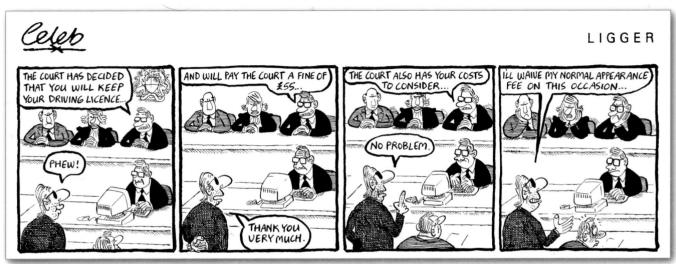

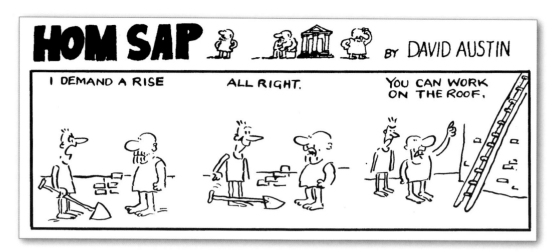

HUNTER

"I met him on the Internet"

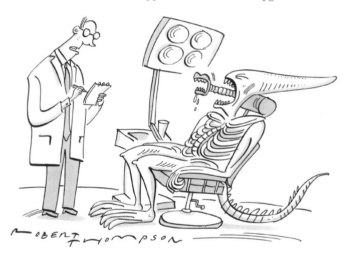

"Better make that two appointments with the hygienist"

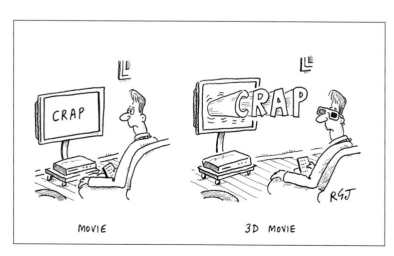

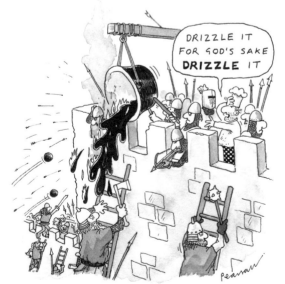

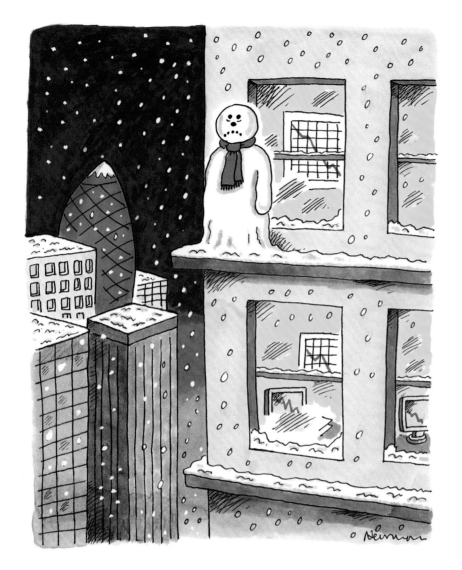

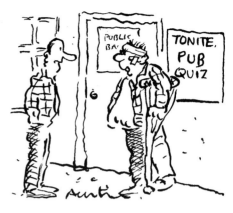

"*A bloke from the US Army was asking the questions*"

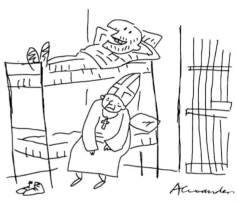

"*Everyone's innocent in here, pal*"

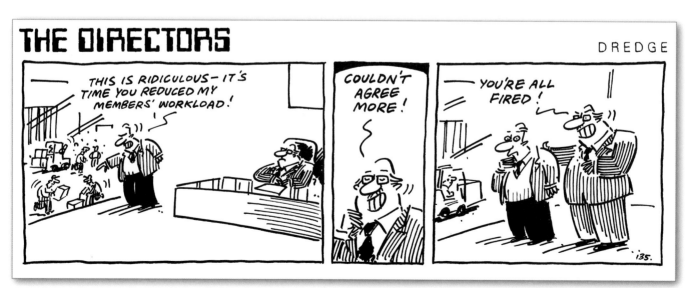

THE DIRECTORS

DREDGE

THIS IS RIDICULOUS — IT'S TIME YOU REDUCED MY MEMBERS' WORKLOAD!

COULDN'T AGREE MORE!

YOU'RE ALL FIRED!

135.

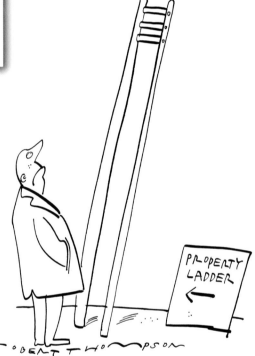

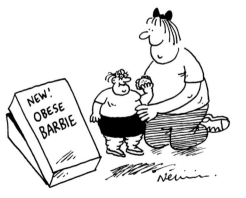

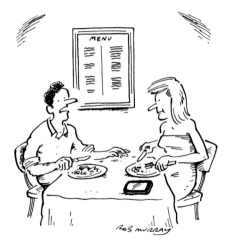

"Is everything alright? You've barely touched your phone . . ."

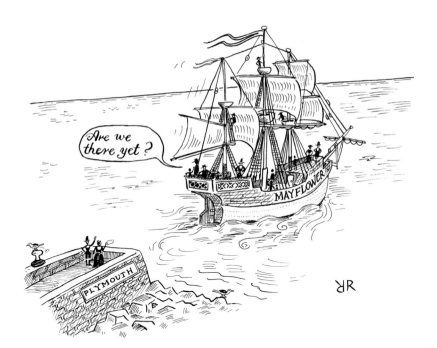

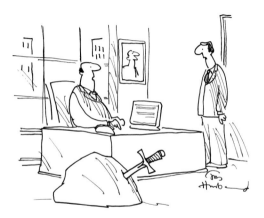

"I'm retiring soon, Marcus, and I'm looking for someone to take over"

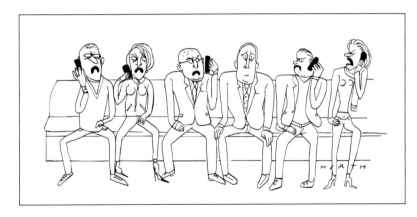

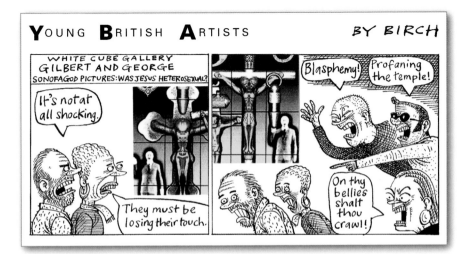

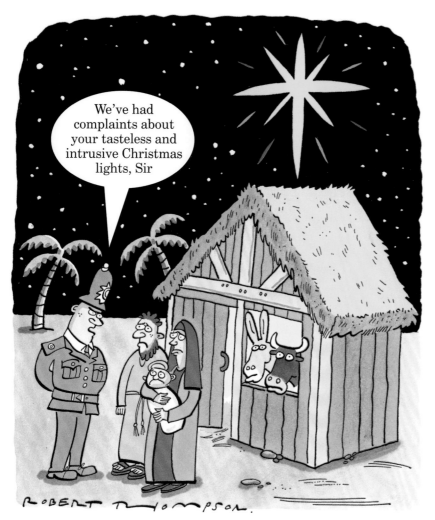

"Are we nearly there yet?"

"Phew! That's a relief – I drink a bottle!"

CAUGHT BETWEEN IRAQ
AND A HARD PLACE

"A shoe bomber? What on earth do you mean?"

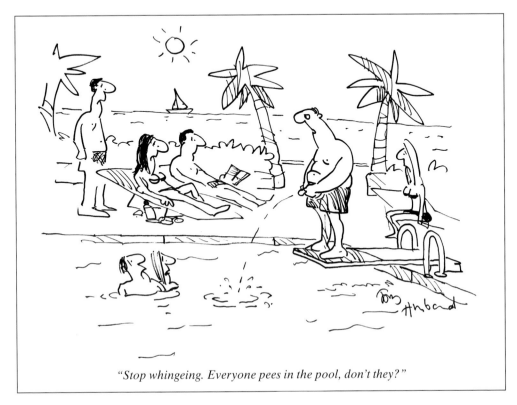

"Stop whingeing. Everyone pees in the pool, don't they?"

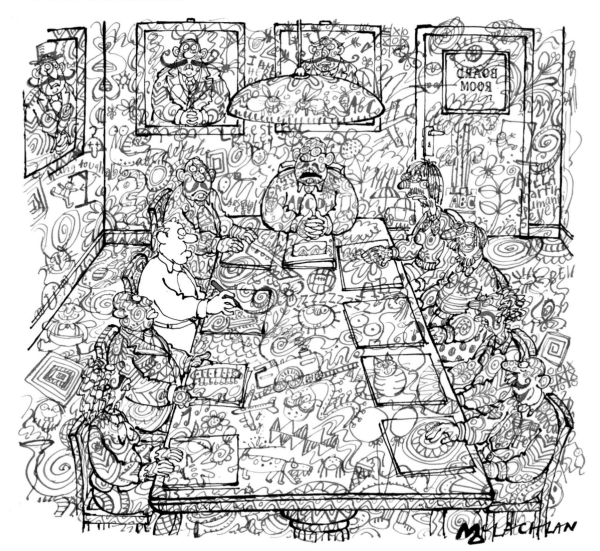

"Are we boring you, Mr Etherington?"

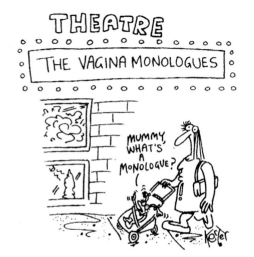

a	BY	SOCIAL INSECTS : A PICNICKERS' GUIDE		
p	M	QUEEN	QUEEN	BASTARD
p	I			
a	K	MALE	DRONE	BASTARD
r	E			
e	B	WORKER	WORKER	BASTARD
n	A			
t	R			
l	F			
y	I			
	E			
	L			
	D	ANTS	BEES	WASPS

PAUL WOOD

Paul Wood was born in 1964 and became a cartoonist after meeting Ed McLachlan, having left school with no qualifications and doing youth opportunity project schemes with West Midland borstal dropouts ('Ah,' he says, 'the Thatcher years . . .'). He finally went back to school and thence to art college. His *Eye* strip *the Premiersh*ts* won the Sports Journalist Association 'Sports Cartoonist of the Year' in 2010.

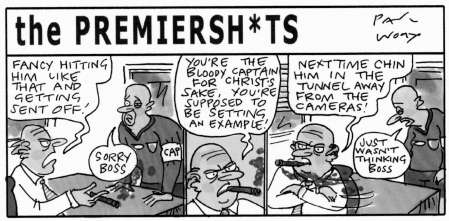

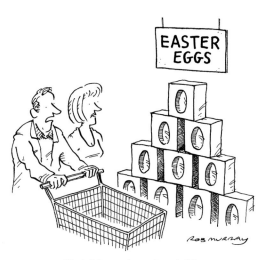

"Is it November already?"

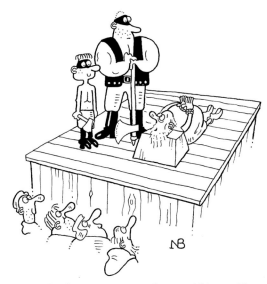

"Prithee, mercy – not the unpaid intern!"

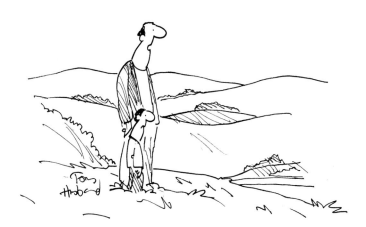

"From this point you can see mummy in a car with another man"

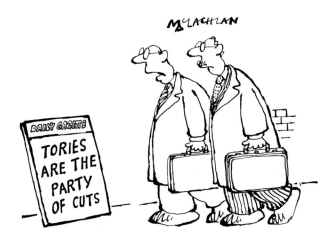

"I hate to see spelling mistakes"

SCENE AND HEARD

David 'Ziggy' Greene came to *Private Eye* via France's *Charlie Hebdo Magazine* – reviving cartooning reportage reminiscent of Ronald Searle's work for *Le Monde* and Heath's *Private View*. His work methods are journalistic – spending 2-3 days at the relevant location, interviewing and recording interviews before committing pen to paper.

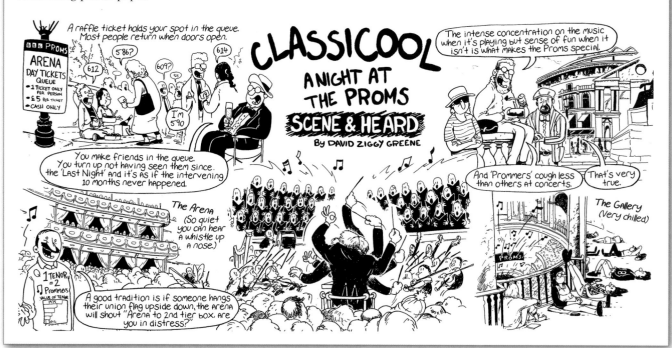

The Adventures of Mr Milibean

Fountain & Jamieson

HENRY DAVIES

"I suggest treatment abroad. Try Lourdes"

*"To be honest, I haven't felt
this indifferent since Diana died"*

*"It's very nice, but defensively I think
the conservatory will be our weak point"*

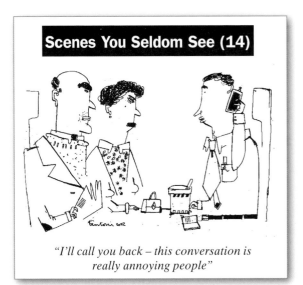

*"I'll call you back – this conversation is
really annoying people"*

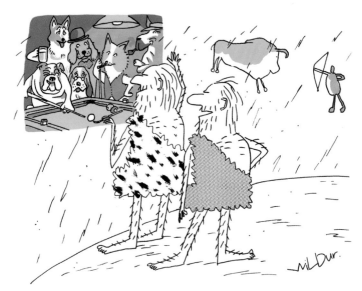

"You've really hit your stride now, Thag"

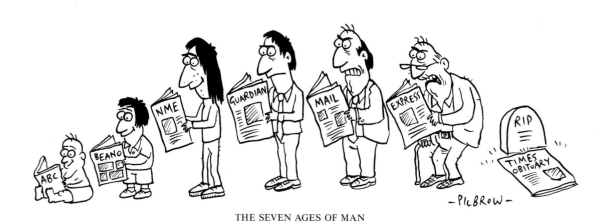

THE SEVEN AGES OF MAN

INDEX

*Pages with biographical notes are in **bold italic***